BARRINGTON BARBER

DRAWING
MASTERCLASS

BARRINGTON BARBER

DRAWING MASTERCLASS

ARCTURUS

ARCTURUS

This edition published in 2010 by Arcturus Publishing Limited
26/27 Bickels Yard, 151–153 Bermondsey Street,
London SE1 3HA

ISBN: 978-1-84837-369-3
AD001420EN

Printed in China

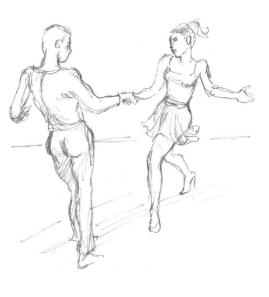

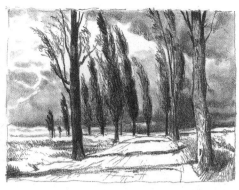

CONTENTS

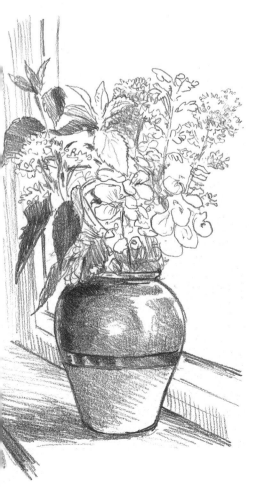

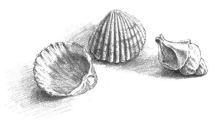

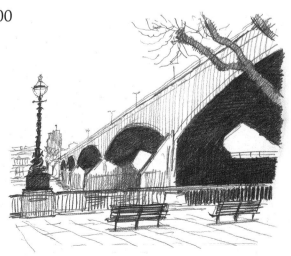

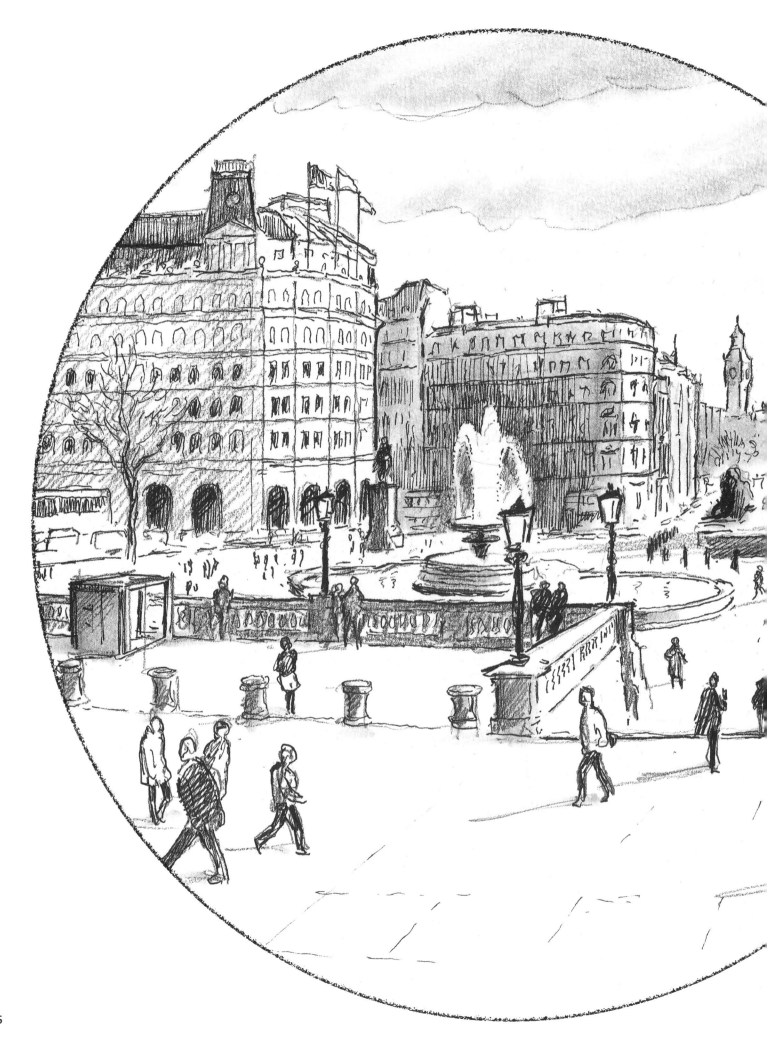

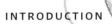

INTRODUCTION

This book presents a series of projects that teach the basic approaches to various areas of drawing, with the emphasis on preparing for a large final work that uses what has been learned on the way. However, there will be many preparatory pieces that will build your artistic skills for the future, so it's not just the final projected work that's important, but also the practices that will help you to reach it.

Drawing isn't a mystery – even if you haven't touched a drawing implement since childhood, you can start to draw with a systematic approach to this art form. Practice is the key to any discipline, and you always become good at what you practise often. Because of the particular form of this book, you can embark on it anywhere and make a reasonable effort to produce a picture. However, if you're an absolute beginner, it's worth noting that the easiest subjects are at the beginning and the more complex ones at the end. All the exercises are based on the way I have taught drawing and art for many years; there are of course many ways to teach art, but these are tried and tested methods that many artists have used in the past.

Each project is complete in itself, so that you can concentrate on one thing to give you a better chance of achieving a good result. However, you shouldn't be downhearted if at first the result doesn't look as good as the examples shown. Remember that all of these – both my own drawings and those after masters – are by professional artists who have had many years practice. In fact you're never the best judge of your own work immediately on finishing it – put it aside and in a few days or even weeks you will have a better idea of your achievement.

So enjoy becoming involved with the creative process and you will understand why nobody ever reaches its end, which is what makes it so fascinating. There is always further to go, even if, like me, you have been drawing for a lifetime.

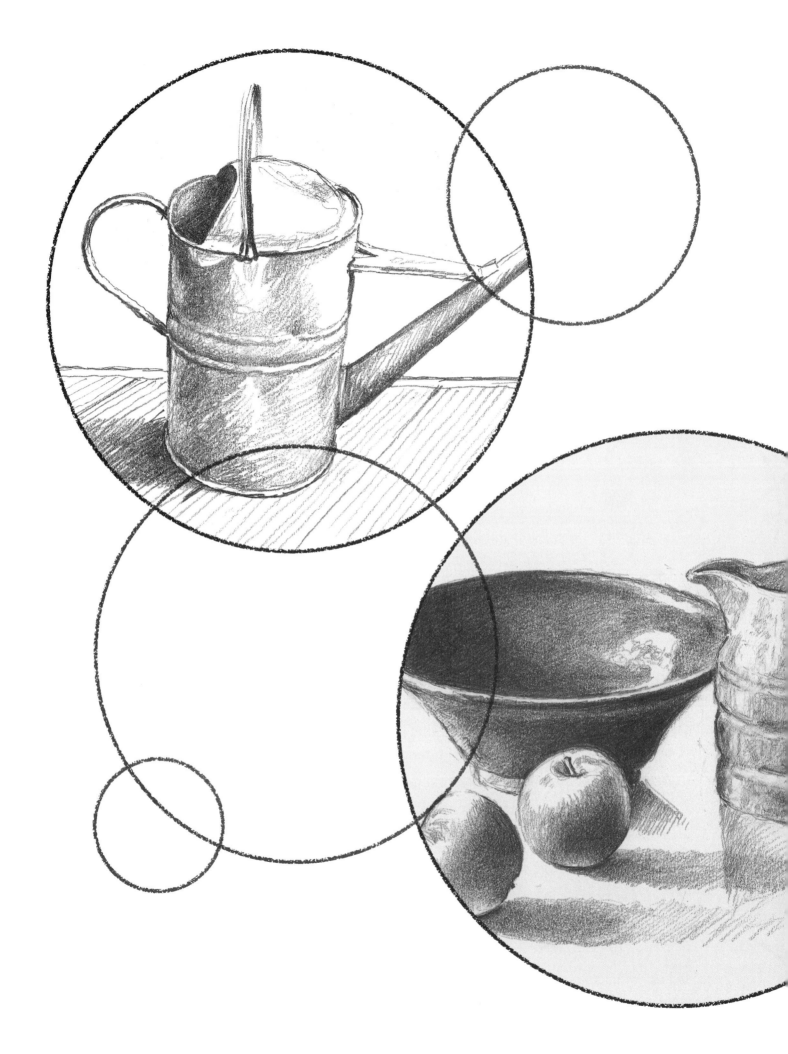

PROJECT 1: STARTING OUT WITH STILL LIFE

This part of the book starts with a series of straightforward exercises that will help you to tackle the process of drawing if you're a beginner. However, even if you're a competent draughtsman it's wise to carry them out because the repetition of mark-making such as this helps you to get the feel of your tools and bring your eye and hand into cohesion.

Once you've developed control of your pencil you can begin to look at everyday objects around the house and make simple drawings of them. The next easy step is to try out your skill at putting together a composition of several objects and producing a still-life drawing. I have suggested a variety of obvious things for you to draw, but you can choose any subject that interests you.

In the later pages of this section I've included some larger and slightly more complex subjects so that you have something to get your teeth into if you find yourself steaming ahead in great shape. The main thing is to enjoy the process of drawing without worrying about how well or badly you're doing initially; just try out your skills of observing and then recording what you see, and you'll find that the more you do this the better you will get. I don't guarantee to turn you into an artistic genius, but with a little effort and the will to persevere you'll soon develop your abilities.

Simple marks

Before we make a start on drawing objects from the real world, it's a good idea to practise some simple exercises as a warm-up. While these first pages are primarily intended for beginners, you'll find that the exercises are still useful even if you've had a good deal of practice.

1 To make a start, try drawing a wavering, continuous line that repeatedly overlaps itself. As you draw, note the effect of the pencil on the surface of the paper. This first exercise is really just to encourage you to realize that the feel of your materials is just as important as the visual result. Without this understanding you'll find that your drawing lacks tactile values.

2 When you feel you have pursued your scribble for long enough, try out a simple sequence of repetitive strokes of vertical lines drawn so close together that they start to look like a patch of tone.

3 Then try some horizontal lines that are more spaced out and are all about the same length, the same distance apart and as straight as you can make them. You are now beginning to control your pencil to achieve an effect.

4 Now try drawing a spiral that starts on the outside edge and moves slowly inwards until you reach the centre. Then do the opposite, starting in the centre and spiralling outwards.

5 Next lay down a whole rectangle of medium to dark tone, moving the pencil in diagonal strokes as naturally as your hand can manage and always in the same direction. Try to keep the tone the same all over.

6 Make a layer of vertical strokes close together, followed by a layer of horizontals going across them, then by diagonals crossing in both directions. As you can see, this builds up a dark tone.

8 Draw several small circles, lining them up in rows of four or five. The idea is to make them as similar as possible and all in regular formation. You are now dividing up space and organizing shapes.

7 Now try drawing a circle as perfectly as you can. Then imagine a perfect circle in your mind and try drawing a circle again. This is not so easy as the previous exercises but is very good practice.

9 Next comes a series of simple conceptual shapes, starting with an equilateral triangle – that is, one with all sides equal.

10 Now try a square, remembering that all sides should be the same length and all corners are right angles (90 degrees).

11 Now draw the same shape but tilted up so that it stands on one corner – slightly more tricky to do.

12 Without taking your pencil off the paper, draw a five-pointed star. This may need a few attempts before you get it right.

13 Now draw two equilateral triangles overlapping to make a six-pointed star.

14 And after that, two squares overlapping to make an eight-pointed star.

15 Now draw a crescent moon shape, which is only parts of two circles overlapping.

11

PRACTICE SESSION

The next step is to concentrate more on tone in
order to draw apparently three-dimensional shapes.

To start with,
draw some
shading, using
vertical strokes that
gradually get lighter
until they disappear
altogether.

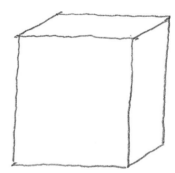

Now draw a
circle and shade
in around the
outer rim, graduating
the tone lighter and
lighter as you approach
the centre. As you can
see, this resembles a
sphere.

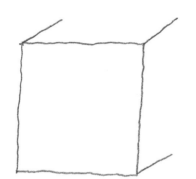

Draw a square, then draw three parallel lines from three of the
corners, as shown. Draw two more lines parallel to the edge
of the square. What appears before your eyes is a conventional
representation of a cube shape – a three-dimensional object.

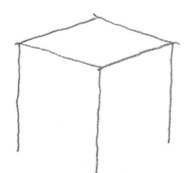
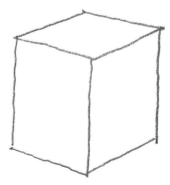

A way to do a similar figure is to draw a flattened diamond
shape, extend three verticals from the corners and then join their
ends to make another cube.

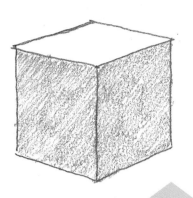
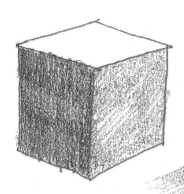
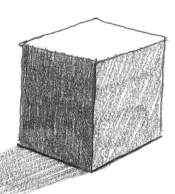

5 Give this last figure a three-dimensional quality by shading in the two lower surfaces of the cube with an even tone – not too dark. Then work over the left-hand surface with a slightly darker tone. Draw in a cast shadow stretching away from the darker side of the cube. All this has the effect of making the cube look even more solid.

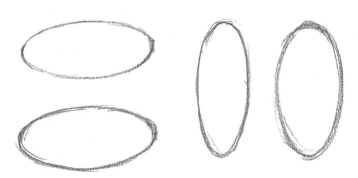

6 The next exercise is to draw some ellipses, which are curved shapes that resemble a circle seen from an oblique angle. If you look at a wine glass, the top edge and the base will appear to be ellipses unless you are viewing it from immediately above. Draw several of these to get the idea, remembering that the curve must be continuous, without any flattened bits or pointed ends. Depict some of them on their narrow ends so that they resemble a wheel seen from an angle.

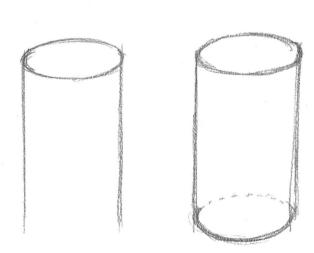
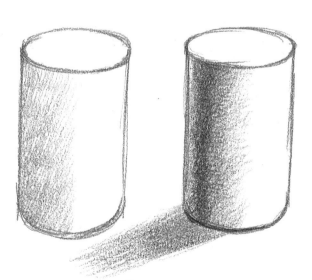

7 You can now use your ellipse-drawing skill to depict a cylinder. Draw the ellipse, then project two vertical lines downwards from the narrow edges. Draw a second ellipse at the lower end of the two straight lines. To make the cylinder appear solid, rub out the top edge of this ellipse.

When you've done that, shade very lightly down the left-hand side of the cylinder, allowing the tone to fade off to nothing about halfway across the length. Darken a strip down the left-hand side of this shadow, not quite touching the side of the cylinder. Finally, put in a cast shadow as you did with the cube.

13

Simple still-life objects

Here we're going to build up to drawing a simple still-life composition, starting with some practice on straightforward household objects to help you tackle the problems that you'll discover. In these examples I've given you a variety of shapes, some easy and others more complex.

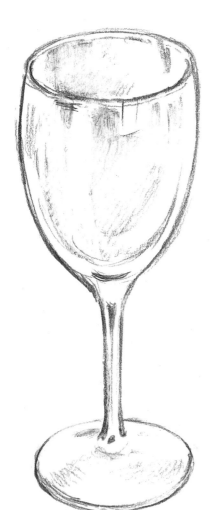

First I tried a tumbler and a wine glass, because they are easy to see through, and so you can see how the shape works. They are both centred on a central line, both sides being mirror images of each other. You could draw a vertical and draw each side of it, as I have done with the tumbler.

I've also drawn in all the tonal values, but before you embark on this do make sure that you have got the shape right.

Next I moved on to two solid objects, which are a bit more complex because of the projections on them. The first is a teapot, which I have drawn with the spout turned slightly towards me. So although the middle part of the pot is based on a central line, the spout and the handle are angled projections off that more balanced shape.

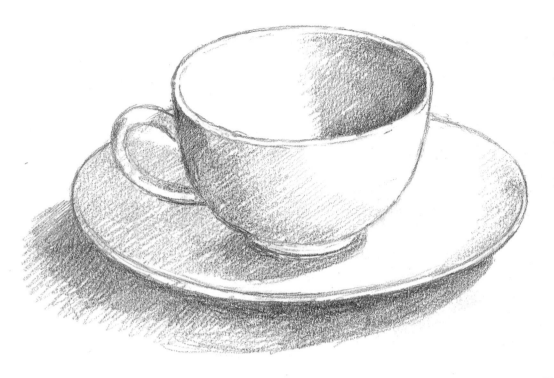

The next example is a cup and saucer, with the handle projecting to one side, and here you also have two objects that fit together to contend with. The shapes are gradually getting more complex to suit your developing skills.

Now a return to a glass tumbler – but this one has faceted sides in the lower half, which produces a more testing shape to draw. Again, as with all of these objects, the main thing is to get the shape right and only then go ahead with the shading.

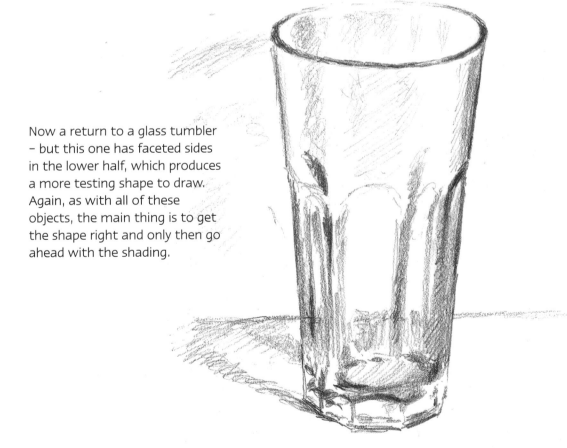

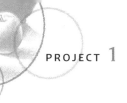

A jug is the next object, but a curved one with a painted rim and handle to make things more tricky. Work on the shape first and then add the tone as before.

This pleasingly old and battered watering can is a little more complex in construction than what has gone before. It is your accuracy of perception that is going to be tested here, so this is good practice.

Unlike man-made goods, objects found in nature often have imperfections and unevenness in form. The trick with this pine cone is to make the tones very dark in the central shadows and lighter where the leaves don't overlap. Because of the variety in shape you don't have to worry if your drawing isn't exact.

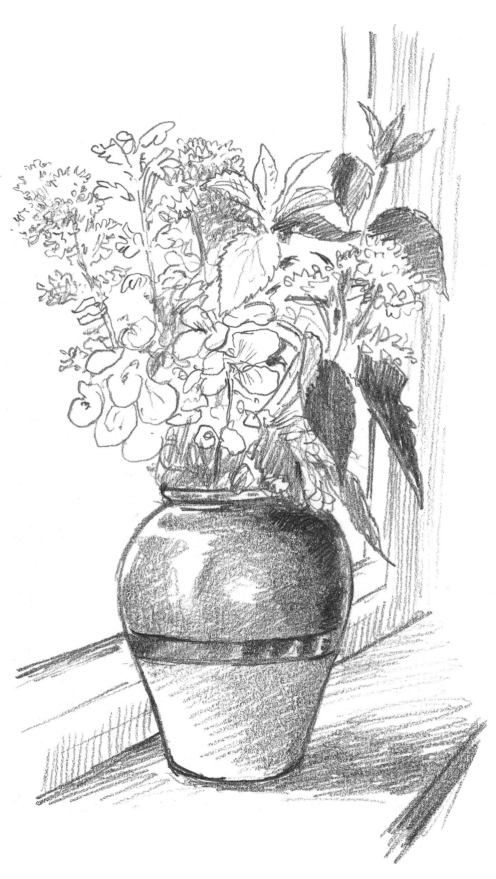

In the case of a vase of flowers, you'll be drawing both natural and man-made things. Try to make the flowers and leaves look softer and more fragile than the vase. We'll be looking more at this kind of arrangement in the next project.

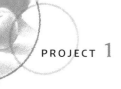

Grouping objects

Now we're going to move on to groups of objects – always trickier than single items as you have to consider their relationship to each other.

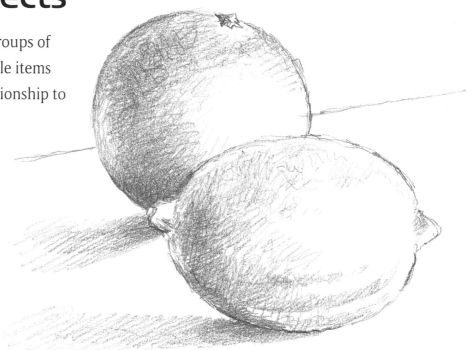

Start with an orange and lemon, placing them in such a way that one overlaps the other. This means that you have to consider the size of one compared with the other, as well as the different shapes. When you put in the tone, notice how the shading on the lower part of the orange helps to show up the shape of the lemon.

Now try three objects – two apples and a pear. The space between the apples is very narrow and causes a nice tension between their shapes. The front apple overlaps the pear and helps to contrast the two shapes. Here you are thinking in terms of a still-life composition.

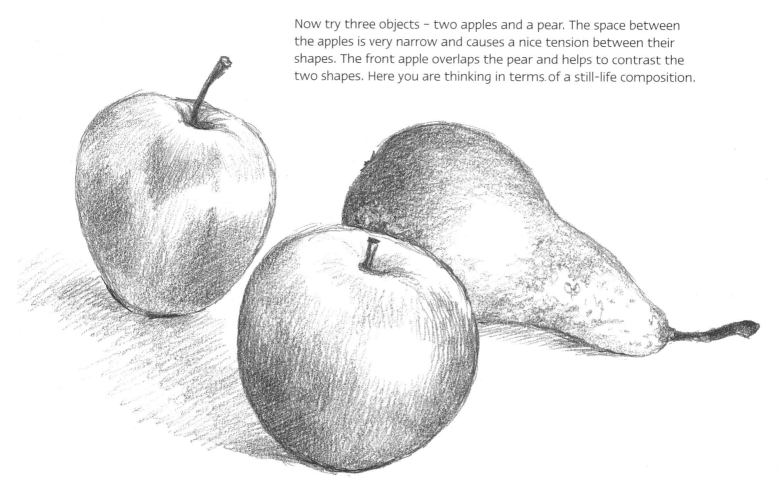

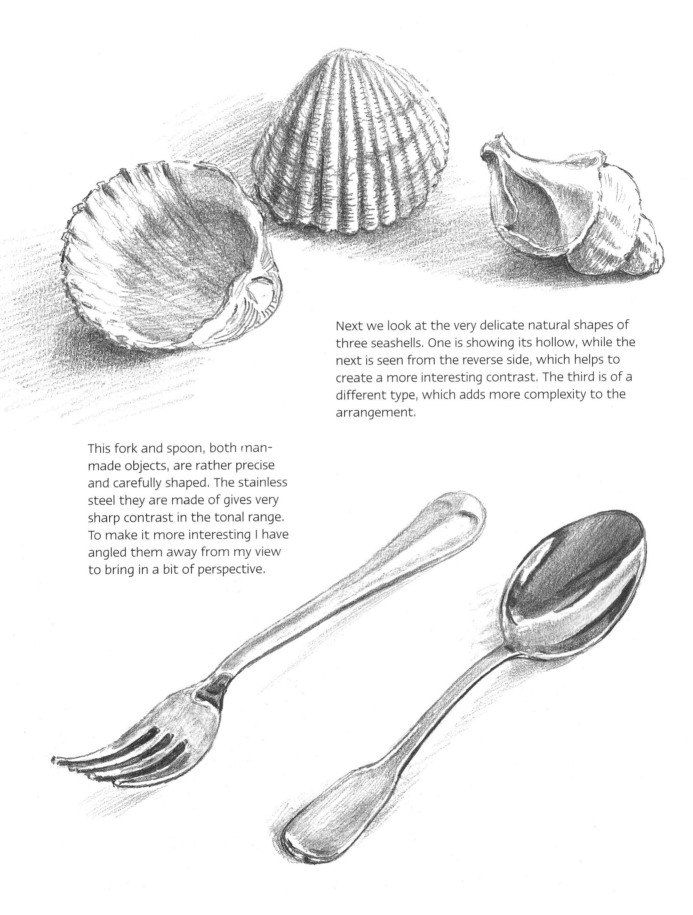

Next we look at the very delicate natural shapes of three seashells. One is showing its hollow, while the next is seen from the reverse side, which helps to create a more interesting contrast. The third is of a different type, which adds more complexity to the arrangement.

This fork and spoon, both man-made objects, are rather precise and carefully shaped. The stainless steel they are made of gives very sharp contrast in the tonal range. To make it more interesting I have angled them away from my view to bring in a bit of perspective.

Larger objects

From small objects we jump to something much bigger, with the challenge of perspective thrown in. This is a normal, fairly straight up-and-down kitchen chair with a padded seat, seen in a strong angled light. The main thing here is to get the proportion between the seat, the back and the legs of the chair right. This can be quite time-consuming, but if you don't take trouble over it the chair will look either unwieldy or out of balance.

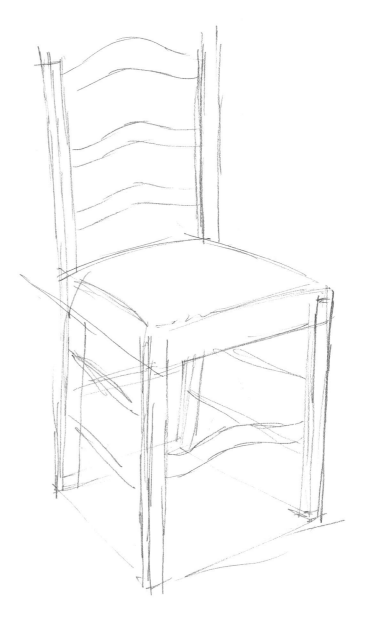

When you are drawing an object such as a chair which has a regular cuboid structure, it's advisable to sketch the block-like shape first to make sure that the perspective of the structure is clearly seen.

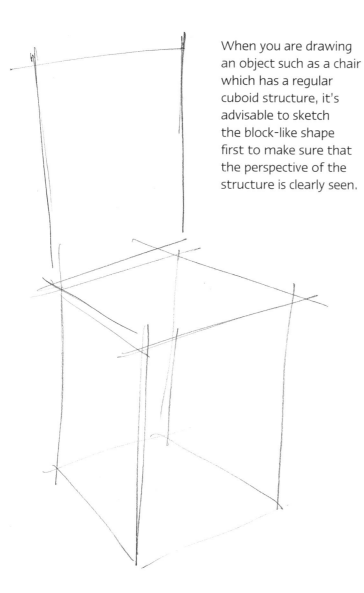

Then draw out the main structure of the chair so that you have a good basis on which to do your more detailed drawing. Look at the perspective of the shape of the chair and try to get all the parts correctly placed.

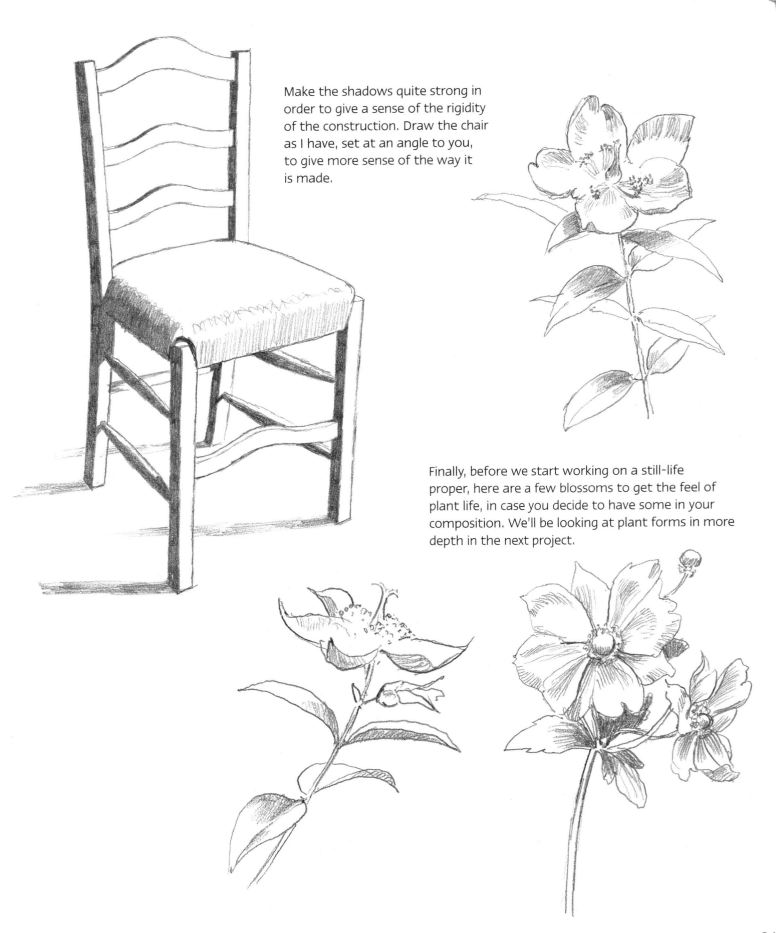

Make the shadows quite strong in order to give a sense of the rigidity of the construction. Draw the chair as I have, set at an angle to you, to give more sense of the way it is made.

Finally, before we start working on a still-life proper, here are a few blossoms to get the feel of plant life, in case you decide to have some in your composition. We'll be looking at plant forms in more depth in the next project.

PROJECT 1

Simple still life

You can decide for yourself what you want to draw for your own first still life or follow my example given here. To start with, I looked around my living room for likely objects and picked up a bowl with some fruit in it. I felt that including all the fruit might be rather complex, so I removed it except for two apples, which I placed on a table by the bowl. I placed a jug on the table to add a more vertical shape to the composition and started moving the pieces around to see what might look interesting.

The light was coming very strongly from the left-hand side of the composition, so it was relatively well lit. I put the jug in a position that just appeared to clip the edge of the bowl from where I was sitting. I moved the two apples so that they were very close together, but not quite overlapping. I thought that this would give some tension to the arrangement.

▲ After assessing the relative sizes of the objects, draw a fairly loose outline of each one, making sure they are in the correct relation to each other and the main shapes are accurate. Use an eraser to correct any mistakes until you are satisfied that you have arrived at a good likeness. When you've had more experience you'll be able to take the accuracy of the drawing much further, but for the moment go by your own perception as to the quality of your drawing. The nice thing about drawing is that you never arrive at a point where you can't improve on your skill – that's what makes it so engrossing.

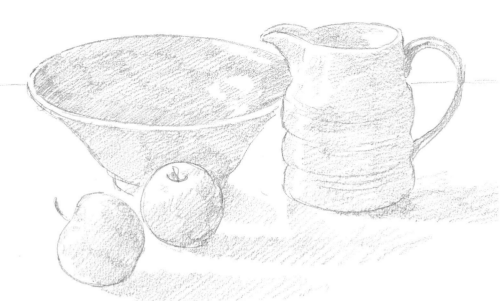

Now put in as much of the shading as you can, but all in a fairly light, even tone. This will train your eye to see the whole shaded area rather than doing each piece separately. While doing this I discovered that the light was in fact coming from two directions, most strongly from the left, but also from behind the objects. This meant I had to make a decision about where the emphasis would be when I put in the stronger tones; you can make things easier for yourself by making sure that the light is only from one direction.

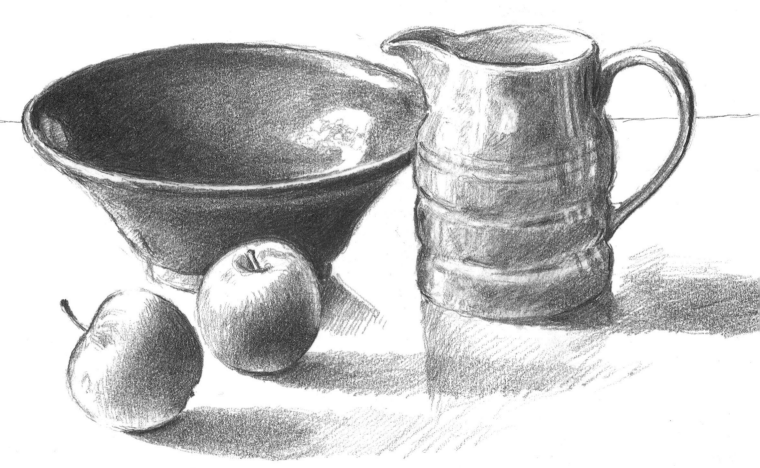

The next stage is where the whole composition starts to gain some feeling of convincing dimensions. Often the best way to proceed is to put in the very darkest tones over the general tone already there, so that you get some idea about how much you will have to grade the tones from darkest to lightest. All the in-between tones are variable depending on how dramatic you want the drawing to look. With greater contrast there's more drama, and with gentler contrast there is a more subtle feeling of depth. In this drawing I've left a bit of drama in the lighting without becoming too melodramatic.

Master examples

You can learn a huge amount by studying the work of professional artists from all eras, so we'll be looking at examples throughout this book. Here are four compositions that, although simple, are carefully thought out and executed.

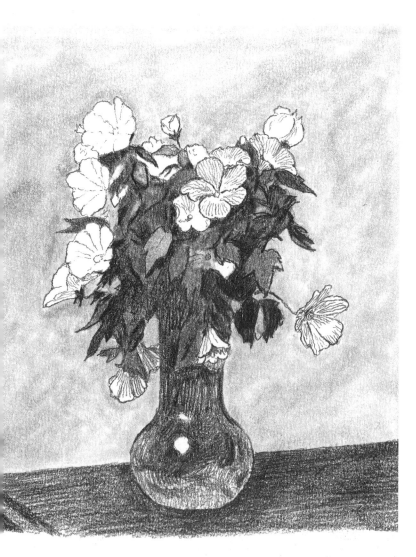

▽ In the floral piece below William Brooker (1918–83) has approached the theme in his inimitable way. He has placed the vase with the single rose in it on the edge of a table, with a well-ironed tablecloth making a strong triangle shape below it at the corner of the table. He has kept his tonal areas very simple, almost flat, so that the composition almost has an abstract feel to it. This cool, dispassionate look at an ordinary theme makes it less ordinary.

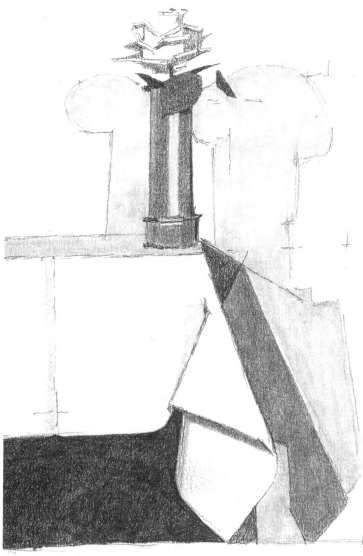

△ Here's a still life that's simple enough in composition, although it's not easy to achieve this degree of sensitivity. The main thing to notice is just how carefully Henri Fantin-Latour (1836–1904) puts in the various tones of the leaves, all of which are darker than the flowers. The contrast between the flowers and the leaves, the jar and the tabletop, helps to give a feeling of the fragile quality of the blossoms rather well. In the next chapter we will be looking in more detail at drawing plants and flower still lifes.

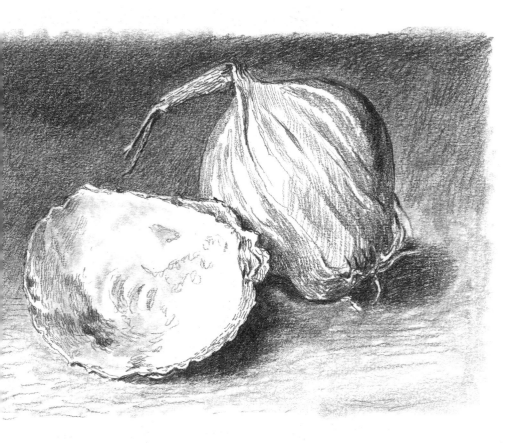

Here William Henry Hunt (1790–1864) has just placed an oyster shell and a large onion close together on a surface with a darker background. He makes the most of the different textures of the two things, so that as a study in materiality it's quite powerful. This is always a good way to approach a simple still life as it intensifies the viewer's experience.

The last of our examples of simple still life is after that master of such things, William Nicholson (1872–1949). Here he shows a jug and a beaker lit strongly from the left against an even lighter background. Because of the strong light the objects almost disappear against the background, with only the strong painted markings on their surfaces giving them some substance. Limiting the objects in this way increases the intensity with which the still life can be viewed.

PROJECT 2: **PLANT STILL LIFE**

In this project you'll learn how to draw plants, which will require sharpening your powers of observation as their natural forms are more subtle and delicate than the man-made objects you have tried. To start with, draw simple shapes; any leaf form is of value because although leaves are relatively straightforward, they have all the subtleties that more complex plants will demand from your skills.

Of course, the plants you wish to draw will often be in a container of some kind, so you'll be including some of the forms that you have already drawn in this new area of natural growth. One difference you'll notice is that although plants are supposedly inanimate for the purposes of a still life, there's always some movement in their growth that means that no drawing you do can ever be completely final. Don't expect to feel you have produced the ultimate portrait of a plant since, like humans and animals, they are always changing.

Drawing plants is a challenge, but with practice you'll soon get the hang of it. Just remember to approach the task with an understanding of not just their fragility but also the great deal of vigour they possess as well. At the end of this section I have shown some work by master artists that should help you to gain some ideas about what and how you might draw.

Simple leaf shapes

When you are drawing still life, plants are the obvious way to introduce some living material into the composition. While you will give some sort of life to objects that you draw with dedication, it's easier if an object is itself a living thing rather than a static shape. Starting with some simple examples will give you confidence in your ability to draw plant material. Try sketching various simple leaf shapes in order to get into the feel of the drawing that you will be attempting. This will sharpen your eye as to how plants look.

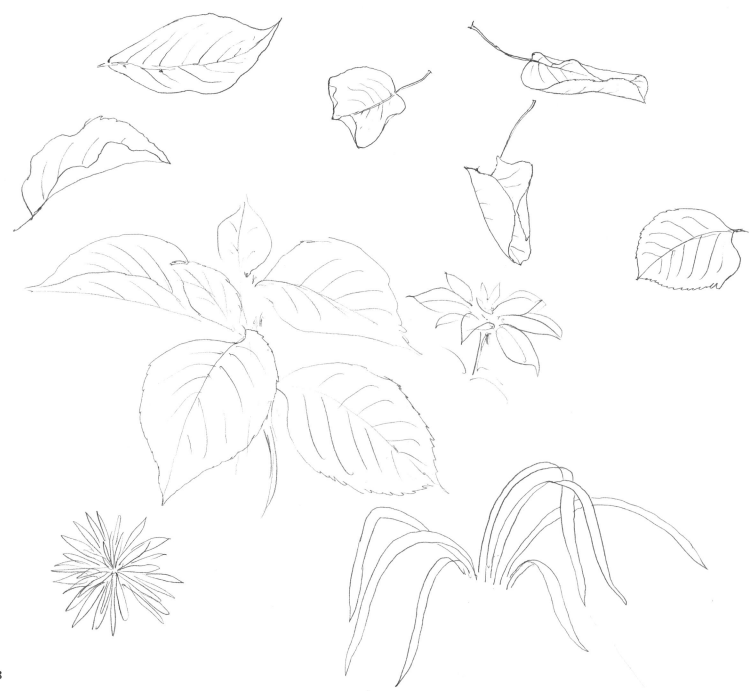

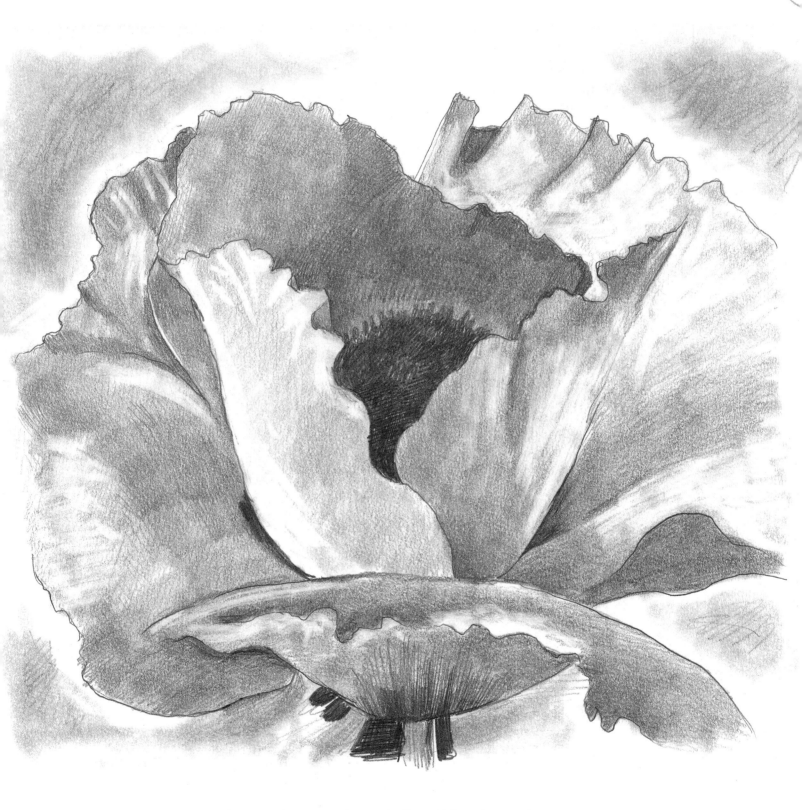

Another way of concentrating on the form of plants is to study a very large version of a flower, as in this picture after Georgia O'Keefe (1887–1986). Looking at a flower on a big scale like this makes you begin to see the possibilities of textural power to be seen in plants. If you are feeling confident, have a go at drawing this.

Developing natural forms

In my garden one day, I happened to notice the beauty of several of the leaves scattered on the lawn. I picked up a few and took them inside to make these drawings, carefully studying their shapes and textures. Have a go at doing the same, all the while trying to draw exactly what you see.

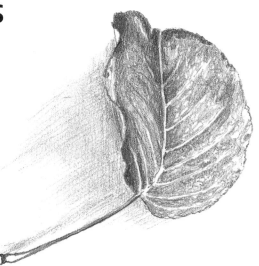

Notice how you can concentrate on a small object such as this with great precision, showing how the veins of the leaf shape the outer form and how, as the leaf starts to dry out and decay, the edges curl up and form interesting shapes. When you try this out, give every detail your attention and treat the leaf as seriously as you would a large, complex object. Draw the shadow as well and see how your dedication makes the small leaf become a really powerful image.

Try several leaves, using examples that you can find easily and that attract you by their colour or shape. This concentration of energy into drawing a simple object is the key to improving your drawing skills.

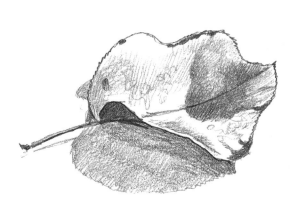

Now go a step further. Select some flowers that you find attractive – you will give them more attention if you like the look of them – and then proceed to draw one or two blossoms with the same sort of detailed attention that you gave to drawing the leaves. You will need to be a little more delicate in the way you approach them because they are much more fragile and exquisite than the leaves, which have a rough vigour.

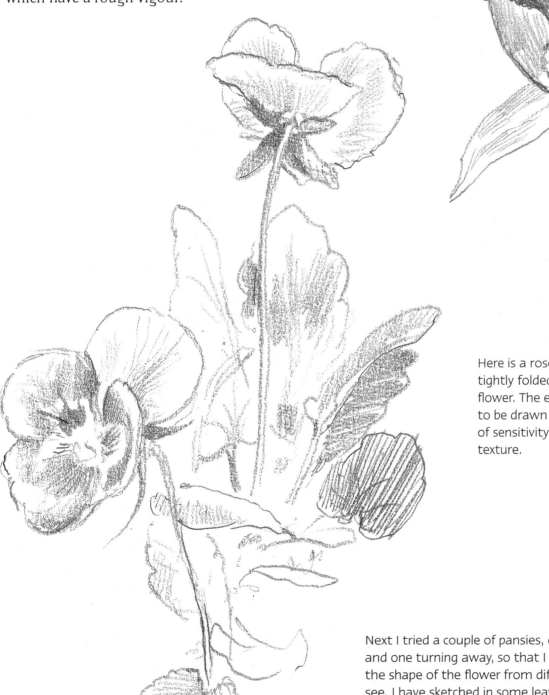

Here is a rose, with its inner petals tightly folded around the centre of the flower. The edges of the petals need to be drawn with a certain amount of sensitivity to get the feel of their texture.

Next I tried a couple of pansies, one facing towards me and one turning away, so that I could get some idea of the shape of the flower from different angles. As you can see, I have sketched in some leaves – but at this stage that doesn't matter so much.

Pots and vases

Then I turned my attention to the sort of pot or vase that I might use to put the flowers in. This is all part of drawing a still life with plants, because you will mostly want to draw them in the comfort of your studio or house. I have tried a couple of glass pots, one suitable for a single flower, and a couple of ceramic vases, one small and the other large.

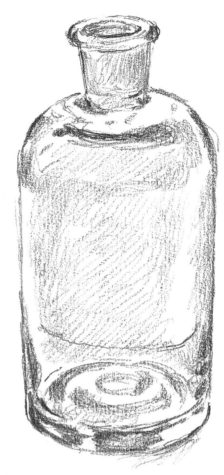

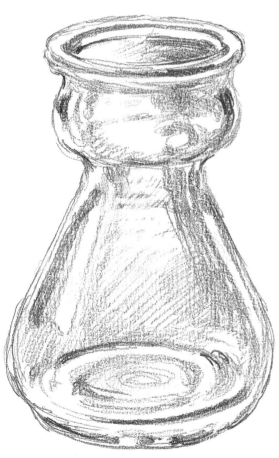

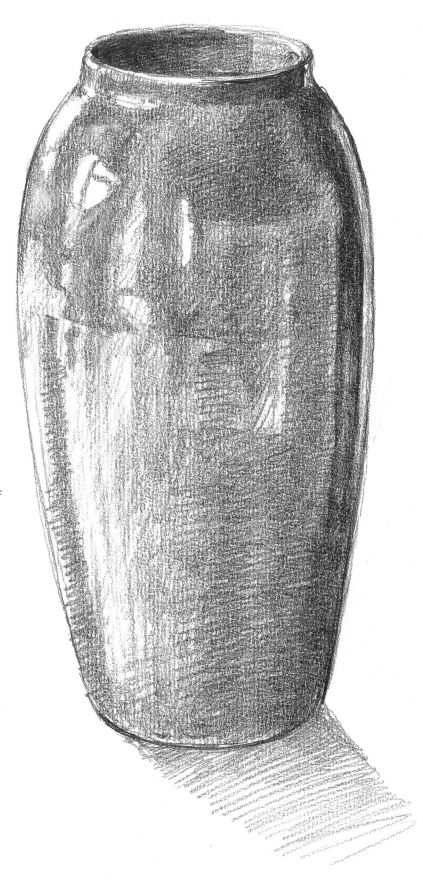

For this large vase I first put in tone across the whole shape and the cast shadow, leaving white spaces for the very brightest reflections at the top rim and down the length of the left side of the pot. Then I built up the tone to the very darkest on the right-hand side, allowing for patterns in shading to suggest reflections on the shiny surface.

A vase and flowers

The next step is to take your courage in both hands and attempt a whole bunch of flowers in a vase, just concentrating on the flowers rather than the vase as well. I came across an arrangement that my wife had put in one of our rooms and decided to make a careful drawing of the whole bunch. When you draw this yourself, block in the large group of flowers in a simple fashion to start with. This will make the final drawing much more effective, and will probably save time as well.

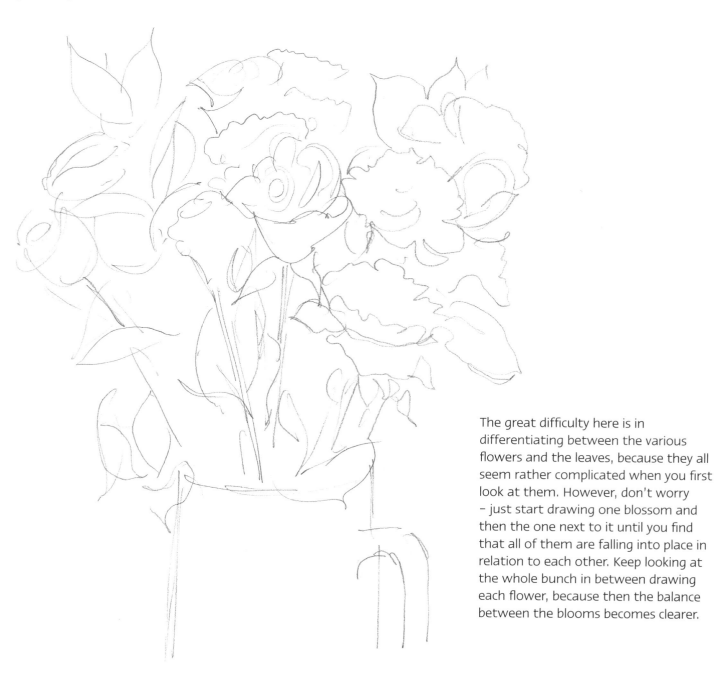

The great difficulty here is in differentiating between the various flowers and the leaves, because they all seem rather complicated when you first look at them. However, don't worry – just start drawing one blossom and then the one next to it until you find that all of them are falling into place in relation to each other. Keep looking at the whole bunch in between drawing each flower, because then the balance between the blooms becomes clearer.

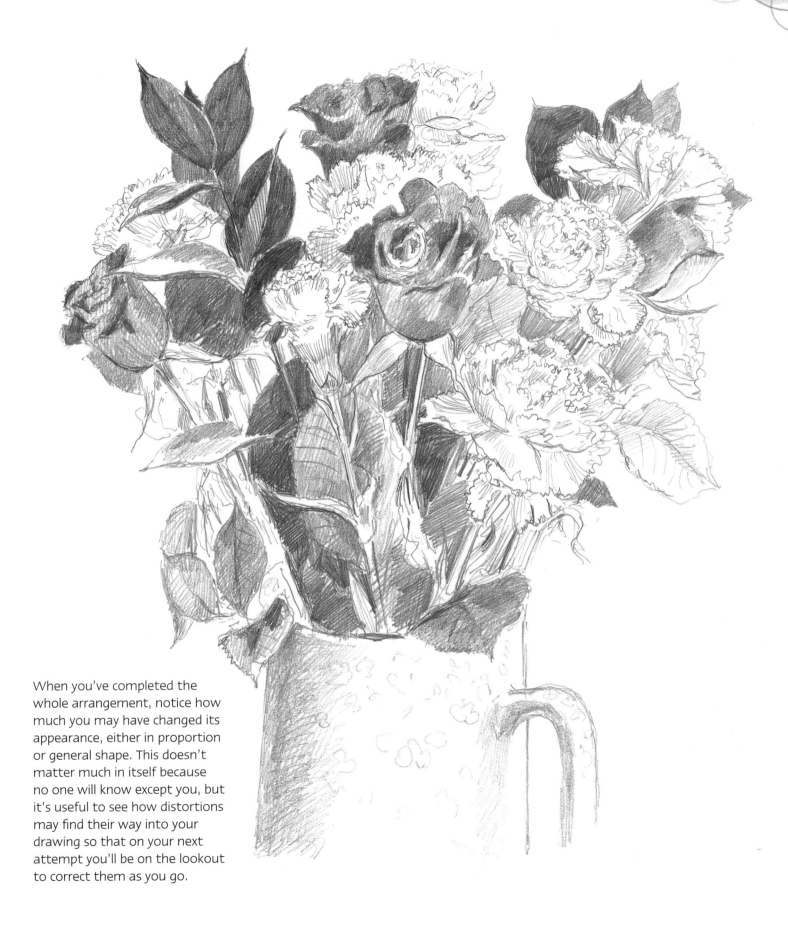

When you've completed the whole arrangement, notice how much you may have changed its appearance, either in proportion or general shape. This doesn't matter much in itself because no one will know except you, but it's useful to see how distortions may find their way into your drawing so that on your next attempt you'll be on the lookout to correct them as you go.

Arranging a plant still life

When trying out various arrangements for my plant still life I
made sure that I drew as many different compositions as I could
to give myself some experience in dealing with the objects that
would feature in the final picture.

I found this first arrangement
far from interesting because the
objects were spaced too widely
across the table and they didn't
form a coherent group.

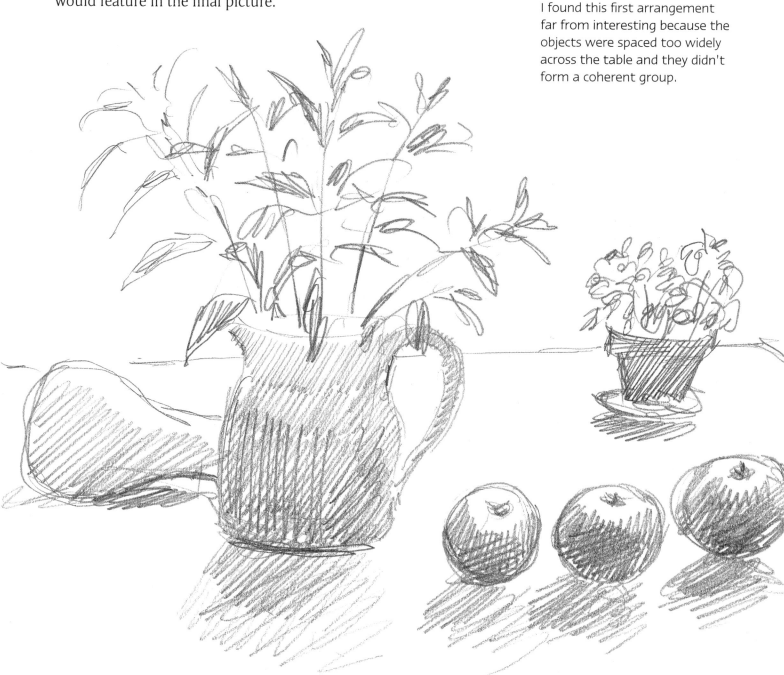

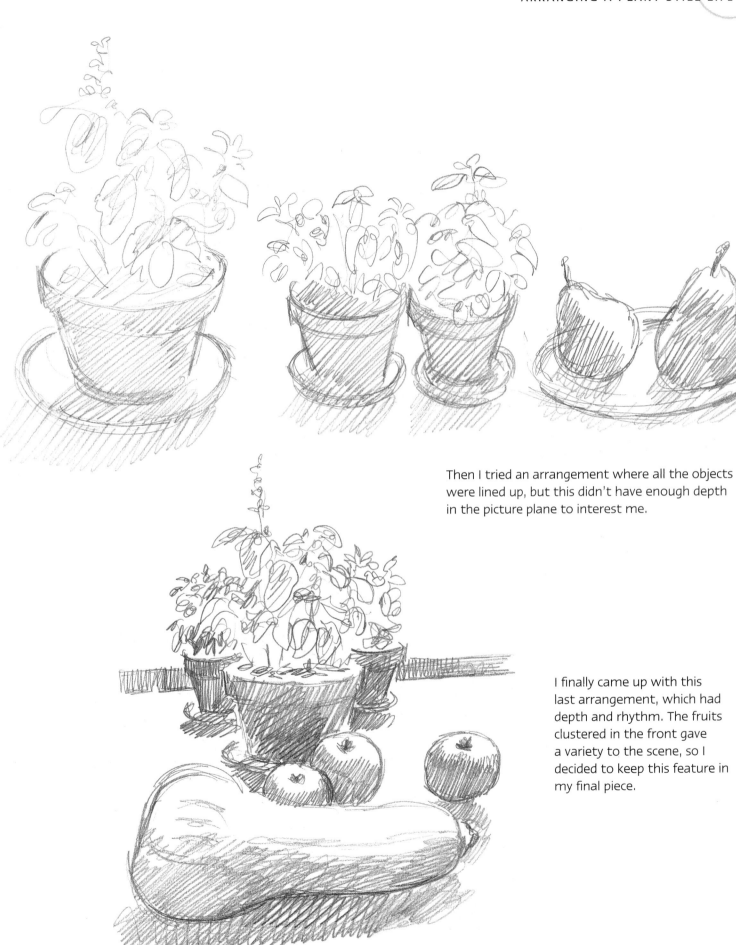

Then I tried an arrangement where all the objects were lined up, but this didn't have enough depth in the picture plane to interest me.

I finally came up with this last arrangement, which had depth and rhythm. The fruits clustered in the front gave a variety to the scene, so I decided to keep this feature in my final piece.

PROJECT 2
Plant still life

Now comes the final task – to arrange a still life composed mainly of plants, but with a few other items to give some balance to the composition. I noticed some potted plants set on saucers on our windowsill that seemed to make a nice set of shapes, so I decided to use these as the main background of the picture. Next I took an arrangement of autumn leaves in a jug and placed that as the main focal point of the composition.

To give a bit of variety to the foreground, I put a large squash and a couple of apples alongside the jug. Now I had a composition that mostly consisted of plant life, although in this case I didn't have any flowers on show. One of the leaves dropped off the main arrangement and lay on the table in front of the jug – a nice accidental touch. The lighting was largely from the left side, with some from behind the arrangement too.

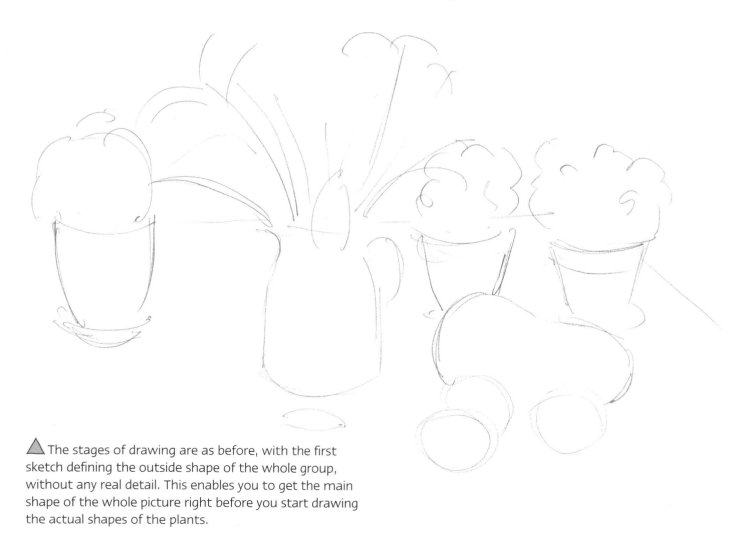

▲ The stages of drawing are as before, with the first sketch defining the outside shape of the whole group, without any real detail. This enables you to get the main shape of the whole picture right before you start drawing the actual shapes of the plants.

38

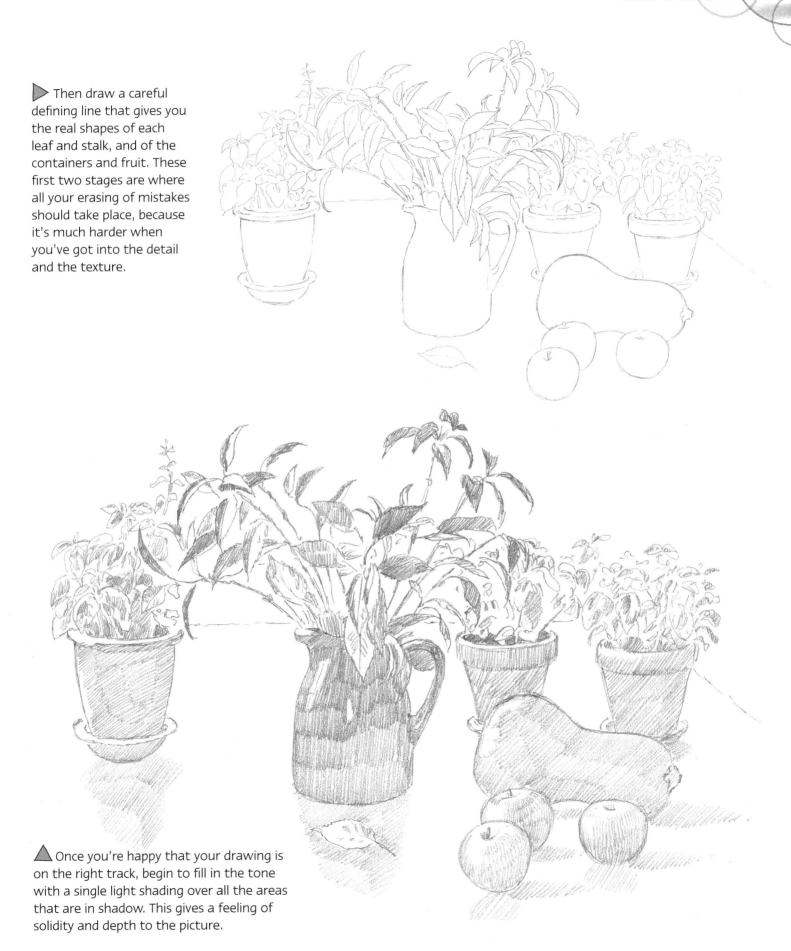

▷ Then draw a careful defining line that gives you the real shapes of each leaf and stalk, and of the containers and fruit. These first two stages are where all your erasing of mistakes should take place, because it's much harder when you've got into the detail and the texture.

▲ Once you're happy that your drawing is on the right track, begin to fill in the tone with a single light shading over all the areas that are in shadow. This gives a feeling of solidity and depth to the picture.

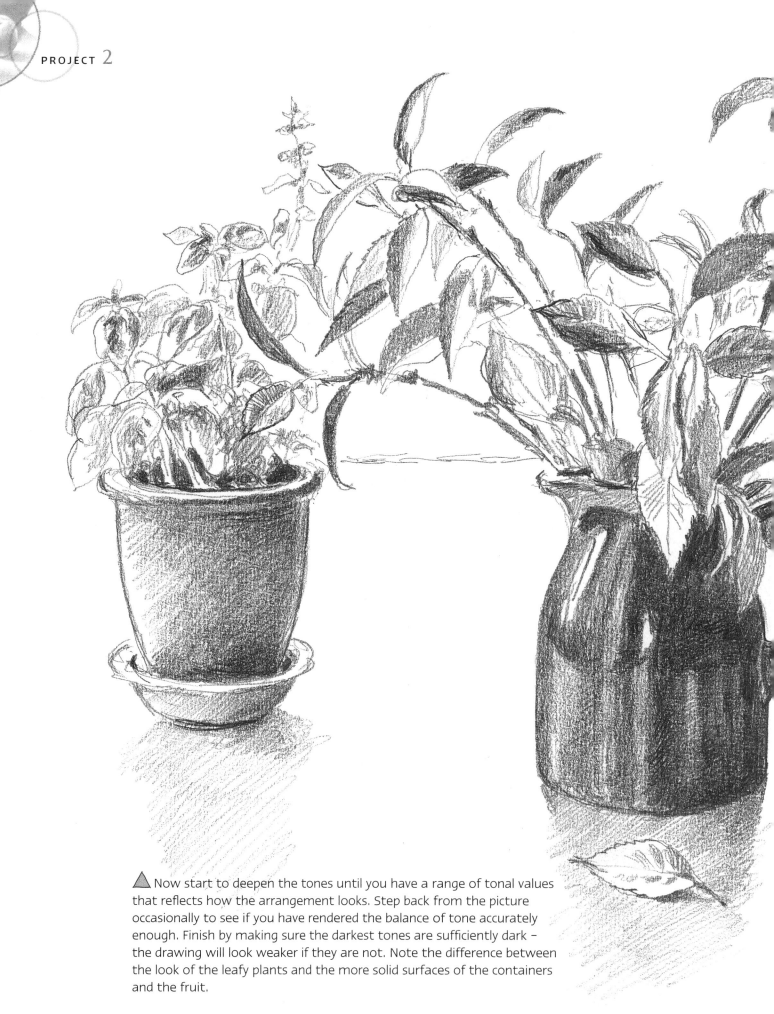

Now start to deepen the tones until you have a range of tonal values that reflects how the arrangement looks. Step back from the picture occasionally to see if you have rendered the balance of tone accurately enough. Finish by making sure the darkest tones are sufficiently dark – the drawing will look weaker if they are not. Note the difference between the look of the leafy plants and the more solid surfaces of the containers and the fruit.

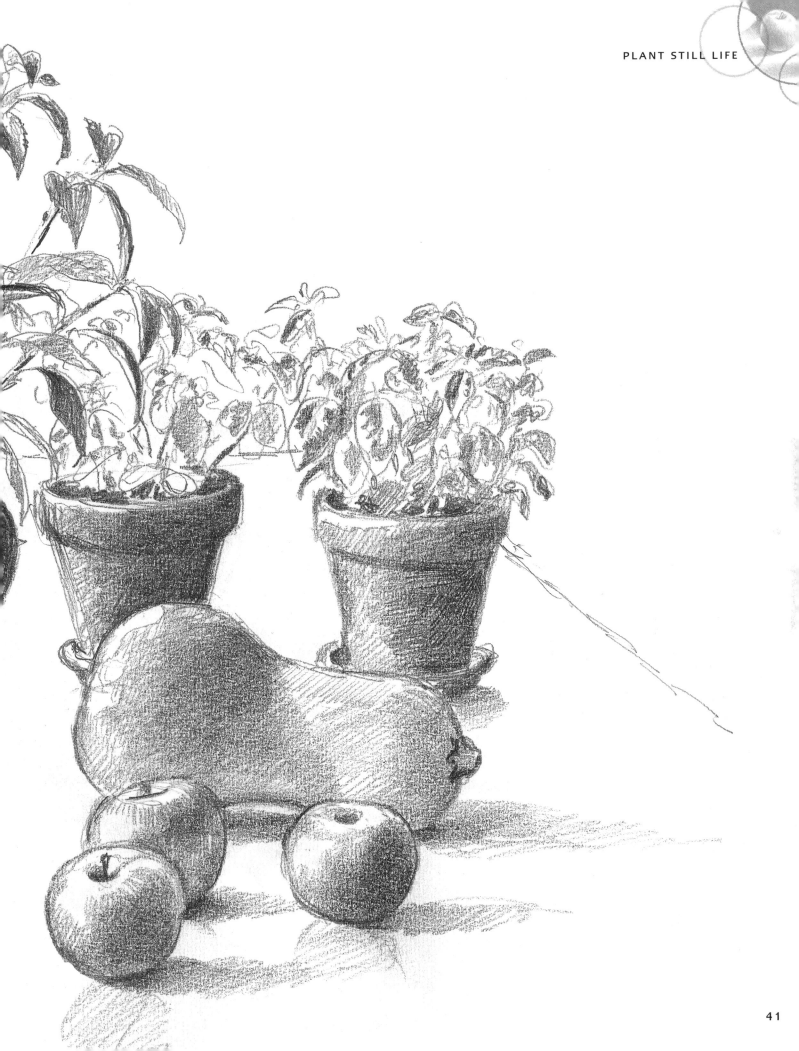

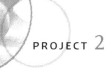

Master examples

▽ The first example is after a modern artist, Diana Armfield (b. 1920), who has given us a bunch of flowers in a glass container in quite strong light. She is an expert at showing the subtlety of the relationship between the objects and their backgrounds, making one merge into the other with great skill.

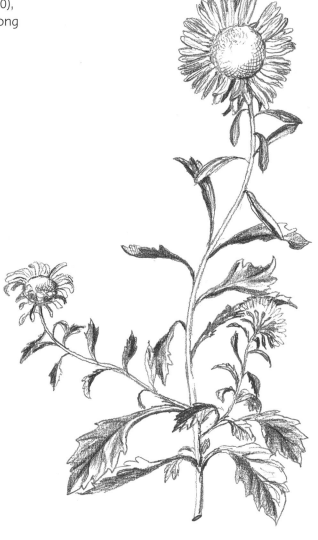

△ This shows a more botanical approach by G. D. Ehret (1710–70), a well-known botanical artist from the 18th century. His drawing is very precise, because he is keen to show the exact shape of the plant so that it can be identified easily. You may not want to do this more technical drawing for finished pictures, but it's worth trying it sometimes in order to improve the accuracy of your drawing.

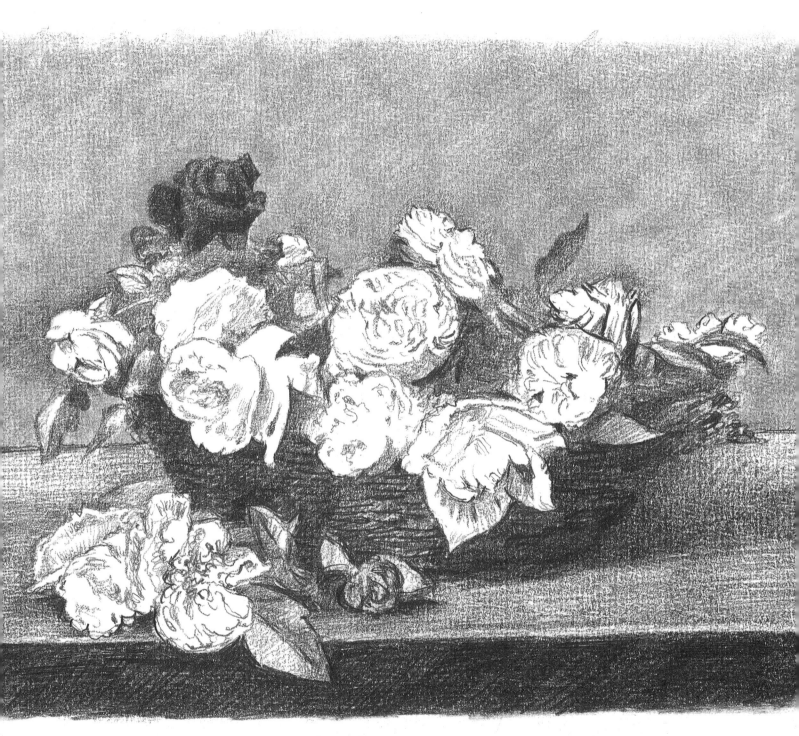

▲ Finally an arrangement after Henri Fantin-Latour (see also page 26) who was renowned for his beautiful and intense flower paintings. Here he shows us a basket of roses with some fallen on to the table in front. This forms the whole of the composition and in lesser hands could be a dull picture – but Fantin-Latour's skill is such that you can almost feel the texture of the petals.

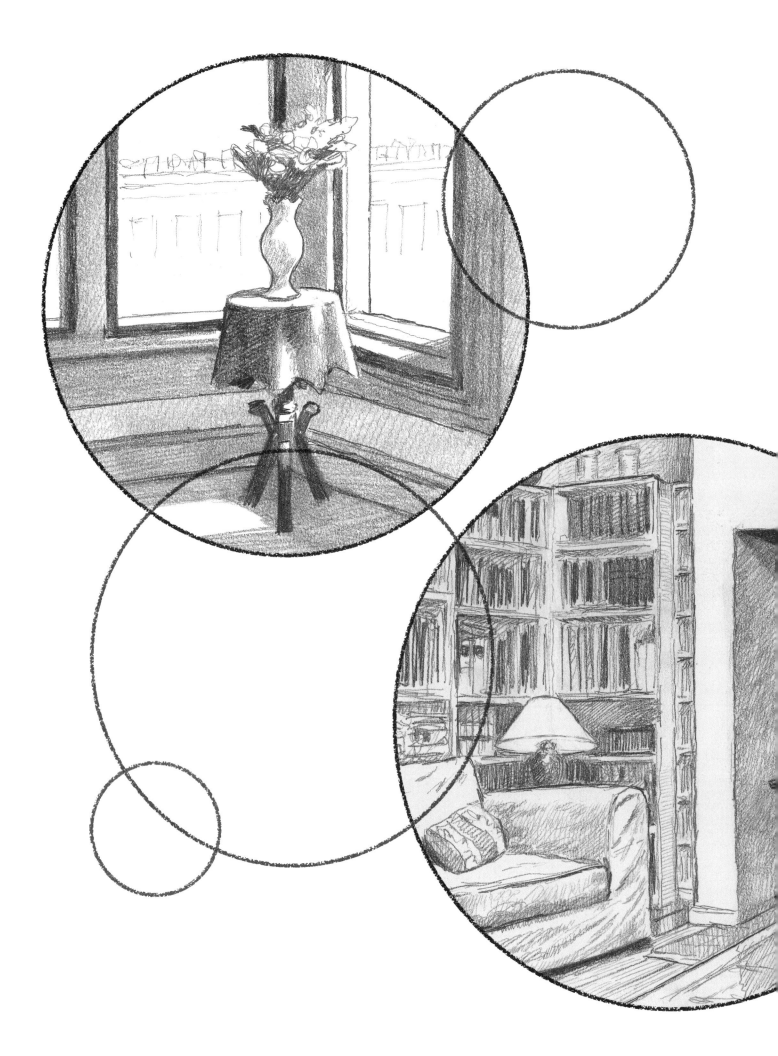

PROJECT 3: INTERIORS – AROUND THE HOUSE

Drawing interiors calls for subtle handling of tone, so this project begins with some simple exercises that will teach you various methods of rendering tone in pen and ink as well as pencil so that you'll have more than one way of achieving your results.

Making the interior of your home your subject is the logical progression from the simple still-life work that you've done so far. You'll find that sometimes your drawings may appear rather awkward until you've discovered how best to tackle a view of a room and its furniture, but don't let that put you off – all artists have to go through this process of deciding exactly how much to show in a drawing. It's the beginning of understanding how to compose the world about you in order to give the most interesting view of it.

Don't exclude untidy details that sometimes clutter a room – the everyday mess of living is part of the way a picture can tell a story that goes beyond just the simple perspective of an interior. And speaking of perspective, it's here that you'll first need to think about this in order to help bring more depth and space into your drawings. Notice how some of the master artists here show what at first glance seems to be quite an ordinary scene but manage by their acute perception to make the interior look potent and full of interest.

Tone and hatching

Here are a few exercises to sharpen up your techniques before you leap into the next project. Since drawing an interior will entail covering larger spaces with tone, these exercises are intended to give you dexterity in hatching and shading to produce varying degrees of tone. I have concentrated on pencil and pen and ink exercises this time.

1 These are the three items that you will need to do these exercises: a soft dark pencil (4B), a fine-pointed graphic pen and a rolled paper stump to smudge some of the pencil marks.

2 Make marks by rubbing the side of the pencil lead against the paper.

3 Make lines all at one angle to produce an overall tone of grey.

4 Draw verticals and horizontals crossing over each other to produce an even tone.

5 Next draw horizontals, verticals and diagonals in both directions to produce a darker tone.

6 Make marks in all directions until a dark cloud of tone is produced.

7 Put in tiny marks like a cloud of dots until they produce an even tone.

8 Now try some pen and ink marks, the first one lots of tiny strokes to produce a dark texture.

9 As with the pencil marks, draw them all in one direction.

10 Then draw verticals all about the same length and the same distance apart.

11 Add some horizontals on top of the verticals similarly equal in length and spacing.

14 Then mark in small dots as close together as possible without touching.

12 Lay some diagonals in one direction over the verticals and horizontals.

13 Then put in more diagonals in the opposing direction over the last three sets of lines.

Now use the first ink technique (no. 8) to produce an area of tone that gradually gets darker and darker. Start with lines in one direction and add more in different directions until you get a solid black.

15

16 Taking up your pencil again, use it to produce a very dark area and gradually soften it to become lighter, fading it out to nothing with the stump.

Drawing around the house

I started this exploration by walking around my own house and drawing small areas of the rooms from different angles and from both a standing and sitting position to give me different eye levels. Some views are quite restricted and others more expansive, but they demonstrate that even in your own house you'll find many possible subjects for a drawing. Don't worry too much if the results are rather uninteresting as pictures – the point is to practise drawing some larger objects and spaces, and also to introduce some perspective.

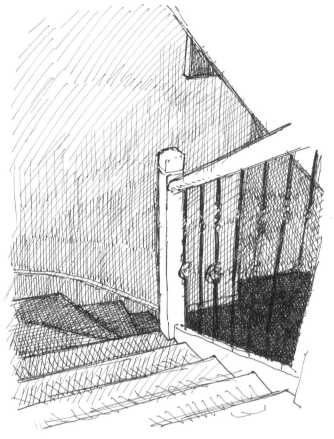

My first view was of an open sitting area at the back of our house. The perspective is shown mostly in the lines of the floorboards and in shapes of the dresser and window. The cupboards and chairs give scope to achieve a three-dimensional effect to add to that given by the perspective.

The next area I chose (above) was tricky because it was halfway up the stairs and the perspective view was slightly unusual. One way to check out your own basic drawing is to take a photograph with a digital camera and note the angles on the screen of the camera to check your drawing by. The top end of the stairs was well lit, while the bottom stairs in the hall were much darker in comparison. This helps to give some feeling of depth to the composition, with the banister rail sharply defined against the gloom.

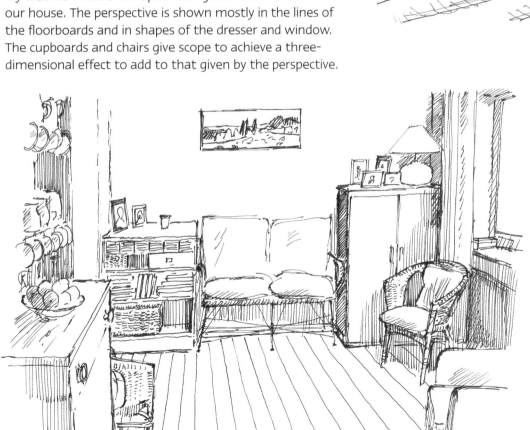

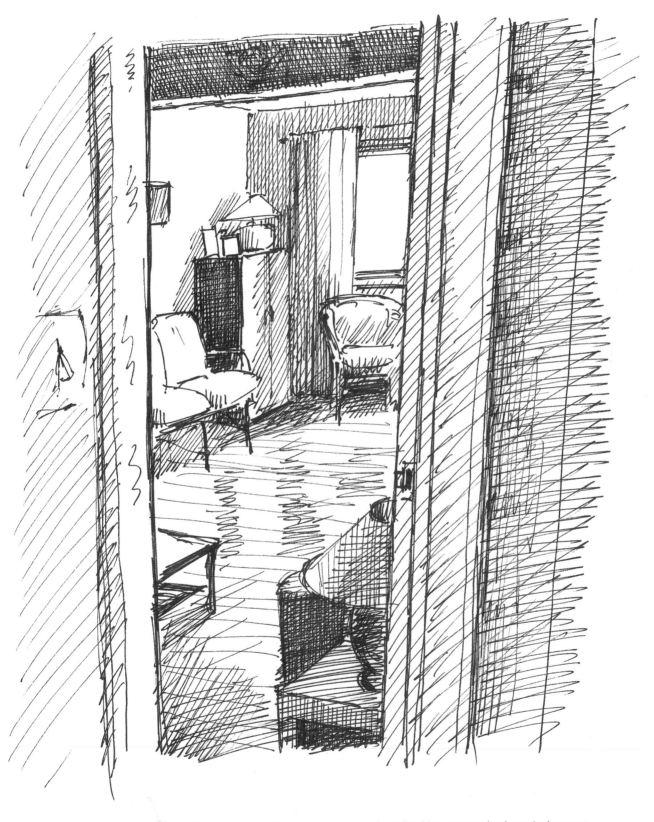

Then I took a view through an open door looking towards the windows at the back of the house. I could mainly see bits of chairs and tables, with the bright light of the window seen through the dark surround of the door jamb. This always makes for an intriguing quality in the picture because it seems to be revealing a secret view.

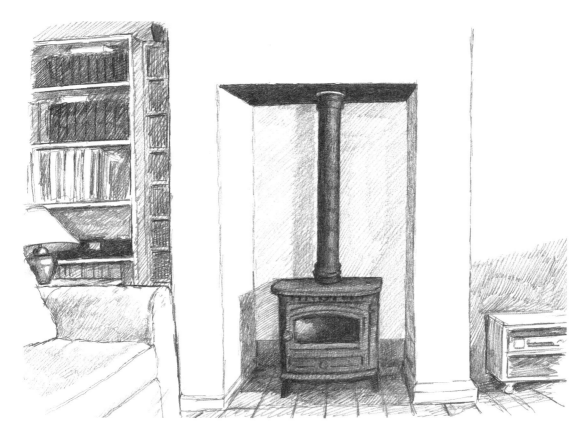

This view is of an inner room with a woodburning stove at the centre and some furniture and shelves glimpsed either side. It is a straight-on portrait of the stove, really, which is quite an interesting thing in itself.

Another room in my own house – a bedroom this time, which is mainly interesting for the view through to another door and the row of paintings on the wall, which help to define the space.

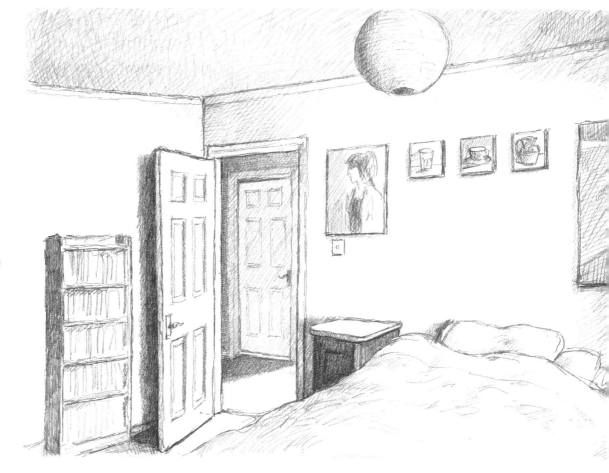

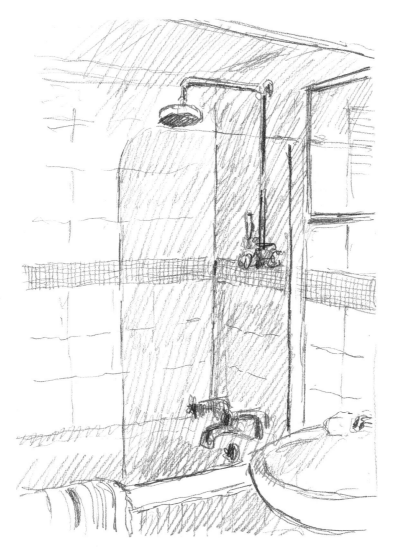

Here is a narrow view through the bathroom door, showing the edge of the washbasin and the shower end of the bath. The tiles on the walls demand the use of some perspective.

Next, moving in close to some objects in a room, I chose to draw the remains of breakfast on a large table, with a bowl of fruit and the tops of chairs around the edge of the table. The interesting thing about this is that it suggests a narrative of the ongoing life of the people inhabiting the house. These accidental still-life pictures are often more potent than an arranged one.

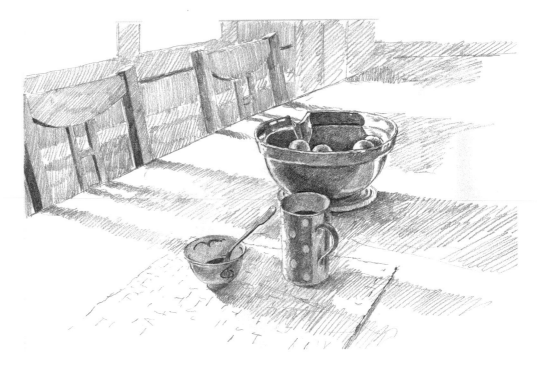

For the next view, I have done a perspective construction to give you some idea as to how the dynamics of the picture will work. This can be done with any interior, although some have more obvious perspective than others. This one, which gives us a view down the length of a table, does demand that perspective is taken in to account. We'll be looking at how to construct perspective in more depth in the next project (see pages 70–1).

In the final drawing you can see how the perspective works, with the table cleared and the floorboards receding towards the windows. The light coming in from the windows and bouncing off the tabletop contrasts with the darker, shadowed areas of the walls.

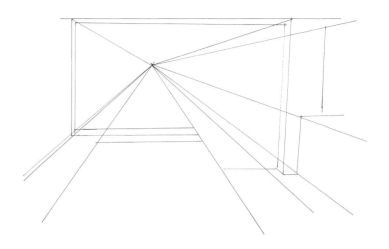

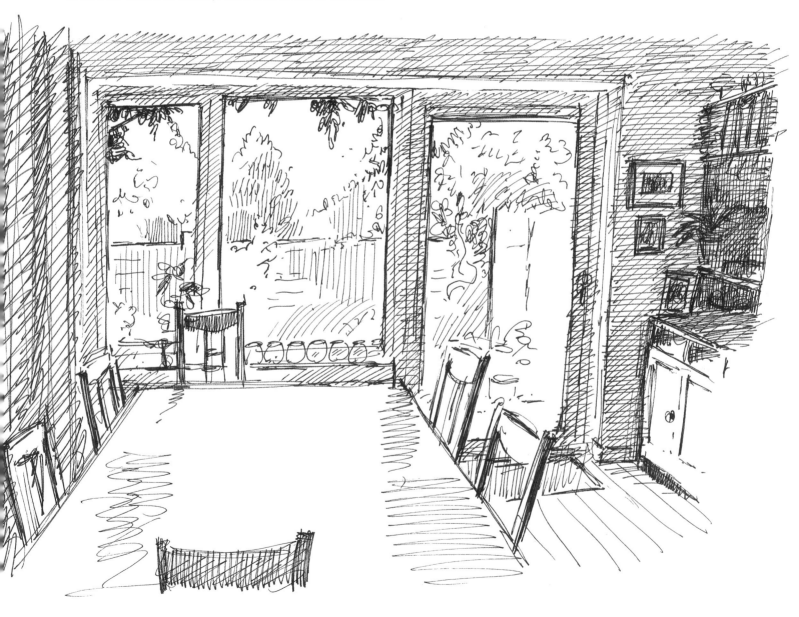

Here is another perspective diagram to show how the construction of the scene gives more depth to the finished picture of my kitchen – another area which is often the site of interesting accidental still life.

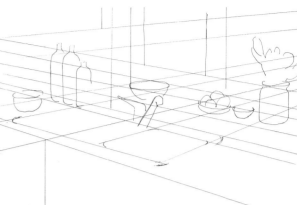

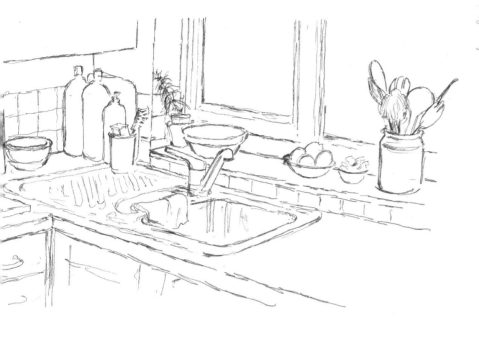

This is the view of the sink and all the paraphernalia surrounding it, as in most kitchens. It might have been even more interesting if there were some washing up piled up on the side of the sink.

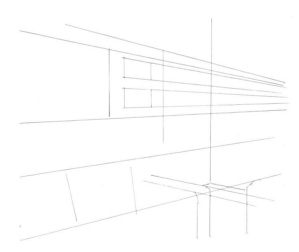

Here the perspective diagram shows how the construction of the drawing below is in fact relatively simple.

This drawing is a view of a sitting area with a mirror on the wall and the corner of a sofa with a door behind it. It isn't highly significant, but there is a small amount of perspective to be observed in the shapes of the mirror and the pictures on the wall.

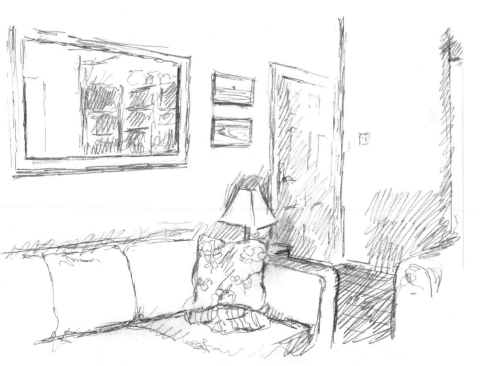

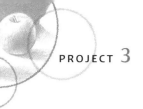

Master examples

The examples I have chosen are mainly after 19th- and 20th-century artists. Many of us live in houses of a similar shape and construction today, or indeed we live in houses built during those centuries. The thing to notice about these pictures is that the artists have taken trouble not to produce a banal picture, but to look at the spaces available and capitalize on them. On these pages, for example, the 19th-century Danish artist Vilhelm Hammershøi (1864–1916) has the doors open in one picture so that we can see right through the house, but in the other he shows a large blank wall with all the furniture down in the lower right-hand quarter of the composition.

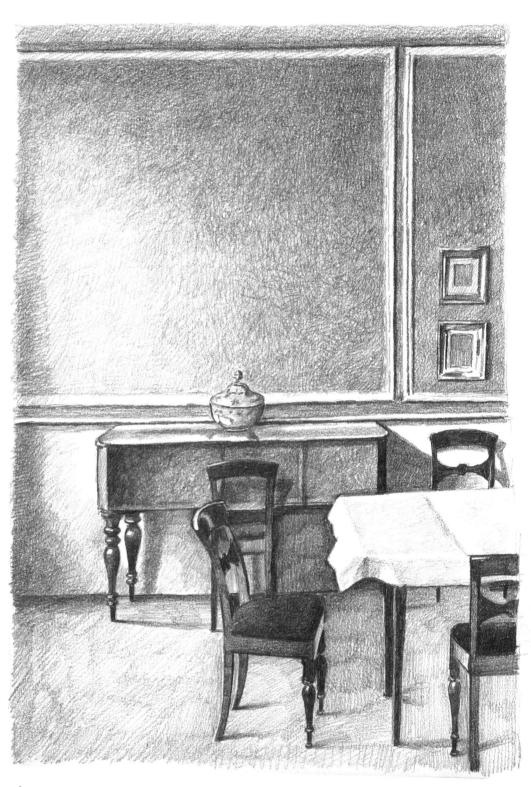

▲ In this picture after Hammershøi, the very blank wall is defined by some beading, with a cluster of furniture in the lower part of the scene. A good side-light coming from the windows helps show the dimensions of the space.

▼ In this scene Hammershøi takes a view through some doors to a distant window. The interest here is very much in the space described by the various areas of dark and light in the rooms shown.

▷ Next is a curving staircase
seen in Paris by the American
artist Edward Hopper (1882–
1967) – a difficult thing to draw
correctly but full of interest for
the aspiring artist.

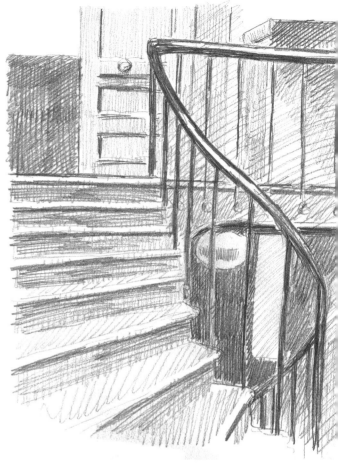

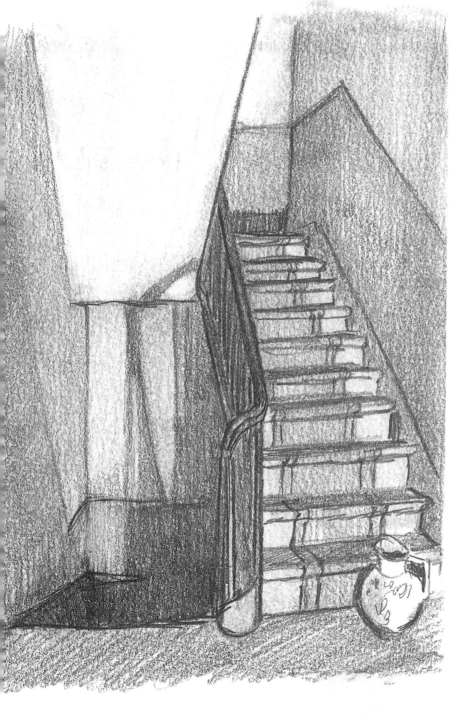

◁ This simpler view of a staircase is after
Xavier Mellery (1845–1921), with a large
jug at the bottom to act as a focal point.
I have omitted a figure that was glimpsed
at the top of the stairs to keep this
inanimate.

▽ Another Hopper scene shows a view through a large window, with a rocking chair and a vase of flowers perched on a small table. I have left out the back view of the figure that was sitting in the rocking chair to show the interior setting alone.

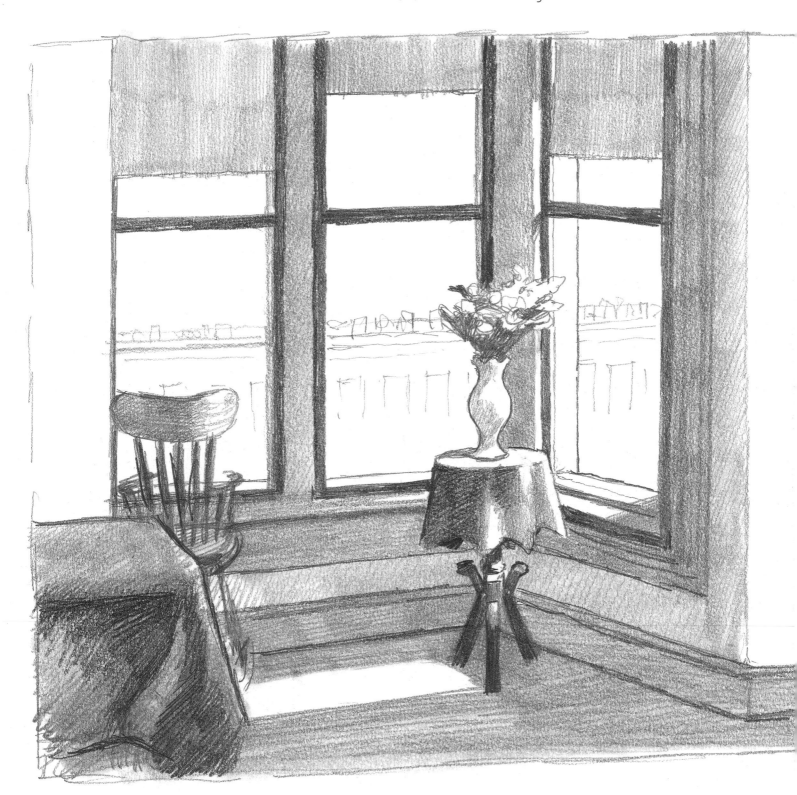

▼ Here is a view after French artist Edouard Vuillard (1868–1940) of a room with the fireplace, a side table and a good deal of clutter, including pictures stuck up on the walls and various objects piled on the table and mantelpiece.

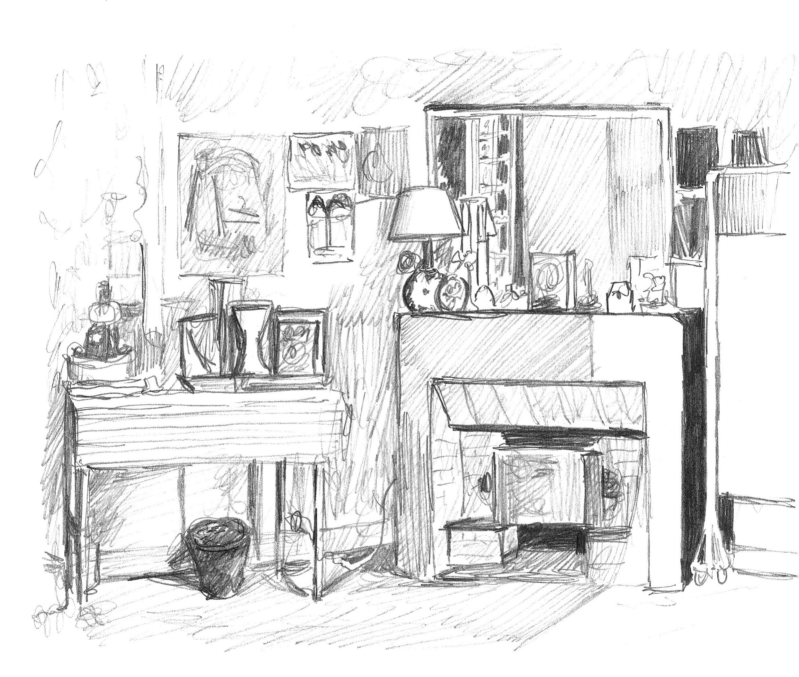

▼ Lastly, Vuillard's view of an attic room shows the spread of furniture across the far end of the space. The interior roof space makes a nice problem of perspective, as does the tabletop in the foreground.

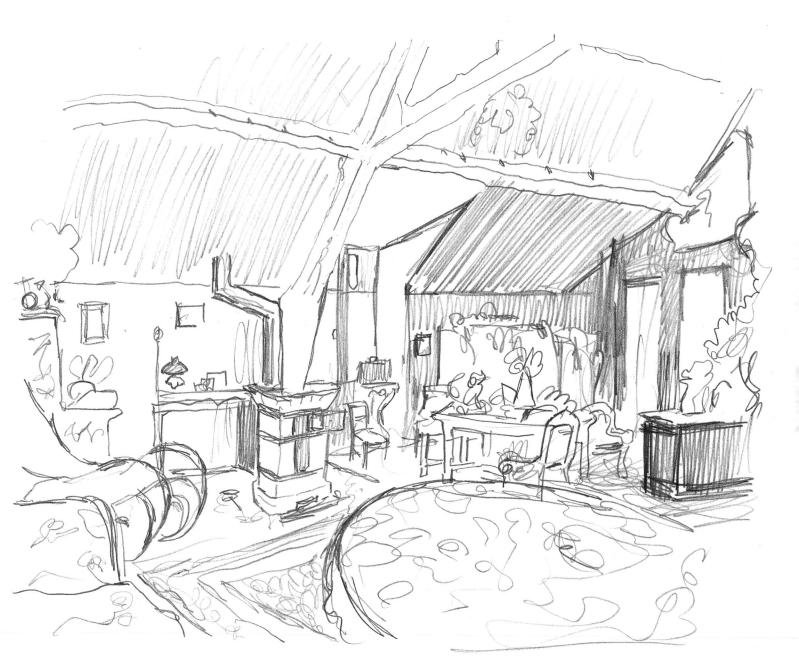

All these examples demonstrate that you don't have to go anywhere in order to have as many exercises in drawing interiors as you like – you can find them in your own house.

PROJECT 3

Drawing an interior

So now we come to the point where we have to put our ideas into practice, and I have chosen for my example the sitting room of the house, with its woodburning stove, bookcases and television set.

▷ The first step is a perspective drawing of the structure of the room from where I am seeing it. As so many of the parts of the room are rectangular in shape, it's not too difficult to produce a perspective. This is a very ordinary room, with no pretensions to grandeur or eccentricity.

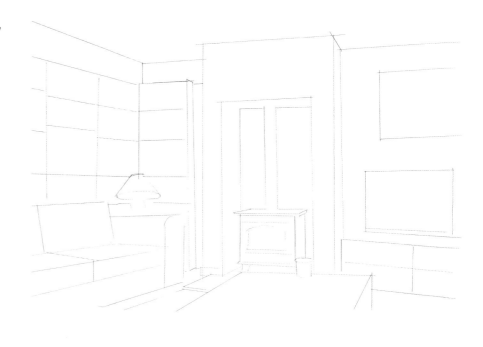

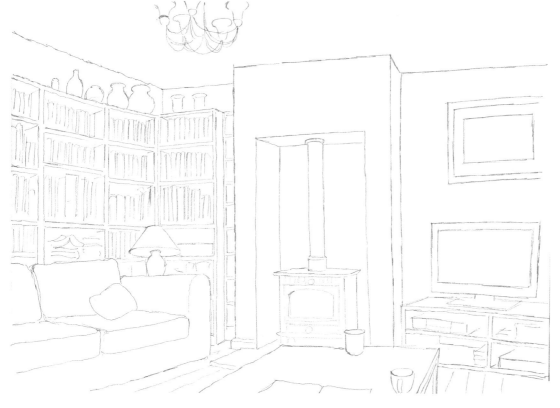

◁ Having got the feel of the perspective, I can now go ahead and start to draw in all the main shapes of the furniture, walls, ceiling and floor, keeping the outline as simple as possible without missing anything.

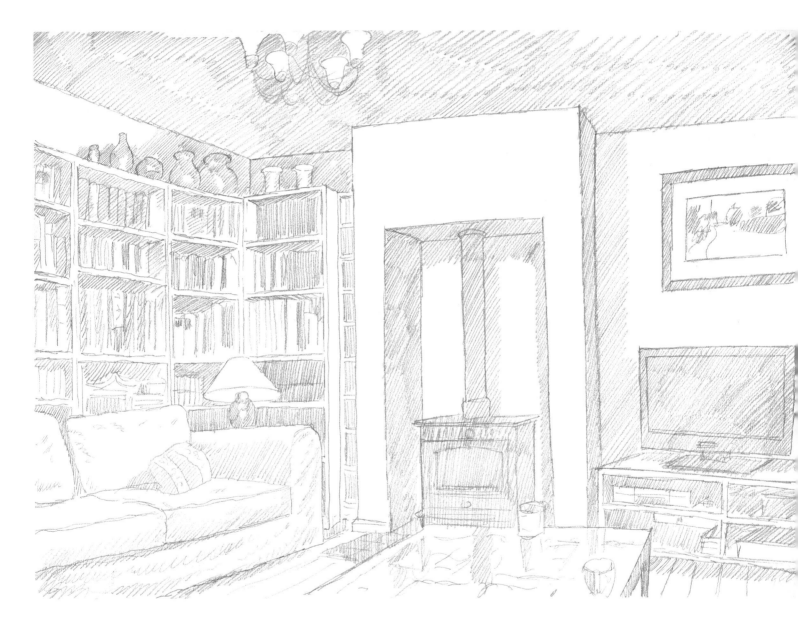

▲ Having arrived at a point where I am satisfied with the accuracy of the drawing – not without a few erasures of misjudged marks – I can now go ahead with the next stage, which is to put in all the areas of shadow in one light tone, which starts to give body to the scene.

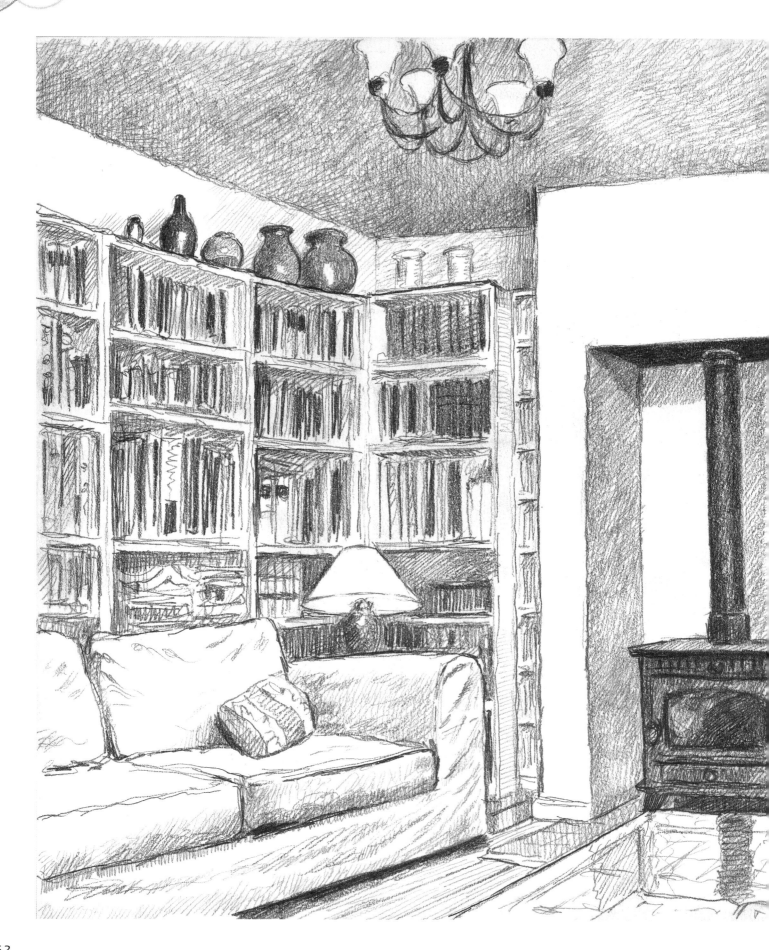

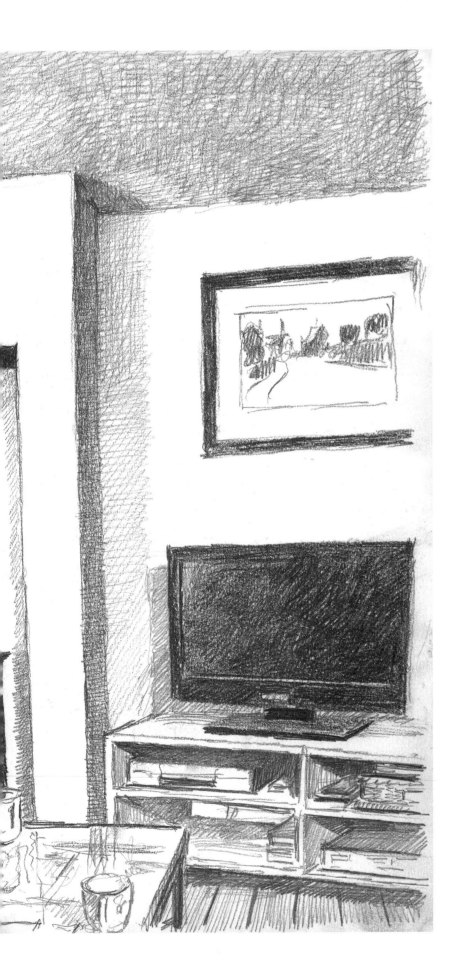

◁ Finally I have to build up the real tonal values, which are sometimes strong and dark and sometimes light and gentle. When you feel that the solidity of the scene has been achieved in your own drawing, stand back to see whether your picture holds together visually. You may have to soften or strengthen some edges, or build up the very darkest tones more intensely.

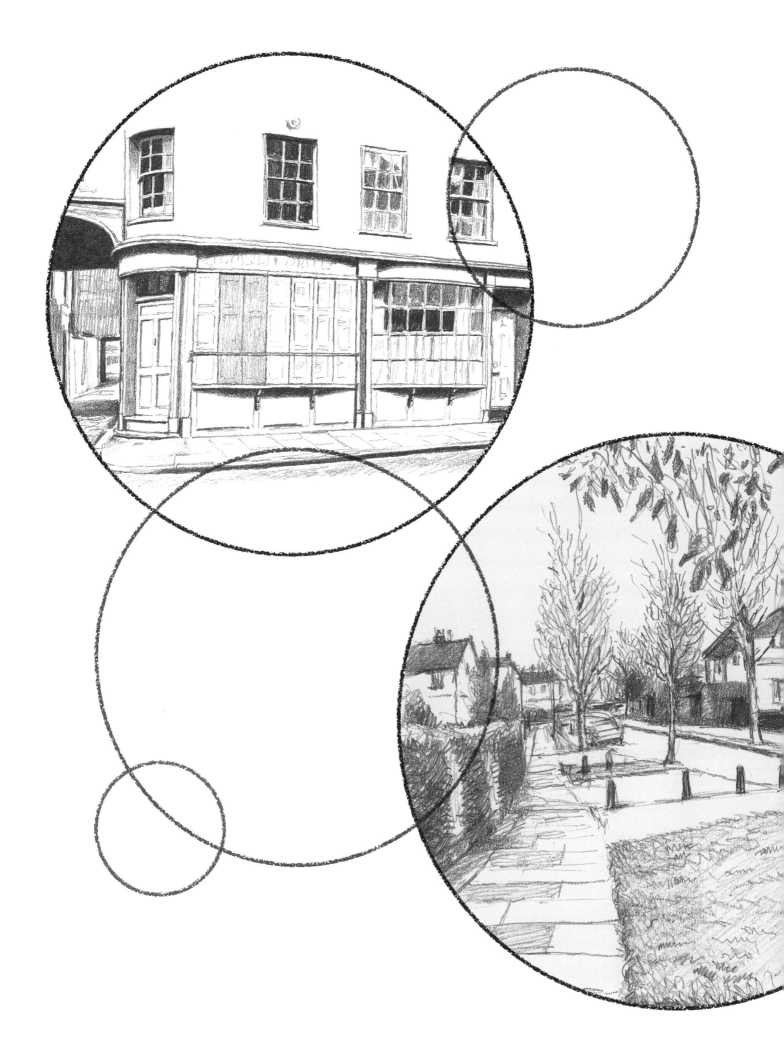

PROJECT 4: EXTERIORS – DRAWING A LOCAL SCENE

For this project it's time to take a look at subjects outside your house. To make the transition easy, my advice is to step out into your garden and then into your own street and try to draw what you see every day. To start with I suggest taking just one or two obvious bits and pieces of the scene, rather than try to get a whole picture all at once; little details or a piece of street furniture such as a pillarbox can be quite fascinating to draw once you start to study them.

You will need to learn a little more about perspective to discover how you can give your drawing of this larger space a convincing three-dimensional quality. The principles are simple enough to understand, and it doesn't matter if your attempts at perspective don't always come off perfectly at first. There are some very successful artists who still have some slightly odd-looking perspective in their works of art.

When you come to produce your final project of a simple scene, go for something that's familiar to your everyday experience of your locality. Don't go a long way to look for some more exotic scene, because it's gaining the ability to render on paper the most ordinary sights that gives you the best practice in this work.

Drawing in your local area

At some stage in your artistic endeavours you're going to want to move outside and draw from a wider scene. The best way to make it a natural progression is to start at the easiest place and go into your garden or near neighbourhood, not to rush off and find a place of great scenic beauty – that can come at a later stage. If you have no experience of drawing out of doors, a wonderful panorama can be a bit daunting and this will dent your confidence.

Here are some obvious things to draw to get your hand and eye in at the beginning.

In my garden in the summer a few garden chairs were scattered about on the grass, so it was simple to just draw them in context without worrying about the whole scene.

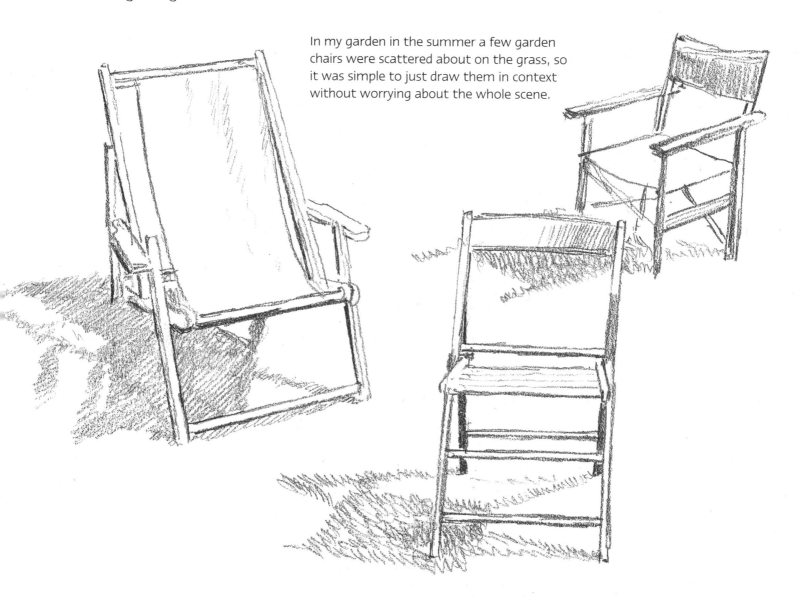

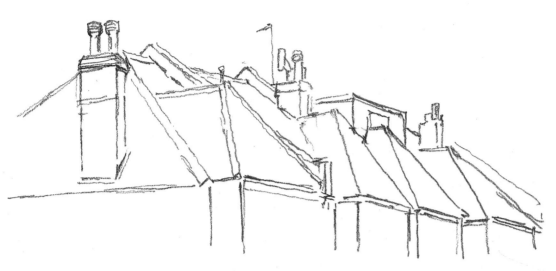

Not far from my house I drew some rooftops, a railway bridge and a group of cars parked along the road. Keeping the drawing simple, I immediately began to get a feel for the space and its general ambience – not at all neat and tidy, but rather haphazard.

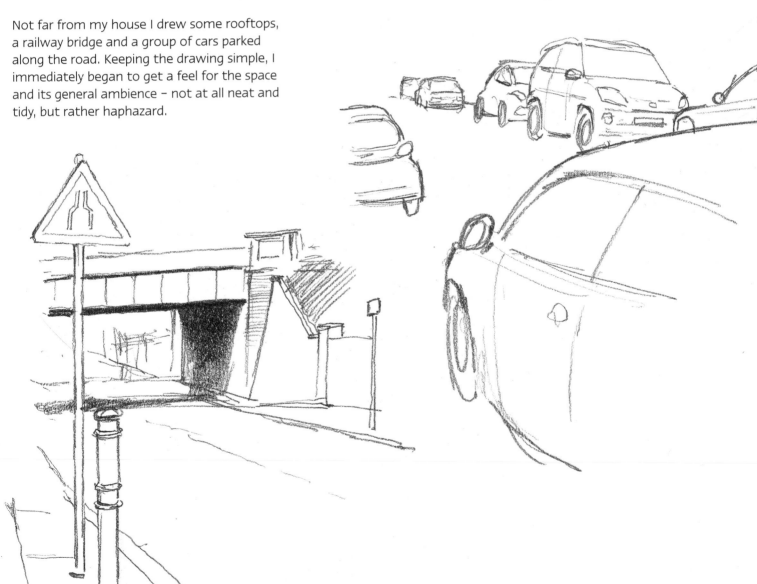

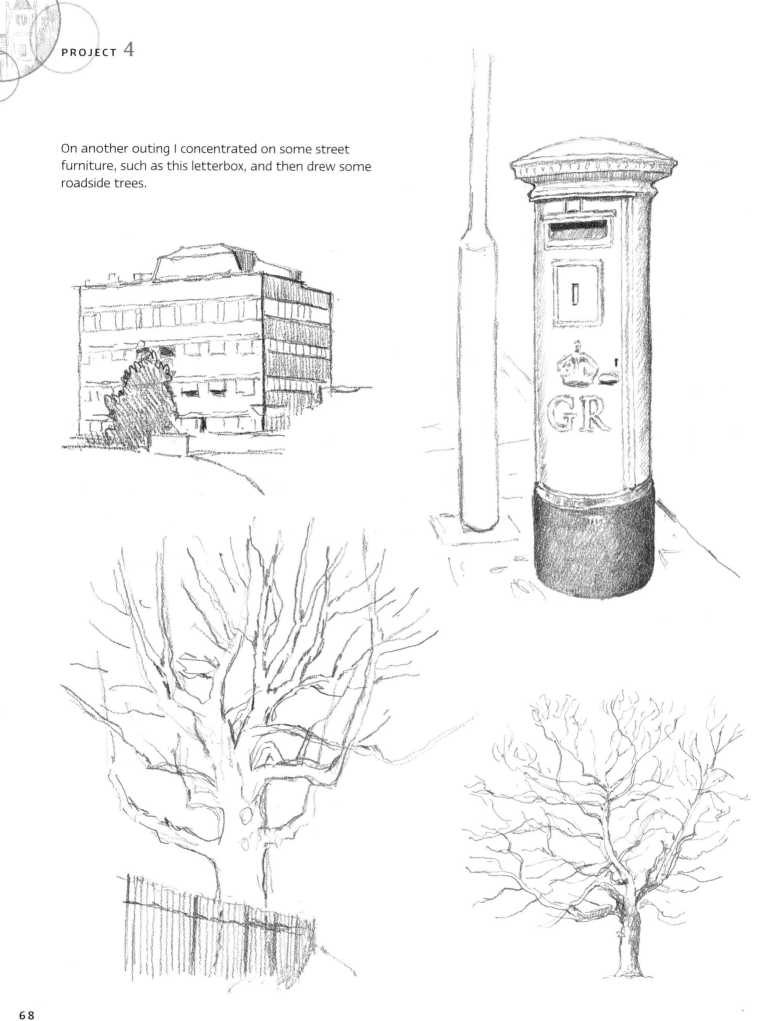

On another outing I concentrated on some street furniture, such as this letterbox, and then drew some roadside trees.

These drawings of a corrugated iron hut by the seashore and a railway bridge have a quality of emptiness, as though something were waiting to happen – for someone to enter or leave the hut, for example, or for a train to run under the bridge. In both of these drawings there is an indication of perspective giving depth, which is what we will look at next.

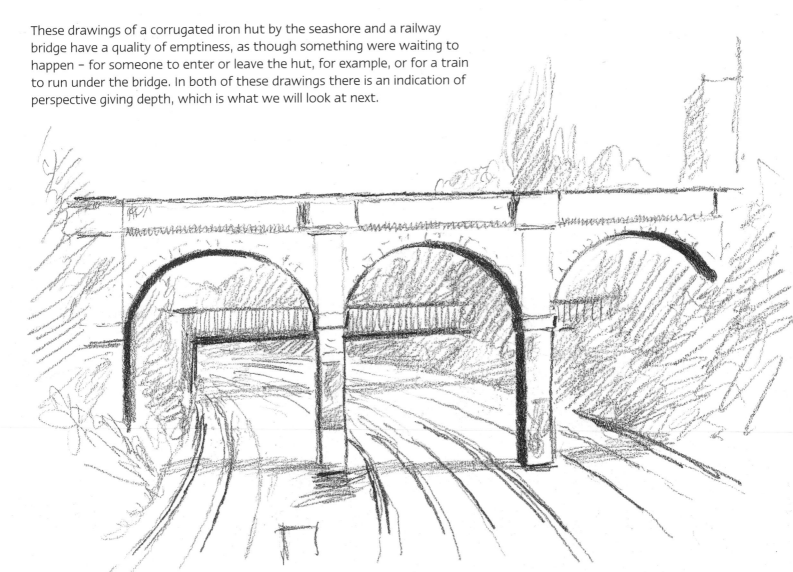

Introducing perspective

When you're drawing anything where there's a certain amount of recession, such as in a landscape, cityscape or large interior space, you'll need to consider the laws of perspective. Principally, these dictate that anything further away from your viewpoint will appear smaller than anything closer. Here I show the simple system which you will need to employ in most of your work.

One-point perspective

The horizon line in your pictures will always be your eye level. Parallel lines running vertically from the foreground will converge to meet at a point on the horizon, called the vanishing point.

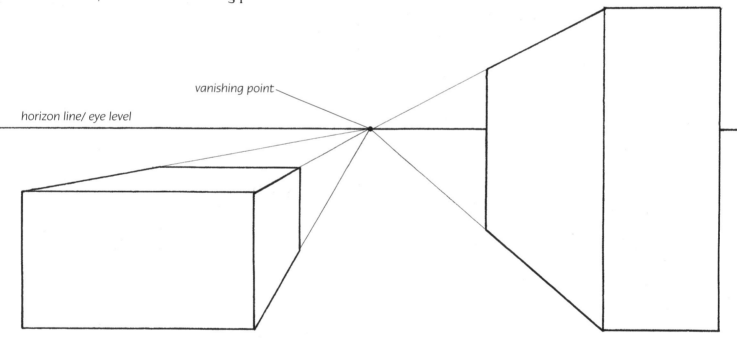

Draw a rectangle below the level of the horizon and another taller one that cuts across the horizon. Then take fine construction lines from the corners of the rectangles so that all join up at the central vanishing point. You can now construct with vertical and horizontal lines the other sides of the cuboid shapes that make it look three-dimensional. You can see how in my diagram I have made the edges of the apparent blocks heavier, so that you are not confused by all the construction lines. I also strengthened the horizon line where it could be seen past the large block shapes.

In this type of perspective you only have vertical lines, horizontal lines, and those lines converging on the vanishing point.

Two-point perspective

When you use two-point perspective the same rules apply, except that this time there are two vanishing points, which will be at opposite ends of the horizon line. This means that your first vertical lines will be in more or less the centre of your drawing.

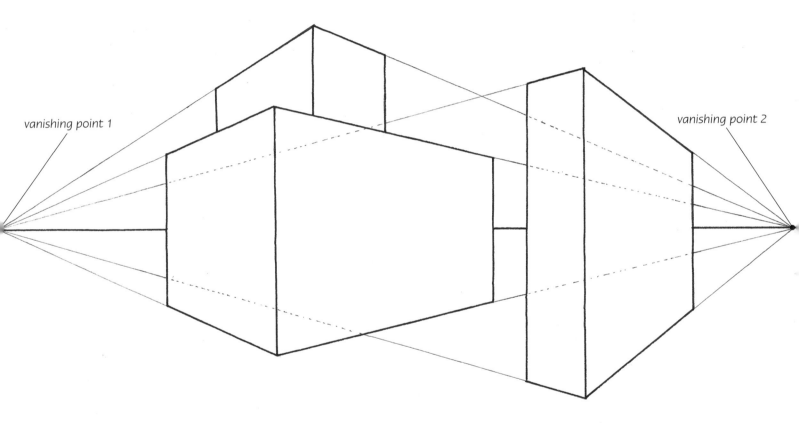

vanishing point 1

vanishing point 2

Here two apparent blocks are set alongside each other. This time the construction lines are drawn from these largest verticals to both of the vanishing points either side.

The next thing to do is to draw more verticals limiting the size of your blocks as you wish. They will appear on either side of the original vertical, parallel with it. Once again I have strengthened the outlines of the blocks and the horizon line where it is visible behind the blocks in order that the eye is not too confused with all the construction lines.

In this type of perspective there are only verticals and lines joining the vanishing points, so it is not too complicated. But it does make you see an apparently three-dimensional space in which there are a couple of building blocks.

Perspective in a landscape

These simple diagrams give you some idea how important perspective can be in a landscape that has many manmade features in it. It's not always so obvious in nature, but the same rules apply if you wish to show the depth of the space in the picture.

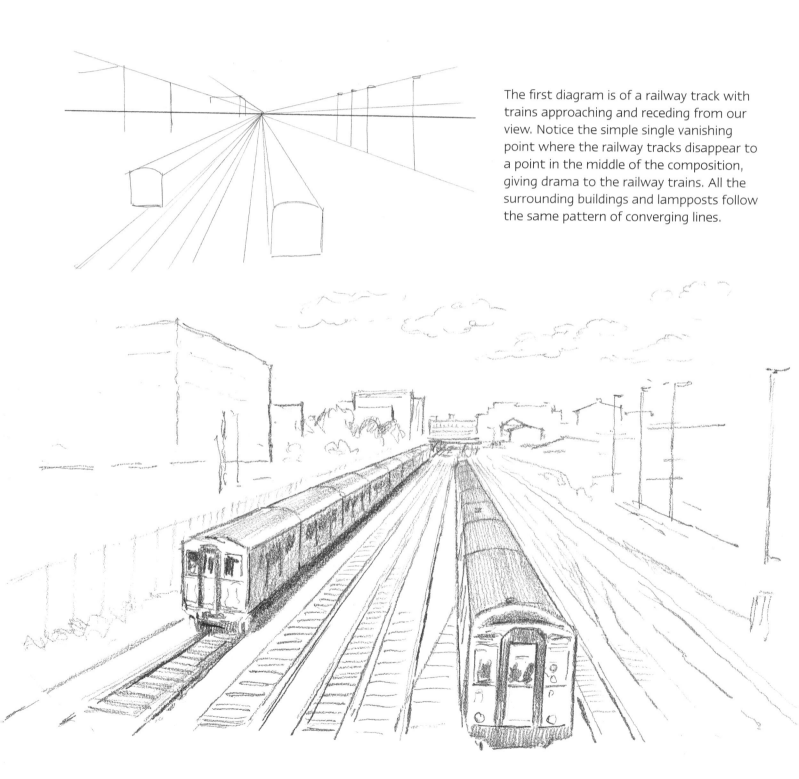

The first diagram is of a railway track with trains approaching and receding from our view. Notice the simple single vanishing point where the railway tracks disappear to a point in the middle of the composition, giving drama to the railway trains. All the surrounding buildings and lampposts follow the same pattern of converging lines.

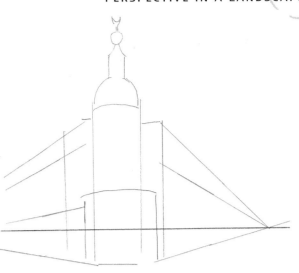

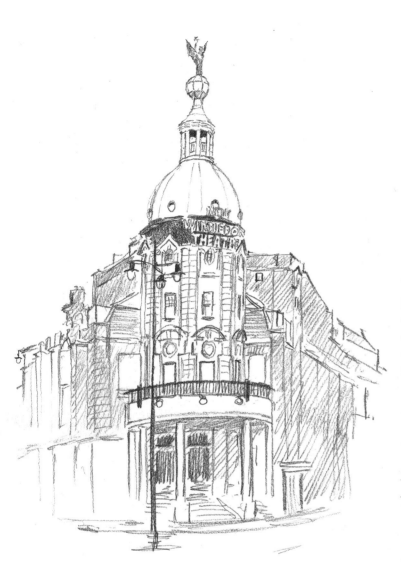

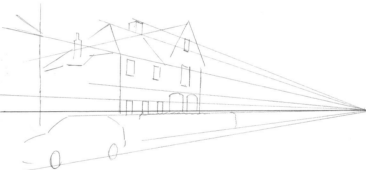

The next scene of a large corner building is in two-point perspective, in which the lines of the tops and bases of the buildings converge from the centre towards the outside edges. As always the horizon line or eye level is important, although it is more difficult to find in a large built environment like this.

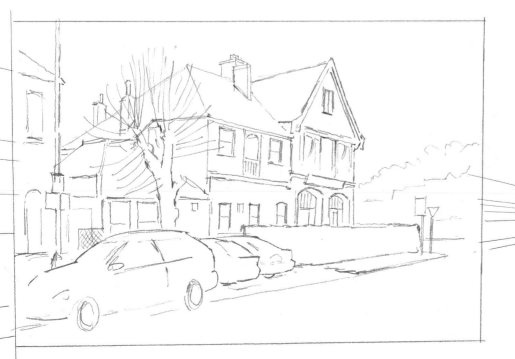

The last example is in fact of two-point perspective, but one of the converging sets of lines is much clearer than the other. This is because the main façades of the buildings are to one side and the hedge and edge of the road emphasizes this direction. However, you can see that the side of the building recedes towards the opposite side although it is slightly masked by the tree.

Gathering ideas

You should now feel ready to try a complete drawing – a simple
one is best to build your confidence. Time spent gathering ideas
for a drawing is never wasted, since if you don't use all of them at
the time they may spark off another drawing later.

While roaming around
London, I came across
these old Dickensian
buildings near London
Bridge that made
a nice change from
all the more recent
architecture.

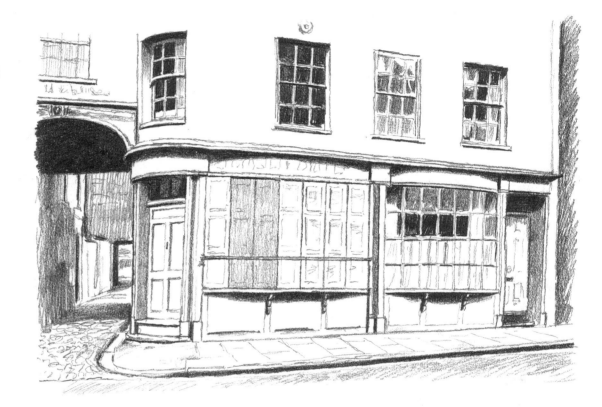

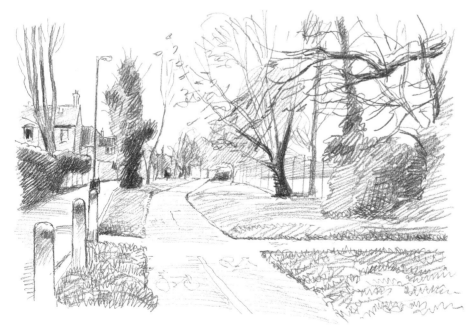

This cycle-path and pedestrian walk
are near my home – you don't have
to go far from your house to find an
interesting scene that can be made
into a good landscape piece. It may
not have great spatial qualities,
but smaller spaces can make very
interesting compositions.

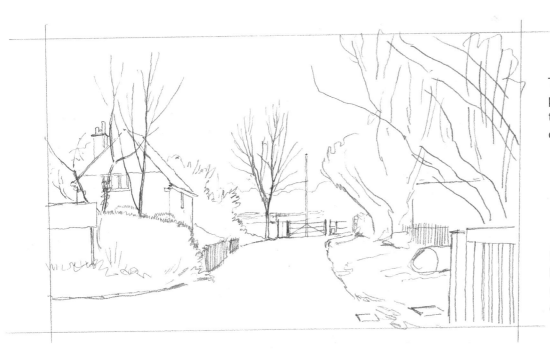

This was the entrance to a primary school, which was tucked away behind the corner.

Here is the entrance to a large recreation ground, usually full of footballers, dog-walkers or cricketers.

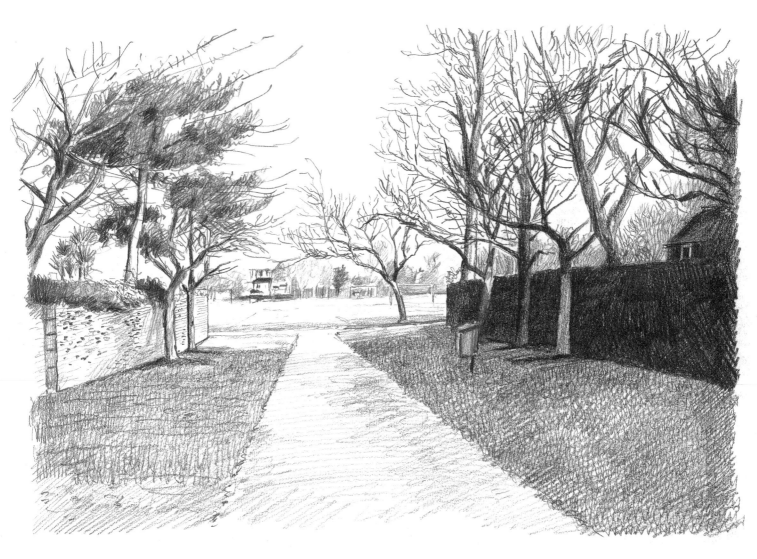

PROJECT 4
Drawing a local scene

As I live in deepest suburbia, this seemed to be the right place to start finding ideas for a local scene since it is the type of area many of us inhabit. Of course, if you live out in the country or by the seaside, you can take advantage of your situation to bring in the greater glories of nature.

▲ First, as always, I made a quick sketch to get the area that I was going to draw clear in my own mind. There was a patch of grass right in front of me with a road curving away and plenty of trees around.

◄ Then with more care, attempting to get the perspective accurate, I drew a careful outline of all the parts of the scene, so I could differentiate between trees, bushes, pavement, grass and houses.

▷ I put in the main tone all over the picture, not yet differentiating between the darkest and lighter tones. This gave me a good idea as to where the greatest emphasis in the spatial qualities of the scene could be made.

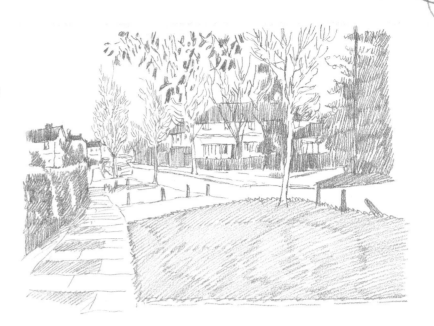

▽ Next I built up the darkest areas with more and more tone. These were mostly parts of the houses and the evergreen trees. I was lucky to have a very dark yew tree on the right-hand side of the picture which acted as a framing device and I emphasized the overhanging leaves at the top of the picture a bit more to also help frame the scene. This is the sort of artistic licence that can greatly help a drawing.

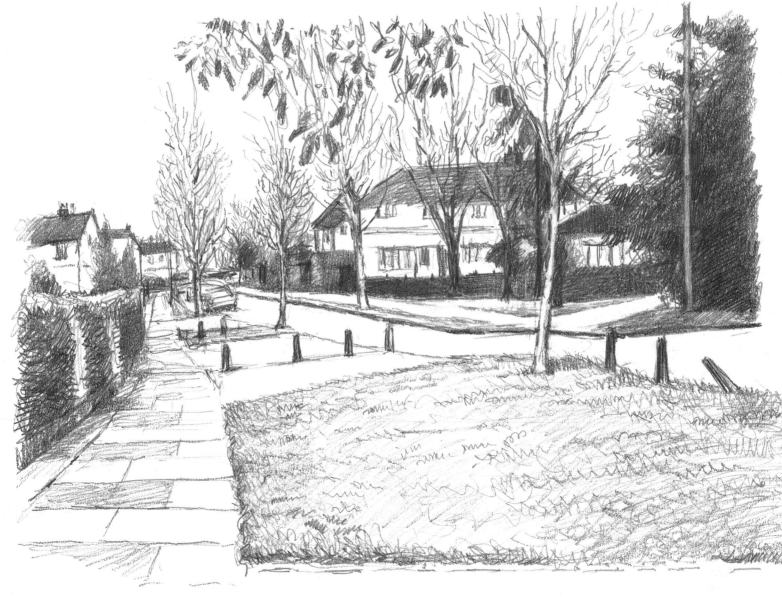

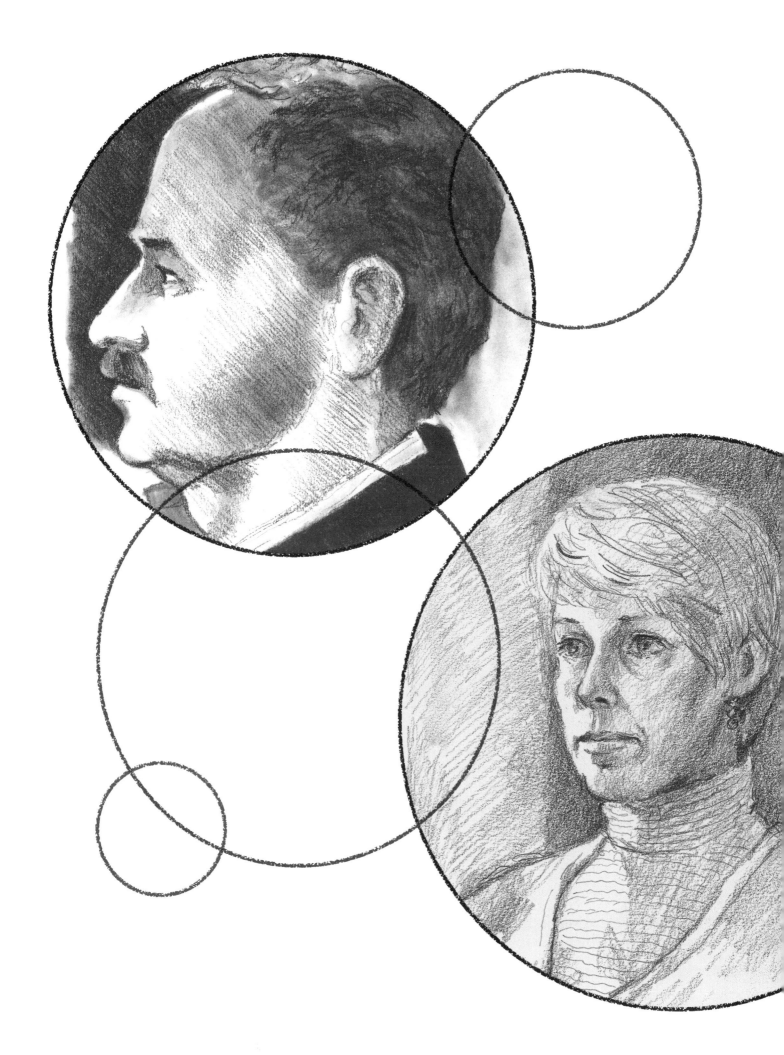

PROJECT 5: INDIVIDUAL PORTRAIT

Portraiture is a form of art that's fascinating for both artist and viewer. Catching someone's physical likeness is a particular skill, and managing to convey something of the sitter's character as well marks out a great portrait from a merely good one. No one will know whether you have produced a still-life set-up accurately, but your portrait subjects and their acquaintances will certainly have a view as to your degree of success. Consequently, there's an inherent challenge to making a portrait that's satisfying in many ways.

Don't be deterred if at first your portraits don't look very much like your subjects, since this field is one of the more difficult ones for a drawing. Keep at it, and with practice and hard work you should eventually be able to produce good likenesses of your sitters. The main thing is to be as objective as you can about the person you are drawing and follow the same method of observation you would use if you were depicting a pot or a flower, which you probably feel confident about by now. This section starts you off with very simple drawings of the head and the main shape of the figure, to make things easy for you before studying how the proportions of the face and body change when they are viewed from different angles. We'll also take a look at how the masters have tackled portraits in their individual styles.

Angles of the head

Before you embark on a portrait, it's a good idea to try out different angles of the head first to see how you want to draw your sitter. In most cases you'll need to show the face clearly so that your sitter can be easily recognized, but there are several variations on just a full face.

A full-face view with the eyes level is a common approach, but you might want to show some of the shape of the nose, which can't be seen so easily from directly in front.

A three-quarters view with the head tilted backwards is interesting to draw, but people may not be able to recognize themselves from that angle.

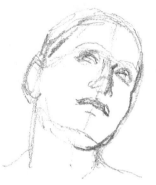

The profile view is very good for the nose and the shape of the head, but of course from this angle you can't see both eyes. This tends not to appeal to the viewer.

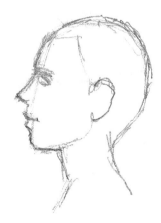

A three-quarters view with the head held level is the one used most often by portrait artists, because everyone can recognize the face and the shape of the nose can also be seen. This is why it's so popular.

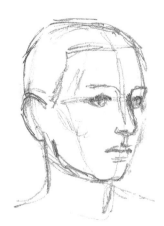

A three-quarters view with the head tilted downwards can be effective, but often gives the impression of sadness.

Framing

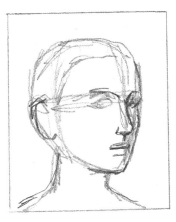

Now you have to decide how much of the sitter you're going to include in your picture. In the first example you see only the head and neck, which is quite a good way to do a portrait because it concentrates on the face. You could draw it without much neck showing, but that gives a slightly brutal appearance.

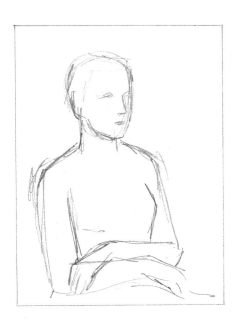

A half-length figure with the arms and hands showing is often chosen because it helps to give a little more grace to the portrait. It's especially suitable if the model is someone who has beautiful hands or uses them for their profession, such as a pianist, a surgeon or a craftsman.

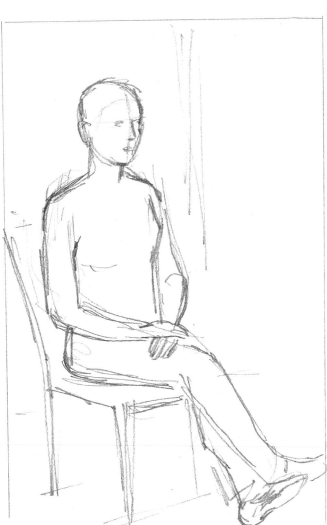

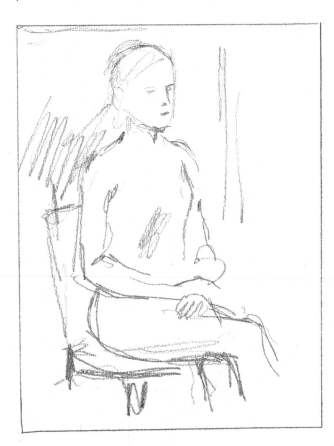

A full-length portrait would include every part of your model, but because the head becomes less significant, a three-quarter length is more commonly used.

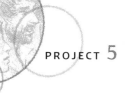
Portraits: different approaches

While a portrait should resemble the sitter in some way, that doesn't mean it must be time-consuming and full of detail. On these pages we shall consider several examples of portraits that approach the subject in different ways before embarking on a short portrait project.

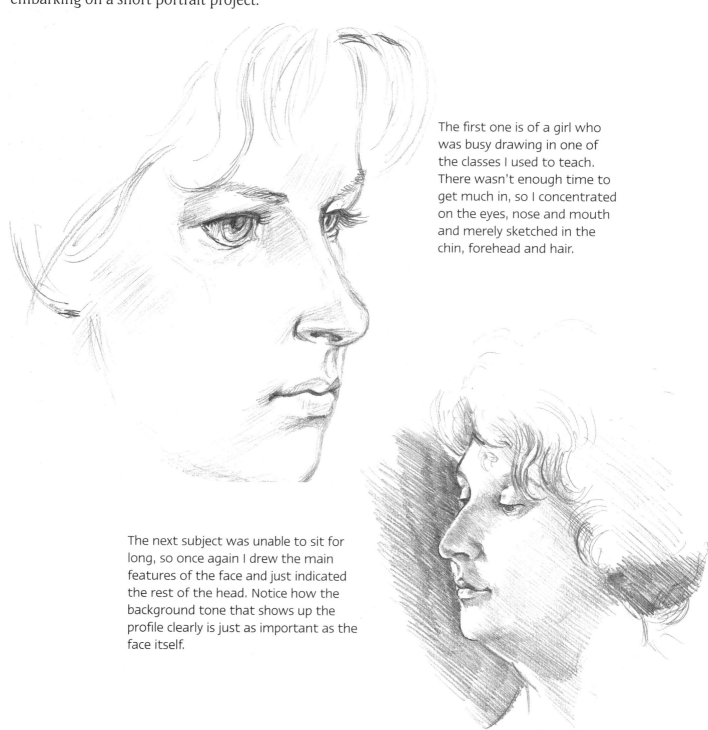

The first one is of a girl who was busy drawing in one of the classes I used to teach. There wasn't enough time to get much in, so I concentrated on the eyes, nose and mouth and merely sketched in the chin, forehead and hair.

The next subject was unable to sit for long, so once again I drew the main features of the face and just indicated the rest of the head. Notice how the background tone that shows up the profile clearly is just as important as the face itself.

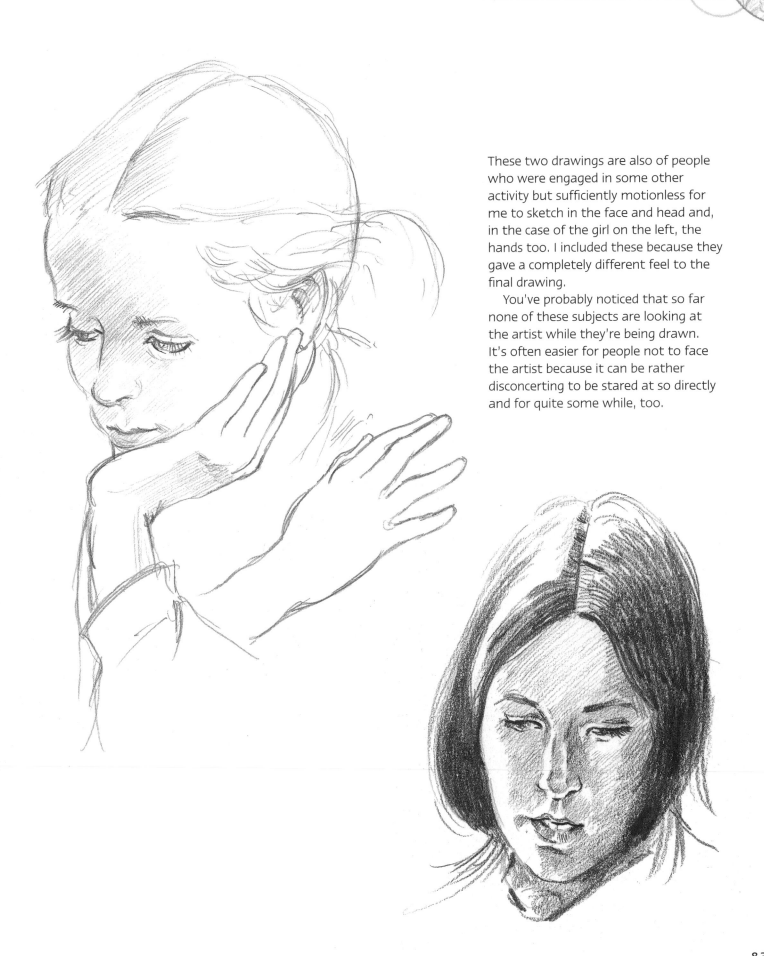

These two drawings are also of people who were engaged in some other activity but sufficiently motionless for me to sketch in the face and head and, in the case of the girl on the left, the hands too. I included these because they gave a completely different feel to the final drawing.

You've probably noticed that so far none of these subjects are looking at the artist while they're being drawn. It's often easier for people not to face the artist because it can be rather disconcerting to be stared at so directly and for quite some while, too.

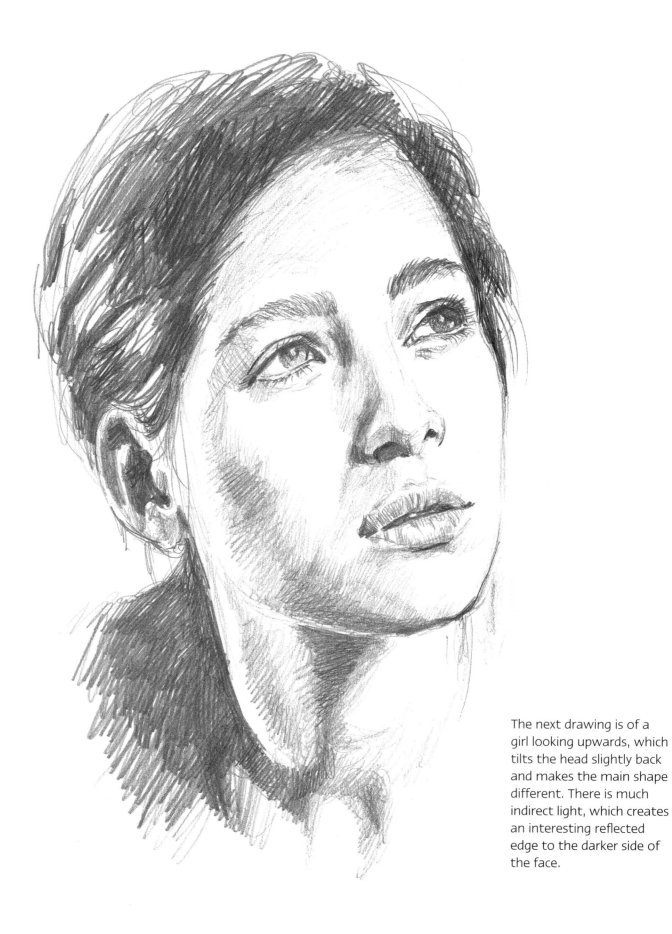

The next drawing is of a girl looking upwards, which tilts the head slightly back and makes the main shape different. There is much indirect light, which creates an interesting reflected edge to the darker side of the face.

This portrait is a complete profile view of a man's head, with a strong dark background behind the face and a lighter one behind the back of the head. Profile views were very popular in the early Renaissance period in Italy, and you might find it quite a good way to start drawing, as it seems easier to catch the exact shape of the face and head. However, it won't be the view that most people like to see in a portrait.

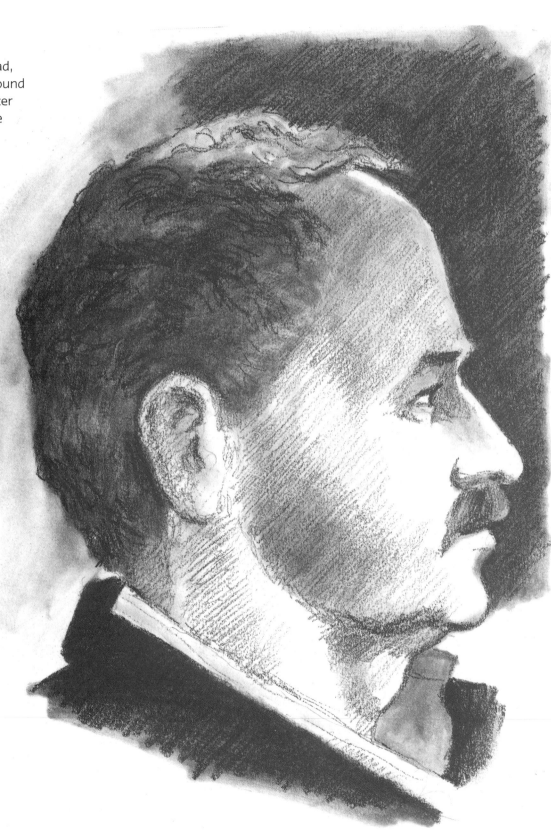

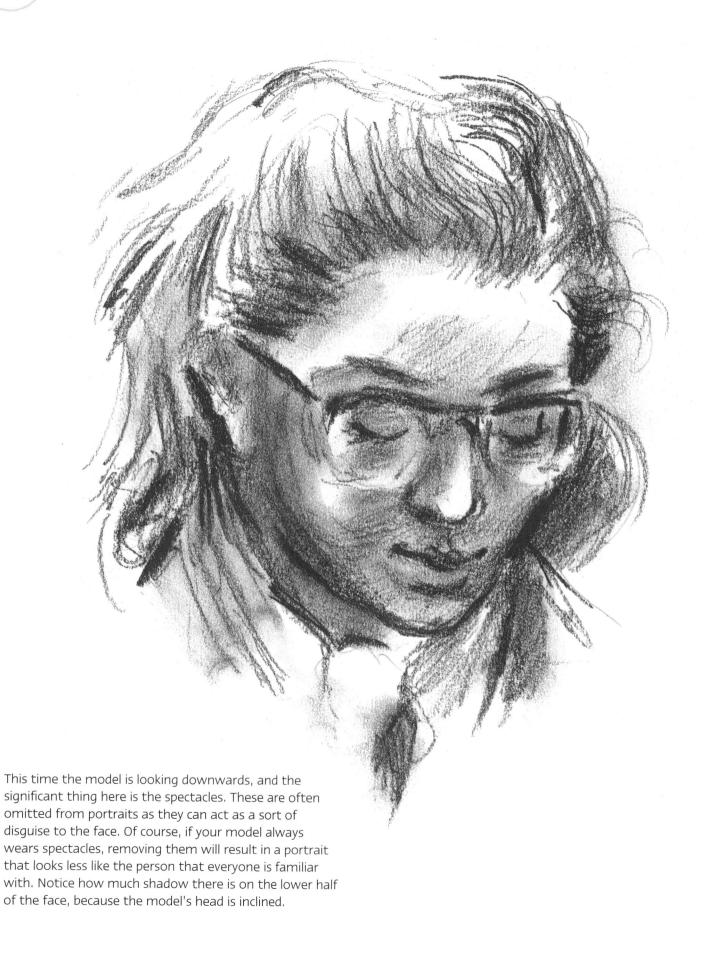

This time the model is looking downwards, and the significant thing here is the spectacles. These are often omitted from portraits as they can act as a sort of disguise to the face. Of course, if your model always wears spectacles, removing them will result in a portrait that looks less like the person that everyone is familiar with. Notice how much shadow there is on the lower half of the face, because the model's head is inclined.

The next two drawings are both of people looking directly towards the artist, and of course this is often the best way to draw someone because it's how they are most recognizable. This man is looking almost challengingly towards the artist, and you can see that he isn't afraid to meet someone's eye.

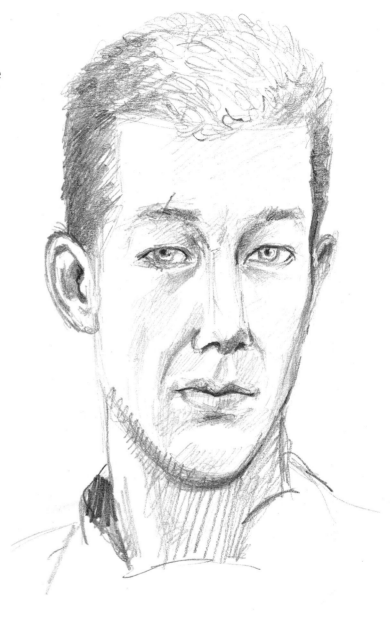

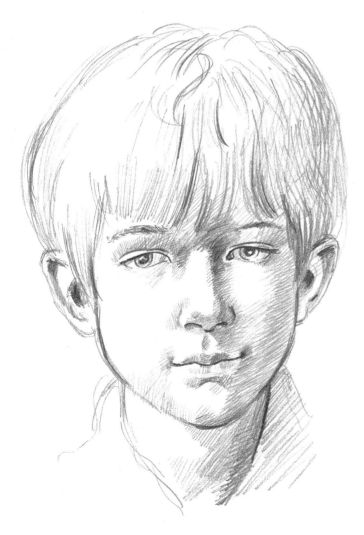

This young boy is my eldest son, drawn when he was quite young. He found it difficult to keep still long enough for me to draw much detail, but we just about managed it. It's noticeable that he didn't look directly at me as I was drawing his eyes.

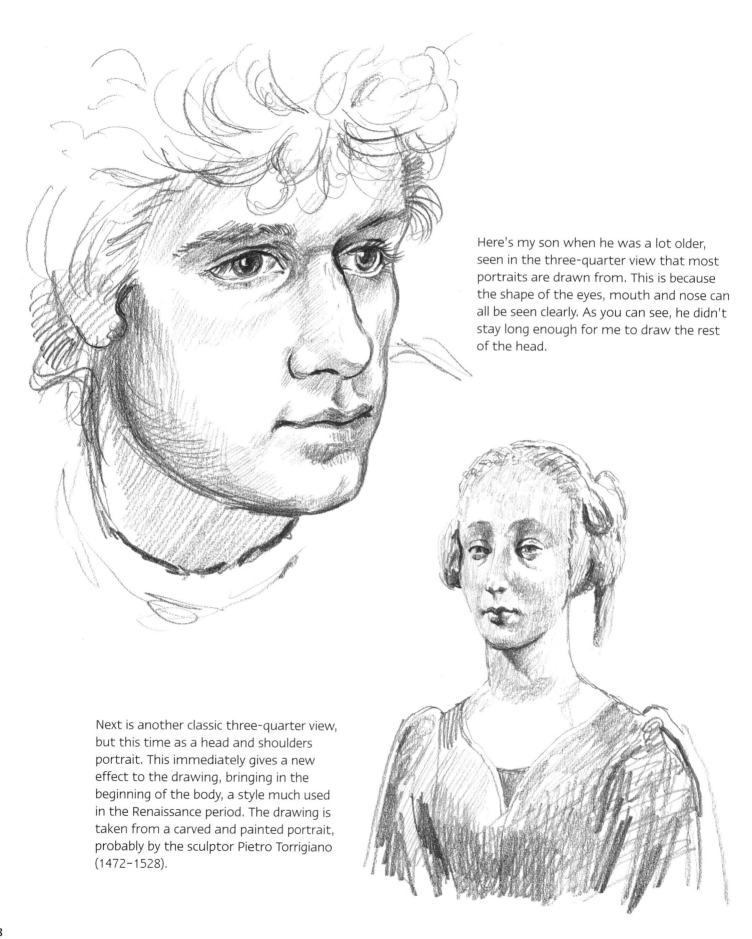

Here's my son when he was a lot older, seen in the three-quarter view that most portraits are drawn from. This is because the shape of the eyes, mouth and nose can all be seen clearly. As you can see, he didn't stay long enough for me to draw the rest of the head.

Next is another classic three-quarter view, but this time as a head and shoulders portrait. This immediately gives a new effect to the drawing, bringing in the beginning of the body, a style much used in the Renaissance period. The drawing is taken from a carved and painted portrait, probably by the sculptor Pietro Torrigiano (1472–1528).

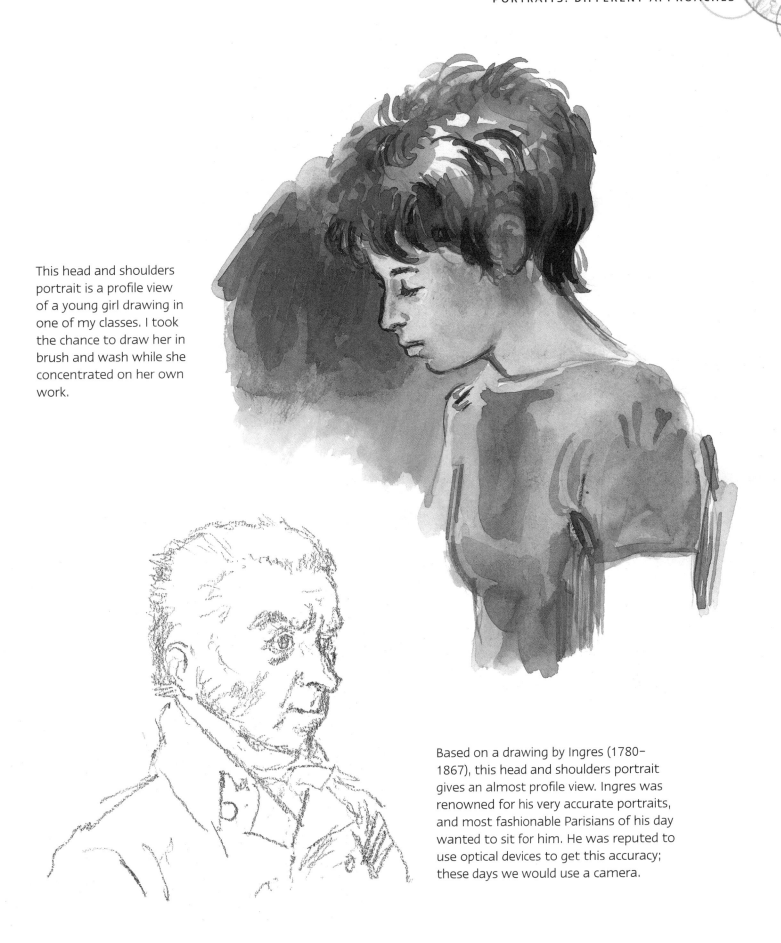

This head and shoulders portrait is a profile view of a young girl drawing in one of my classes. I took the chance to draw her in brush and wash while she concentrated on her own work.

Based on a drawing by Ingres (1780–1867), this head and shoulders portrait gives an almost profile view. Ingres was renowned for his very accurate portraits, and most fashionable Parisians of his day wanted to sit for him. He was reputed to use optical devices to get this accuracy; these days we would use a camera.

The next two drawings are full-length portraits, which are great fun to do but take a bit longer than just the head or head and shoulders. Here extra interest comes from the way in which people use their body to express their character or mood. Sometimes you may even find that body language contrasts with the message in the facial expression.

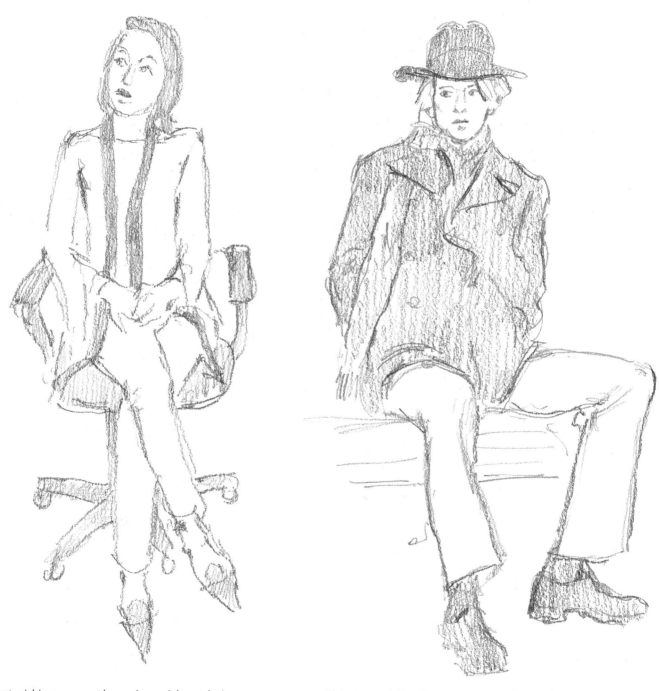

The first girl is apparently posing without being very interested in how the picture will turn out. This is from a series by David Hockney (b. 1937), and quite possibly she was only modelling as a favour to him.

This portrait is of a young man dressed in a rather poetic fashion. He looks as though he is dreaming of some interesting creation while he sits in the cold.

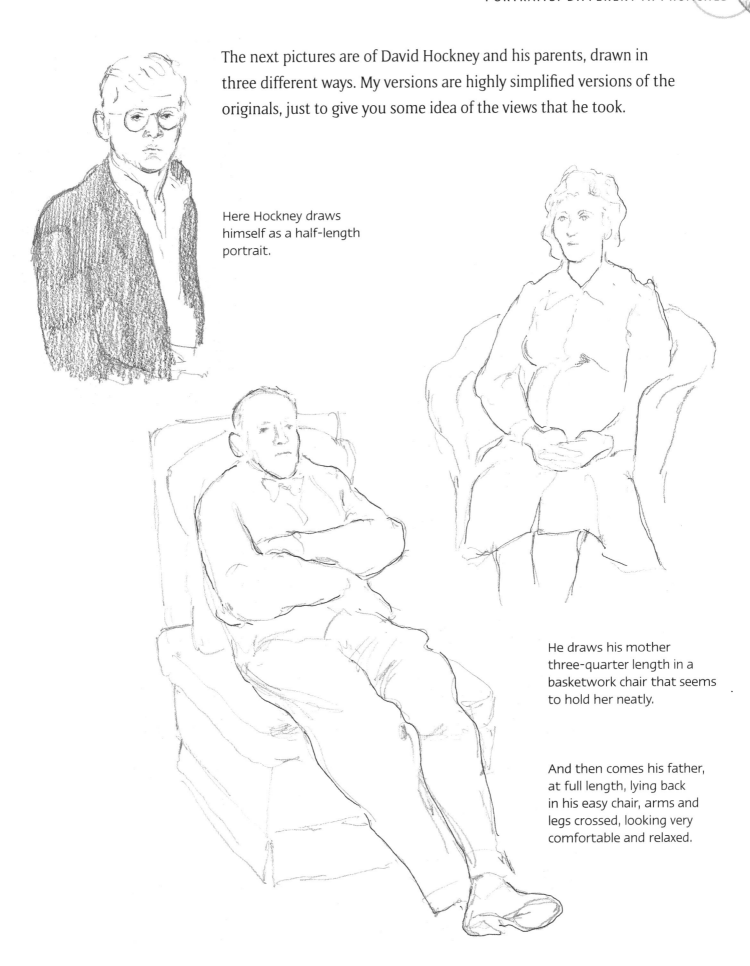

The next pictures are of David Hockney and his parents, drawn in three different ways. My versions are highly simplified versions of the originals, just to give you some idea of the views that he took.

Here Hockney draws himself as a half-length portrait.

He draws his mother three-quarter length in a basketwork chair that seems to hold her neatly.

And then comes his father, at full length, lying back in his easy chair, arms and legs crossed, looking very comfortable and relaxed.

An individual portrait

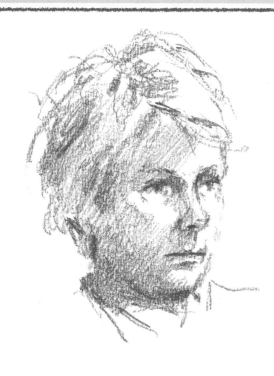

Before embarking on a finished portrait it's good practice to draw your model several times quite quickly in order to get a good idea of how they look. This familiarization with the model's head and figure is never wasted and can give you greater insight into their personality as well as their physical characteristics.

Preliminary drawings

For this project I chose to do a drawing of my wife. As she has sat for innumerable portraits by me, familiarizing myself with her face was not an issue. However, I find that whenever I draw someone, even if I know them well, I keep discovering new subtleties in their features that help the final effectiveness of the portrait.

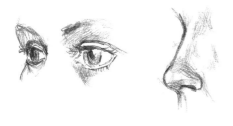
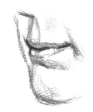

First of all I drew several quick sketches of my wife's head from several angles and in different mediums, including chalk, pencil and pen and ink. I also drew her eyes, mouth and nose separately, so that I could accurately see how their shapes would work in a drawing.

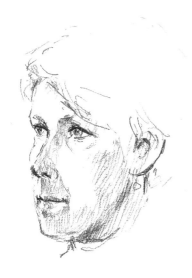
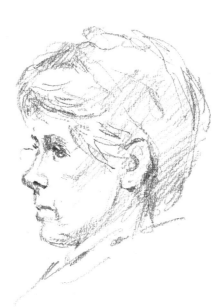
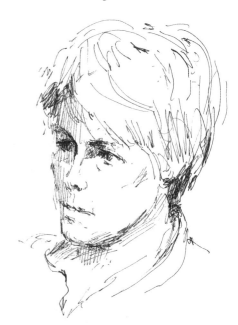

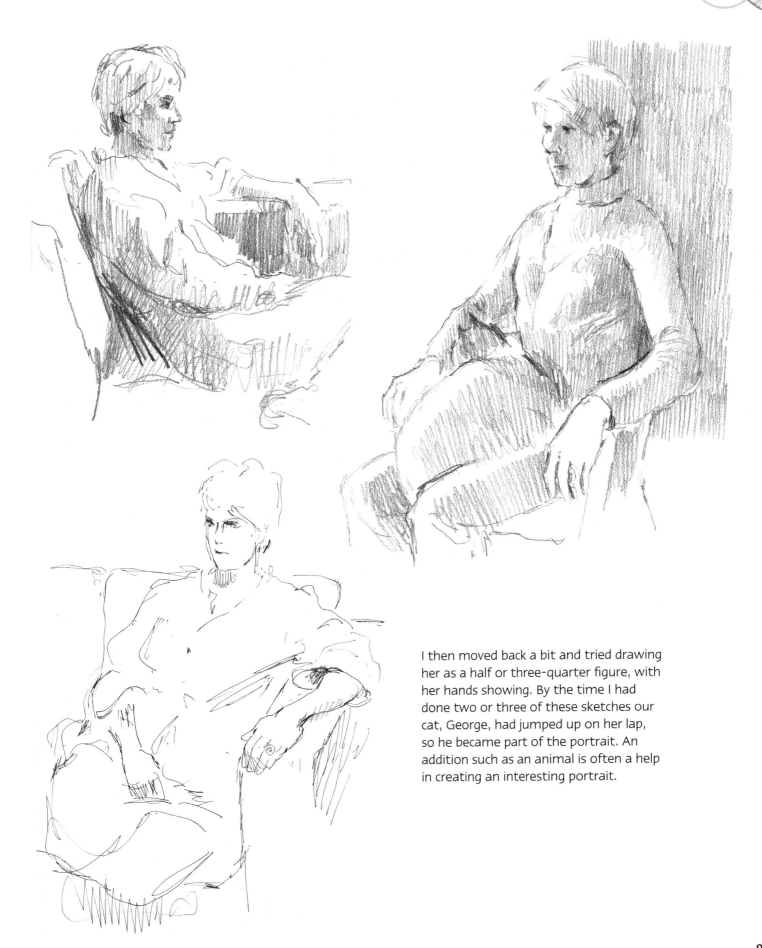

I then moved back a bit and tried drawing her as a half or three-quarter figure, with her hands showing. By the time I had done two or three of these sketches our cat, George, had jumped up on her lap, so he became part of the portrait. An addition such as an animal is often a help in creating an interesting portrait.

Finally I had to make a decision as to how this portrait was going to be done, and opted for the three-quarter view. However, by this time my wife was rather impatient with it all and I had to put it back to a later day. When we resumed, after she had taken up the pose, the cat decided he wouldn't miss this opportunity and leapt into the frame as well. You may well find your own model losing patience, in which case it's best to postpone rather than try to persuade them to stay against their will – you will probably never get them to pose for you again if they remember it as an irritating or boring experience.

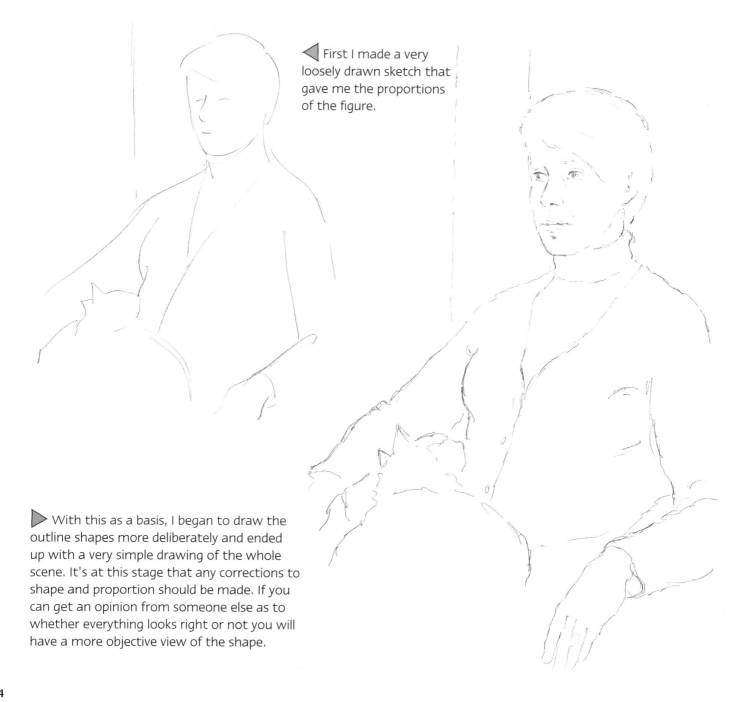

◀ First I made a very loosely drawn sketch that gave me the proportions of the figure.

▶ With this as a basis, I began to draw the outline shapes more deliberately and ended up with a very simple drawing of the whole scene. It's at this stage that any corrections to shape and proportion should be made. If you can get an opinion from someone else as to whether everything looks right or not you will have a more objective view of the shape.

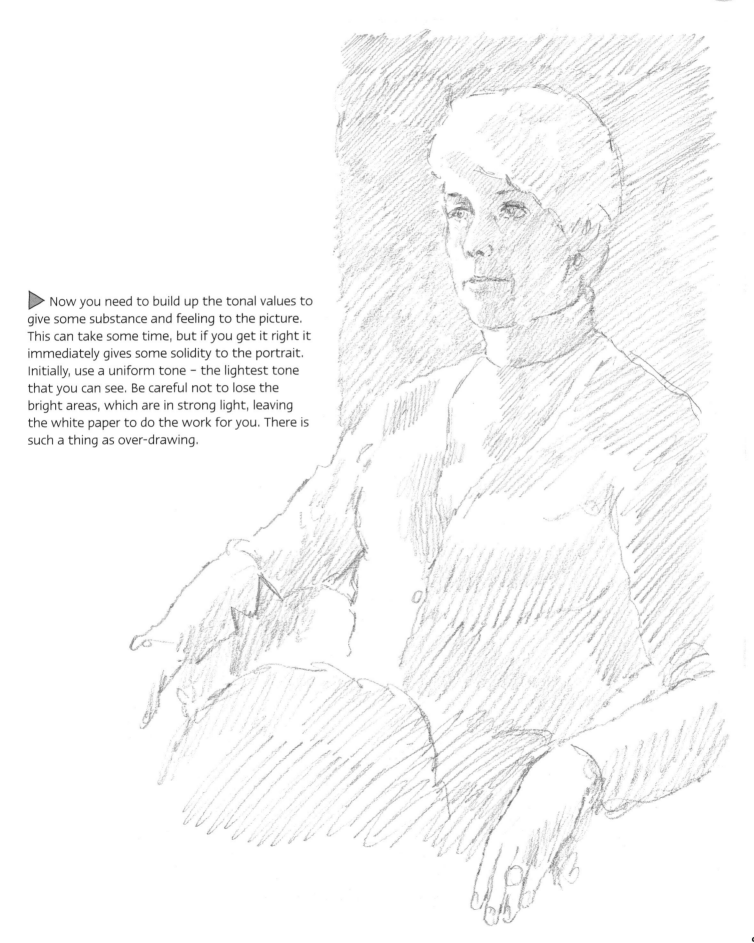

▷ Now you need to build up the tonal values to give some substance and feeling to the picture. This can take some time, but if you get it right it immediately gives some solidity to the portrait. Initially, use a uniform tone – the lightest tone that you can see. Be careful not to lose the bright areas, which are in strong light, leaving the white paper to do the work for you. There is such a thing as over-drawing.

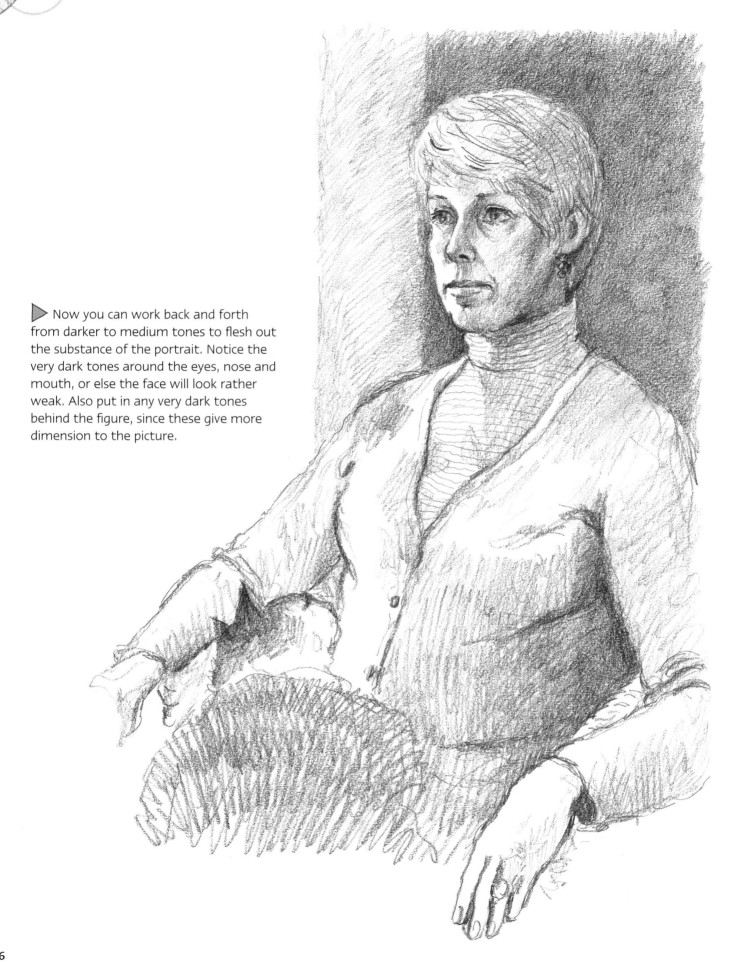

▷ Now you can work back and forth from darker to medium tones to flesh out the substance of the portrait. Notice the very dark tones around the eyes, nose and mouth, or else the face will look rather weak. Also put in any very dark tones behind the figure, since these give more dimension to the picture.

Master examples

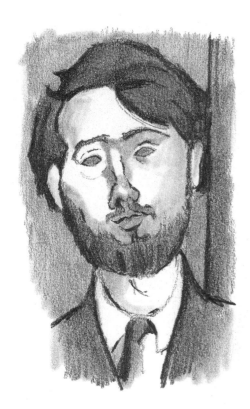

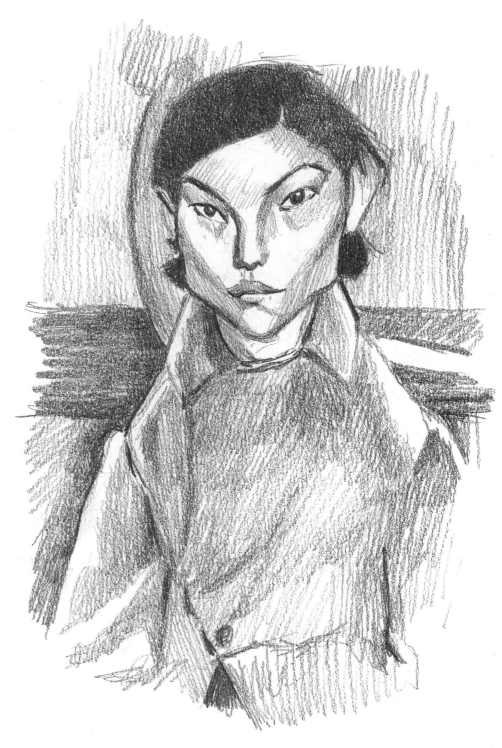

▲ ▶ Drawn after Amadeo Modigliani (1884–1920), these two portraits are of an unnamed young gypsy (right) and Leopold Zborowski, a Polish writer and art dealer (above). Both of them are quite stylized, but the character of these people comes across in a way that a more conventional rendering might not have shown. The angularity of the gypsy's face has become so pronounced that the portrait is almost a caricature. The portrait of Zborowski is more naturalistic, but formalized as well, giving a dramatic effect to the picture. These examples show that you do not always have to be totally accurate in your drawing in order to achieve a good portrait.

Next we have a couple of examples after that brilliant painter Lucian Freud (b. 1922). The first one, of the prominent lawyer Lord Goodman, is a pen drawing with multiple etched lines defining the form of the head. As the sitter has a very distinctive head and features, the artist is not afraid to pile on the effect of lines and bulges in the form. One of the reasons Freud is so cherished as a portrait painter is that he certainly doesn't hold back from showing every blemish on the surface of his models.

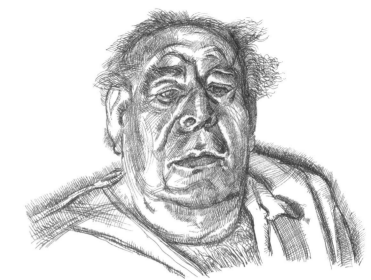

The second is taken from the painting *Woman in a Grey Sweater*. The main characteristics of the form are shown simply and powerfully, giving a strong sense of the dimensional qualities of the head. Notice the way the arm curled around the head helps to give added informal framing to the face.

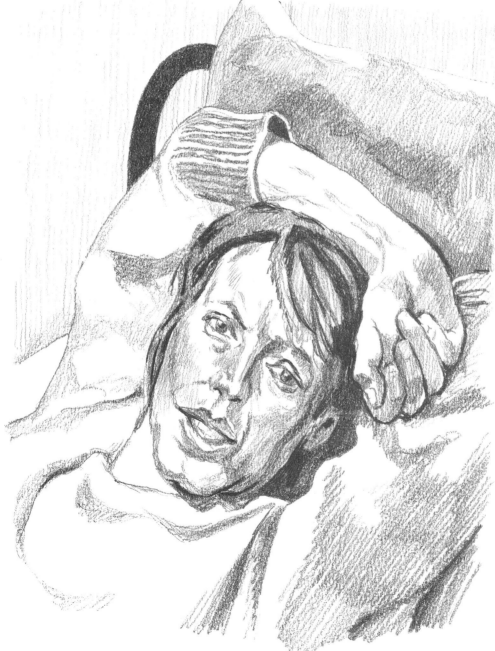

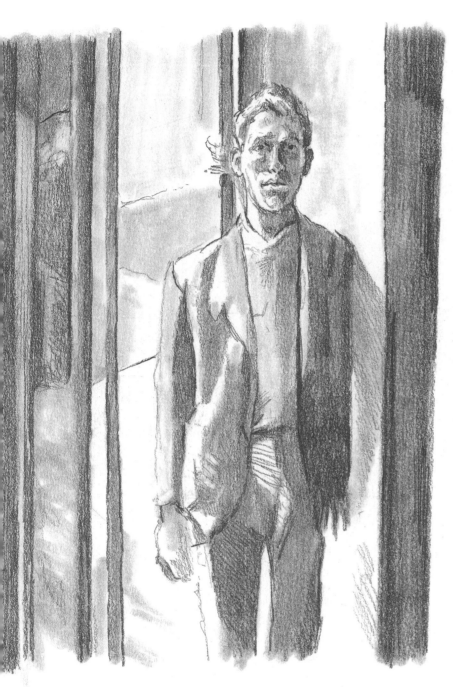

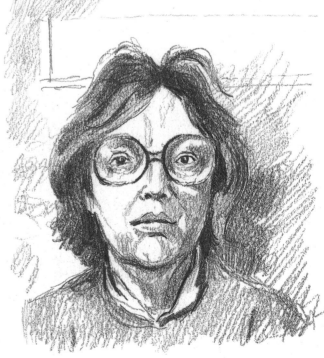

◁ Michael Andrews (1928–95) is an artist who influenced my own work in the 1960s. The drawing here is taken from his painting of a young man seen standing three-quarter length in a doorway. This produces very unusual lighting effects, which increases the drama of the picture. All the verticals framing the figure seem to increase the importance of the face in the composition.

▷ The second of Michael Andrews' faces shown here is a simple head, dramatized by the enormous spectacles and the dishevelled hair. This informality is a good way of producing a portrait that has immediacy and a sort of lived-in look.

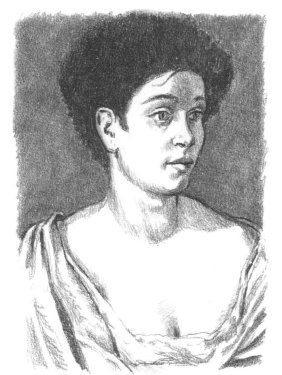

◀ The next two drawings are after portraits by Mary Cassatt (1844–1926), the American painter who was an habitué of the Impressionist circle in 19th-century Paris. The first is quite an early example of her work, and you can see the traditional qualities of the portrait painters of a generation before showing strongly. However, her ability sings out in this face, which has some quality of a Goya. She has kept the picture very simple and direct.

▽ In the second portrait, she has now become much more the Impressionist, in that the whole scene, including the background, makes a pattern of shapes with no obvious focal point. She has caught the daylight feel of the garden location, the figure of the woman being very much part of the scene.

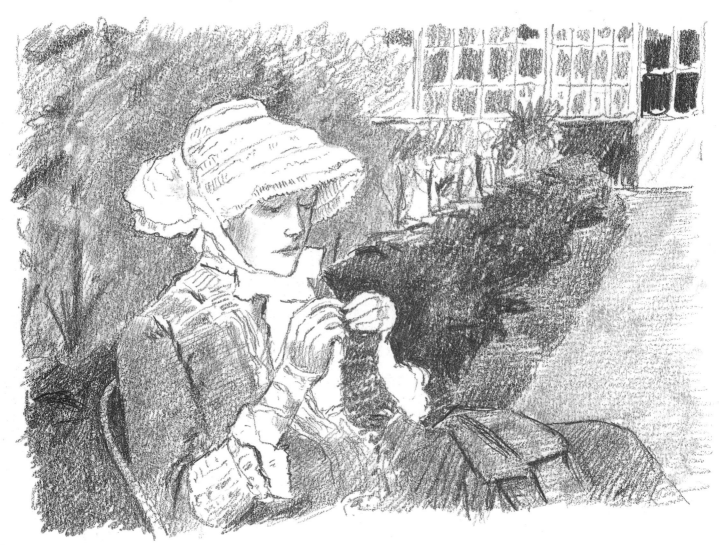

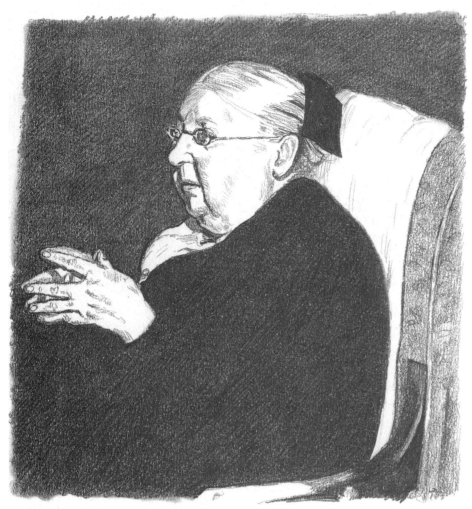

◀ William Nicholson (1872–1949), an early 20th-century painter, is our next example, and he shows a certain graphic strength in his work; many of his powerful poster designs have become iconic. In his study of the great garden designer Gertrude Jekyll he has emphasized the simple graphic qualities of the dark and light shapes, so that although he hasn't neglected the character of the sitter, he has produced a very strongly designed pattern.

▶ In the portrait of Sir Arthur Quiller-Couch, an author of some fame, Nicholson has reduced the drama by keeping the tones lighter and closer together. This gives a strong impression of the light in the room at the time and gives the author a certain faded charm. We can guess his age and also the faded colouring in his face and hair.

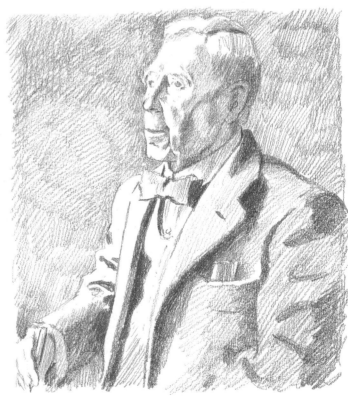

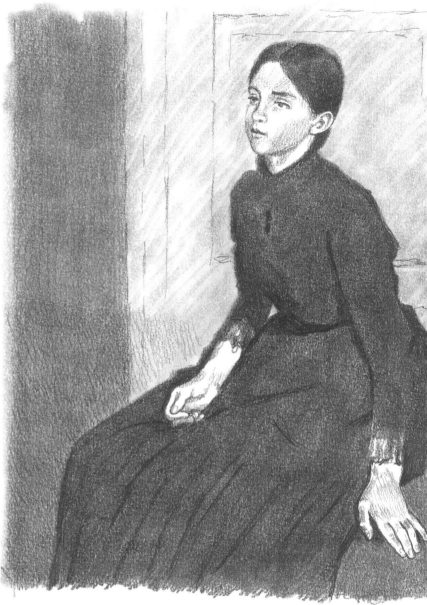

▷ The Danish artist Vilhelm Hammershøi (see also pages 54–55) was not a great producer of portraits, but these two of his sister and his wife are quite brilliant. The one of his sister was attacked in his own lifetime for being too vague and unformed, but to our modern view he appears to have given a beautiful gentleness to his portrait that is very attractive. Note how he has used the three-quarter length form to give movement and liveliness to the picture.

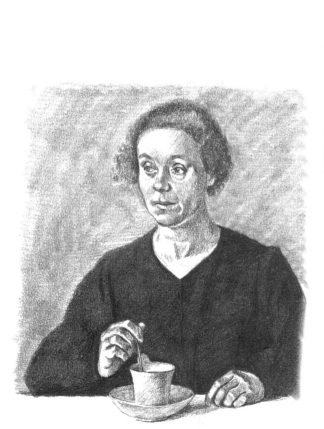

◁ The second one, of his wife, is sharper in detail, but he still gets across the vulnerability of the subject in the simple device of her stirring a cup of coffee. This ordinary, everyday gesture seems to say that she is not really posing for her portrait, but has been caught at a time when she didn't expect to be drawn. Again he brings a liveliness into the essentially static form.

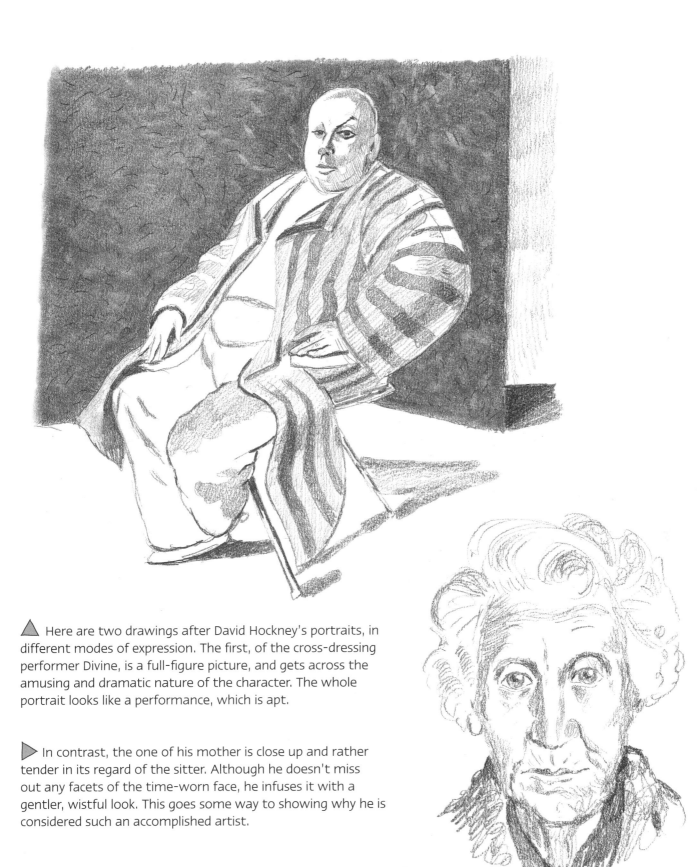

▲ Here are two drawings after David Hockney's portraits, in different modes of expression. The first, of the cross-dressing performer Divine, is a full-figure picture, and gets across the amusing and dramatic nature of the character. The whole portrait looks like a performance, which is apt.

▷ In contrast, the one of his mother is close up and rather tender in its regard of the sitter. Although he doesn't miss out any facets of the time-worn face, he infuses it with a gentler, wistful look. This goes some way to showing why he is considered such an accomplished artist.

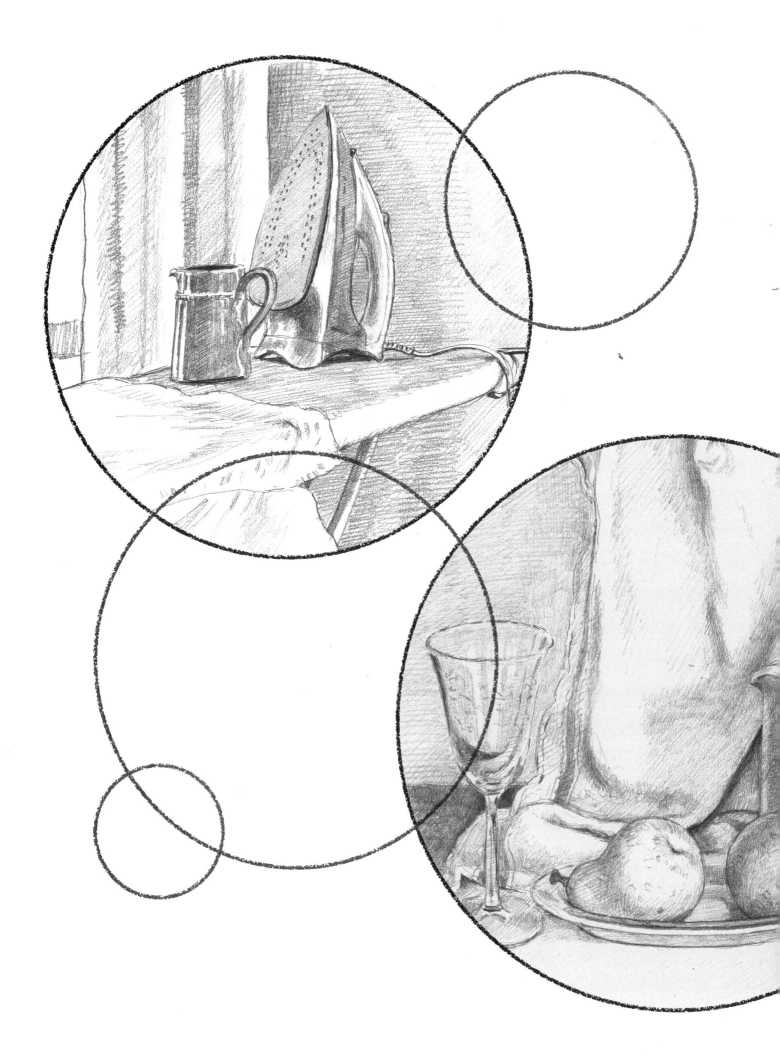

PROJECT 6: COMPOSITE STILL LIFE

In this section of the book, we look at still life in more detail and with more complex composition. One of the ways that you can arrive at an interesting still-life arrangement is to look for accidental ones around your house. I find that every day I come across natural compositions of objects that have come into being by virtue of the everyday habits of living. Sometimes they are complete in themselves, while on other occasions they just need a slight alteration to make a very pleasing still life.

You'll find it useful to make separate drawings of all the objects that you choose for your large still life to familiarize yourself with their shapes and textures. This sort of preparation is never wasted, and you'll often achieve some very good examples of your drawing skills to refer to later on for another project.

The final arrangement of a still life should be made up of things that you find interesting in themselves. Don't put anything in the arrangement that you don't really want to draw. Have faith in your own taste – it really does make a difference to the intensity and quality of your work.

Last but not least, familiarize yourself with still lifes by artists that you admire to gain some wider understanding of all the possibilities. The master artists shown here will set you on the right path.

Choosing and assembling objects

When you move on to more ambitious still lifes composed of a larger number of objects you have to take more time to think about their arrangement. The first thing is to look around for objects that have some attraction for you, bearing in mind that they should give you some contrasts of shape and form. You may perhaps like the idea of drawing a set of things that are similar in shape, but this is best left until you have developed your skills further as it's more difficult to make a dynamic composition from them.

Look around your house to find about seven or eight objects that seem interesting. I often find that I've picked out too many things that have a similar shape, so I'll sometimes deliberately look for things that I'm less automatically attracted to.

Here are two objects that I chose for the very reason that they are dissimilar. The pot with paintbrushes stuffed in it is a complex thing to draw and has a vertical thrust, while the wooden box is very simple and has a strong horizontal shape. These would give plenty of contrast in a composition and might provide an interesting dynamic for the final arrangement.

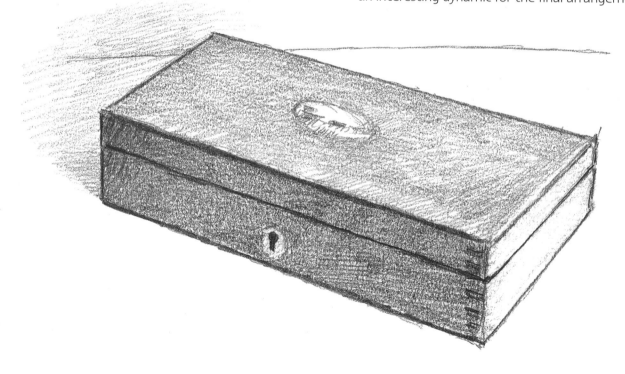

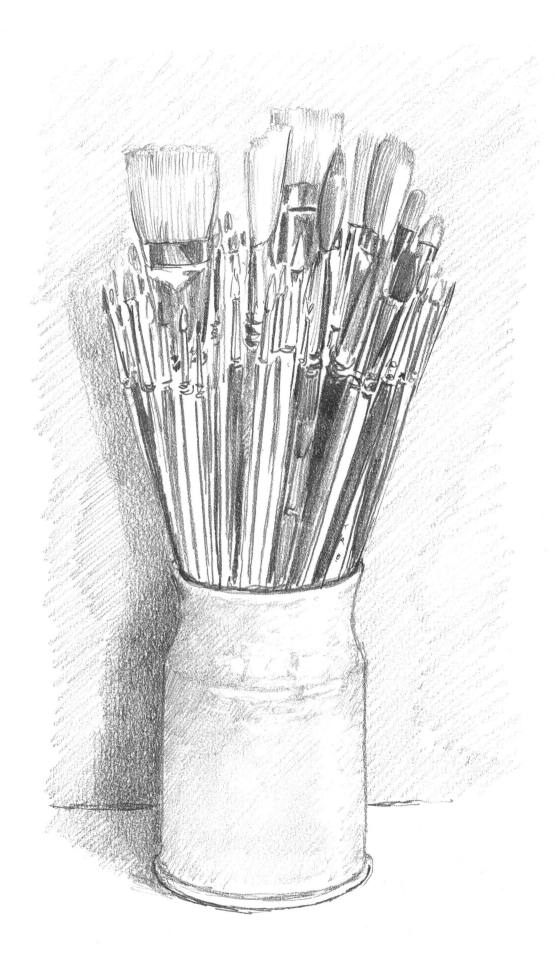

Then I looked around and noticed an ironing board with a shirt, an up-ended steam iron and a jug of water that my wife had been using to fill the iron. While this in itself makes a good set of shapes, it's rather limited in the number of objects and wouldn't look very natural if others were added.

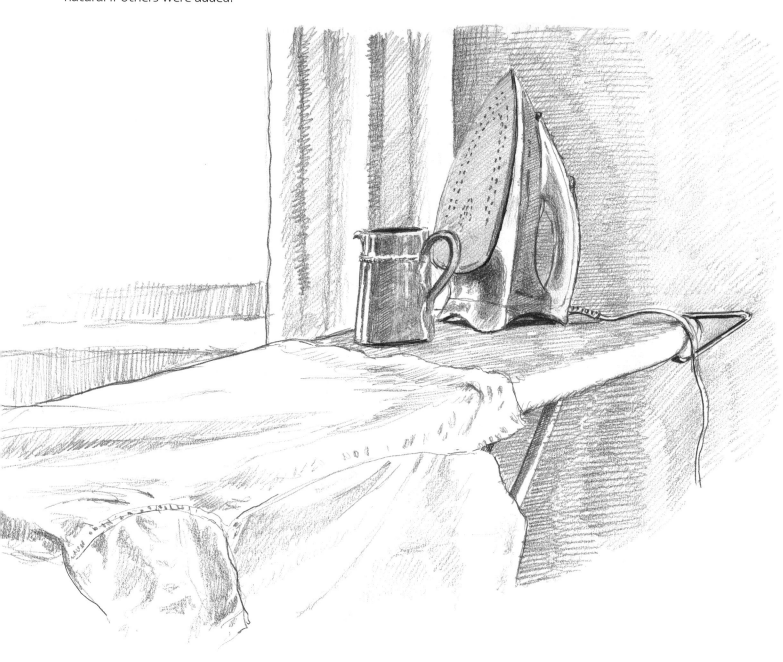

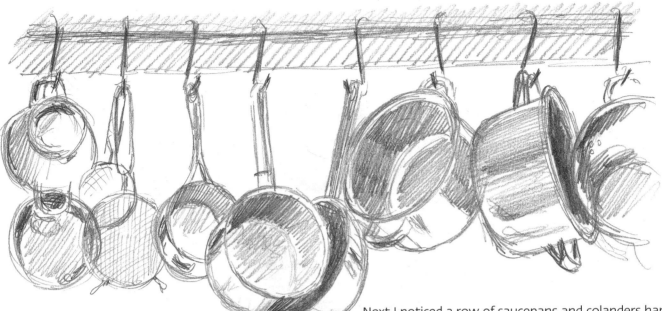

Next I noticed a row of saucepans and colanders hanging above our kitchen window that gave an immediate group of objects in a natural enough setting, and with a certain drama because of the lighting from behind. However, it also was a rather elongated shape as a whole, and there wasn't much contrast between the shapes.

Still in the kitchen, I assembled several objects on the worktop to see if they would make a good arrangement. The lighting was again fairly dramatic and the objects were quite interesting in themselves. But somehow I was still not satisfied with the composition, so I looked around again.

This gives you some idea of the kind of task you are setting yourself when you decide to draw a more complex still life – but it's worth the trouble to put some thought and imagination into it rather than just choosing the first things that you come across.

Still-life details

It will pay dividends if you practise drawing all the individual components of a still life rather than having a go at them for the first time as part of a composition. You'll feel more confident that you can complete the still life and there'll be less erasing to do as you go along.

First draw a piece of cloth such as a tea towel, folded simply. This will give you some idea about the final work.

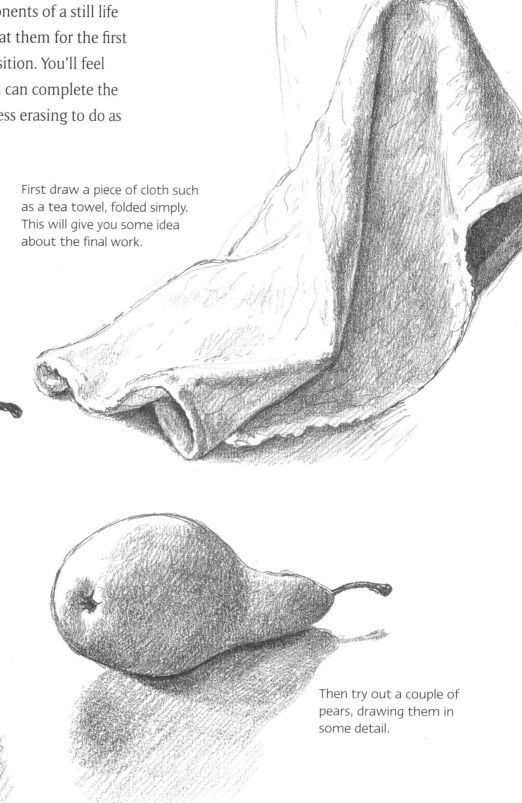

Then try out a couple of pears, drawing them in some detail.

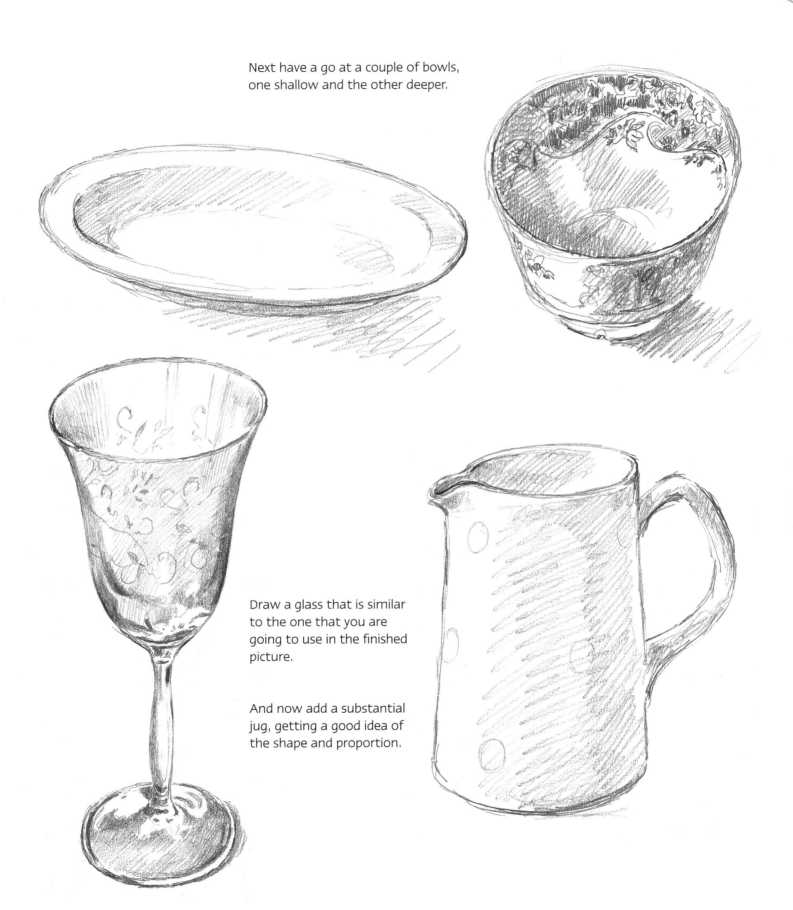

Next have a go at a couple of bowls,
one shallow and the other deeper.

Draw a glass that is similar
to the one that you are
going to use in the finished
picture.

And now add a substantial
jug, getting a good idea of
the shape and proportion.

Composite still life

You are now ready to embark on this classic still-life arrangement with a piece of cloth draped as a background, some fruit on a dish, a wine glass, a jug and a cup and saucer. This is of course fairly contrived, but as a test of your drawing ability it gives you some very interesting problems.

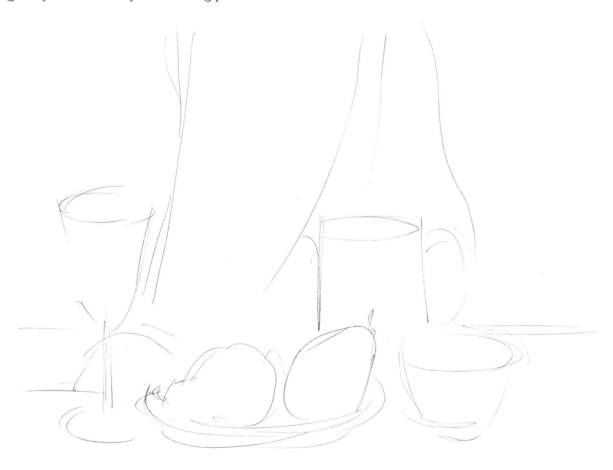

▲ I placed the dish with two pears on it in the centre of the foreground with the jug tucked in just behind it, on one side. Then I draped a tea towel on a board behind them to make a nice set of folds that weren't too complex. It's a good idea to keep the background fairly simple for a still life of this type.

Then I put an etched wine glass to the left and a small willow-pattern bowl in the right foreground. So here I had seven objects in an arrangement with a good variety of shapes and textures.

After looking very carefully at the whole composition, your first step is to loosely draw in the main bulk of the various objects to get some idea of the proportion and balance of the various parts. Try to get the sizes of the objects and their relation to each other as accurate as you can, since taking trouble at this stage will save you a lot of work later on.

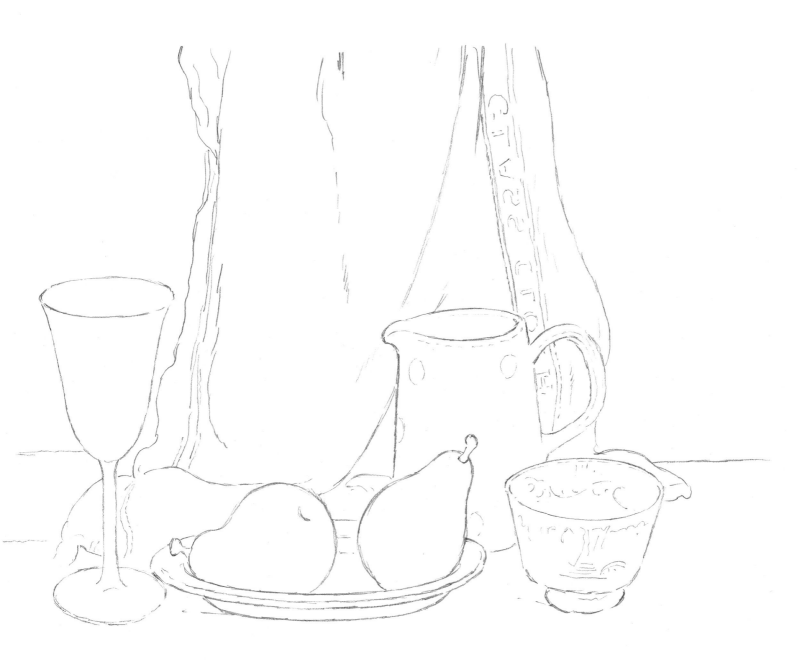

▼ Now you need to draw in the full shape of each object more carefully, making sure that the shapes are as accurate as you can achieve. After the whole thing is finished you'll probably realize that there are some things that you might have drawn better, but don't worry – that always happens and it will make you want to go on to the next drawing in order to grow more skilful. Get it as good as you can at this stage, then don't look back.

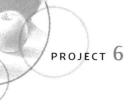

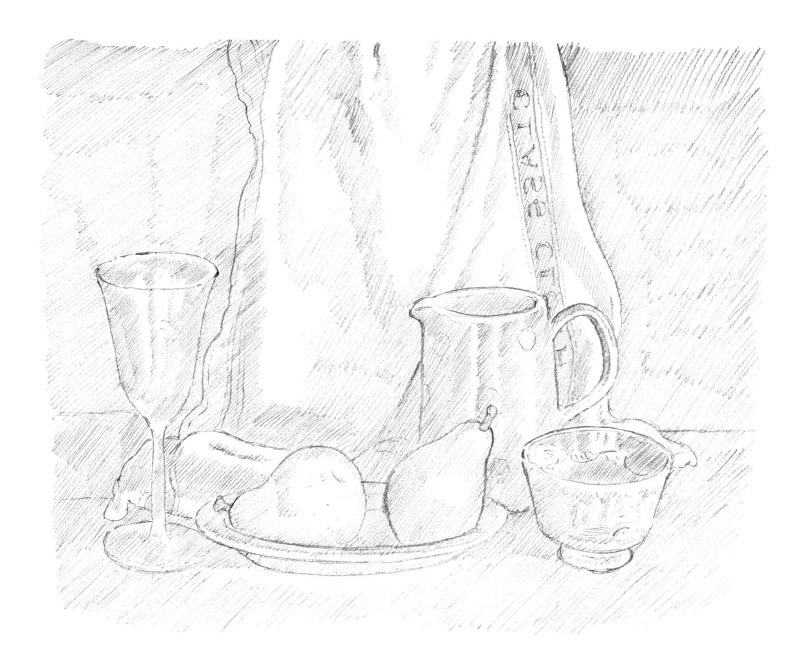

The next step is to add tone over all the shadowed parts that you can see on the still life. I had light coming from the right-hand side and slightly from the front, so there was quite a lot of tone present. Keep the pencil marks light and uniform all over the picture at this stage. I have drawn my tone all in one direction to make it more obvious as a demonstration, but it doesn't matter if you vary the pencil strokes as long as you keep the depth of tone light.

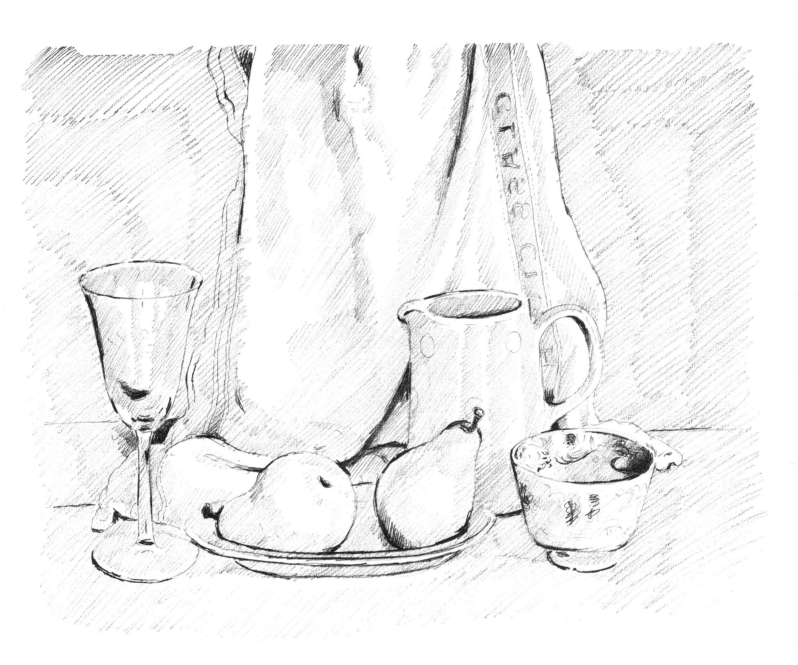

△ Put in all the very darkest areas so that you now have the very darkest and very lightest tone on the paper. This gives you the two extremes between which the mid-tones will be.

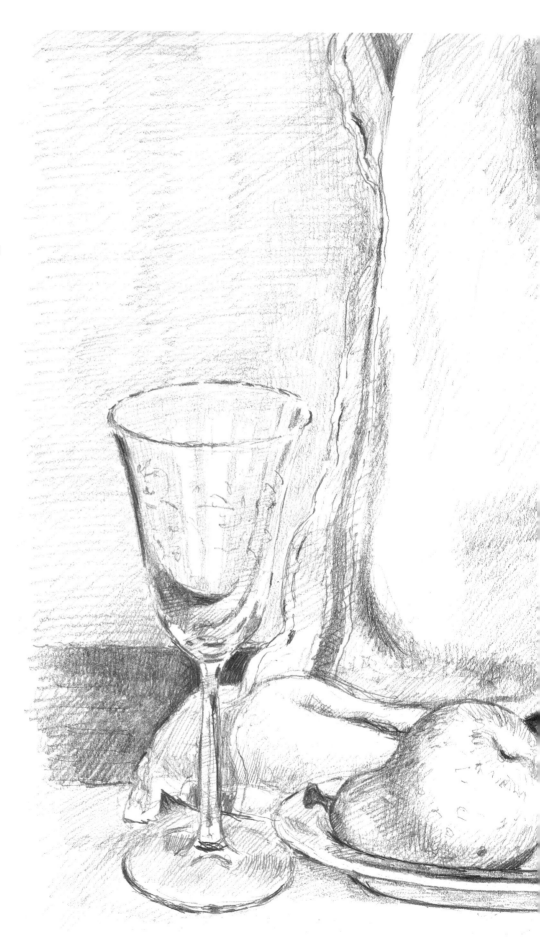

Finally, put in all the graduated tones that will harmonize the whole picture and make it look more convincingly three-dimensional. Build these up gradually and keep stepping back from the picture so that you can see how they are working. The more subtle your tonal values are, the more convincing the picture will look. This is a very useful practice – and always remember that you become good at what you practise.

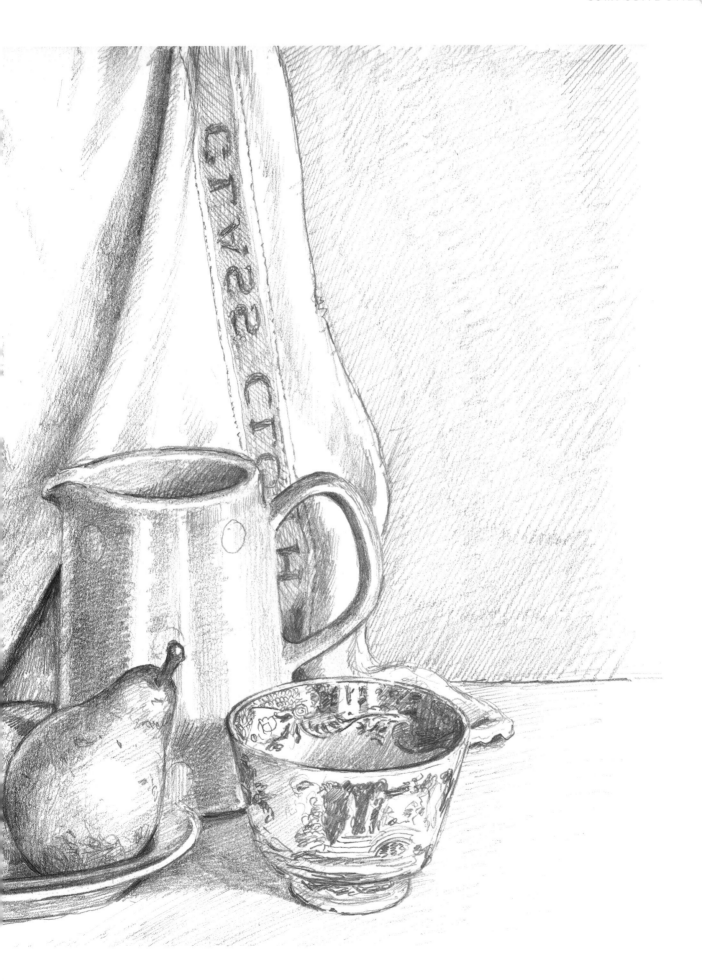

Master examples

I have copied these examples of still-life compositions by other artists to make the point that there are many different ways in which a still life may be rendered – so don't feel you have to follow my style of drawing, because you will soon evolve your own that will satisfy you rather than just echoing other works that you see. However, it's always useful to draw in the manner of another artist that you admire because you learn a great deal from the exercise.

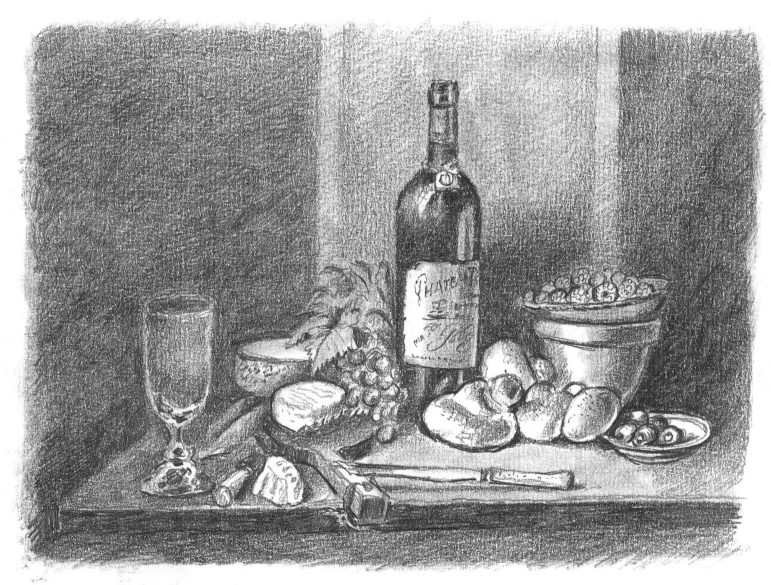

▲ My first example is after a modern artist, Brian Davies (b. 1942), who paints and draws in the manner of the old Dutch masters of still-life painting. His precise technique is evocative of the texture and form of the 17th-century painters. He puts the objects against a dark background and they stand out from the gloom, catching the light and revealing their texture in such a way that you can almost feel their surface qualities.

▽ A less traditional form of still life is this one after Eric Ravilious (1903–42) of two pairs of wellington boots, a chair and a table with cups, teapot and notebooks arranged on it.

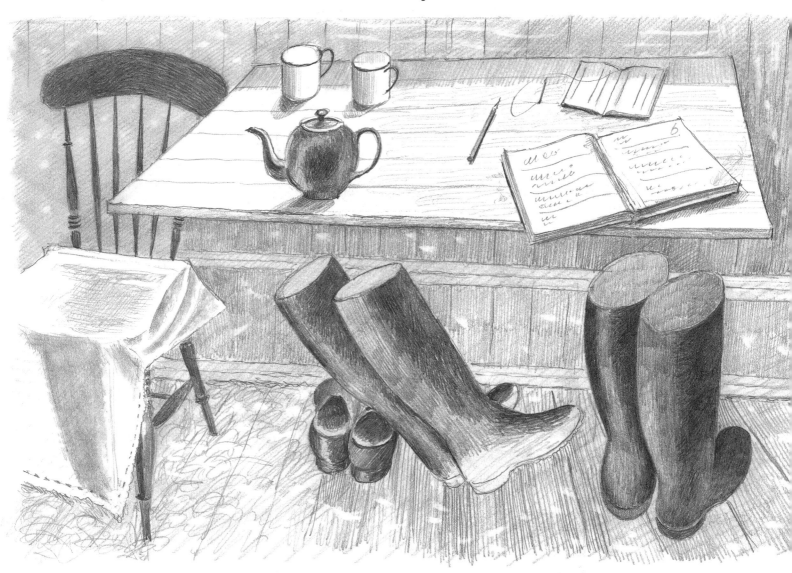

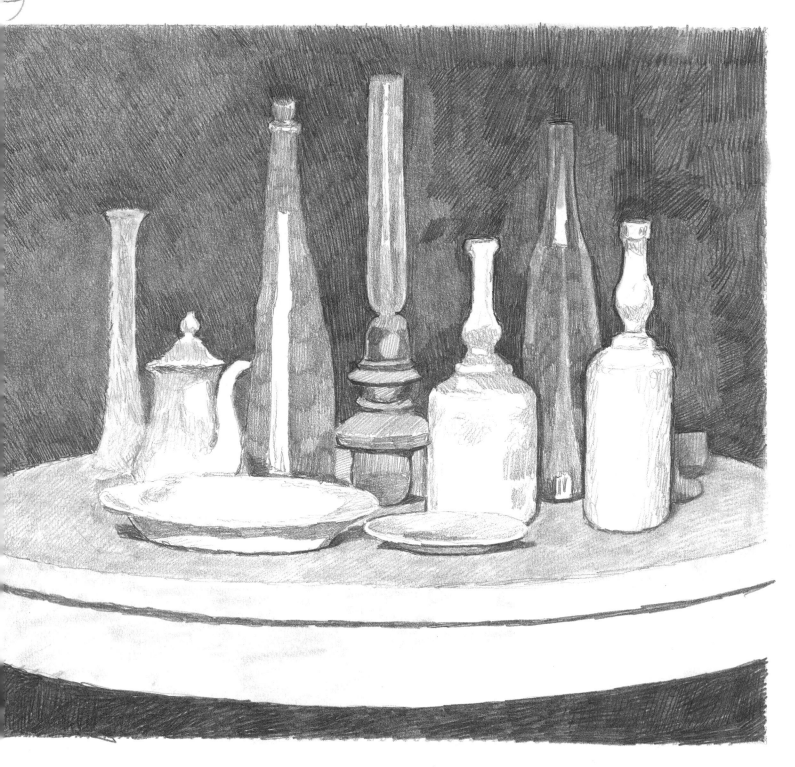

△ Here Giorgio Morandi (1890–1964) depicted a cluster of bottles and similar shapes, stacked close together on a table. The varying heights of the verticals set against the horizontals of the plates gives a composition with plenty of visual interest.

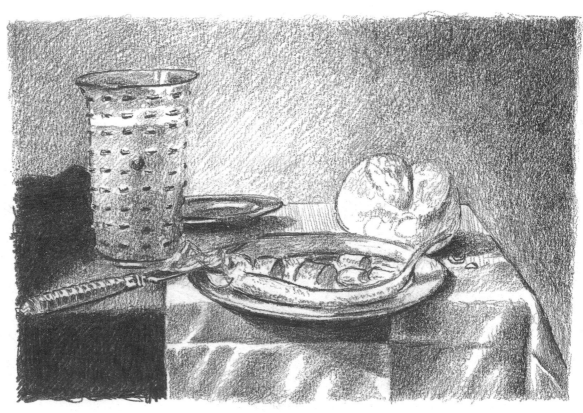

▷ This picture after the artist Pieter Claesz (1597–1660) shows how a very satisfying arrangement can be produced with only a few objects that possess some contrast in shape and texture.

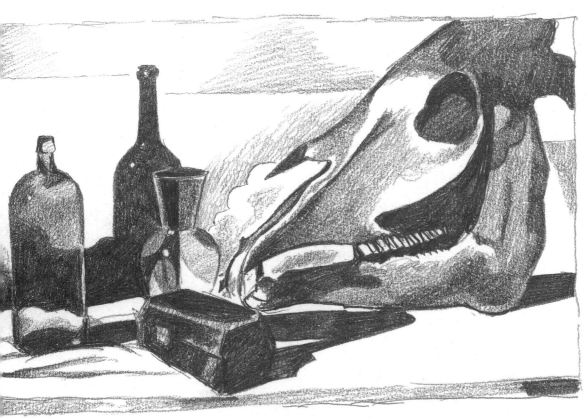

◁ There's a more dramatic use of contrast in this still life after Charley Toorop (1891–1955), where the dominating shape of the cow's skull makes the glass objects look fragile and pushed aside. The extreme tonal contrast also helps the dramatic thrust of the picture.

121

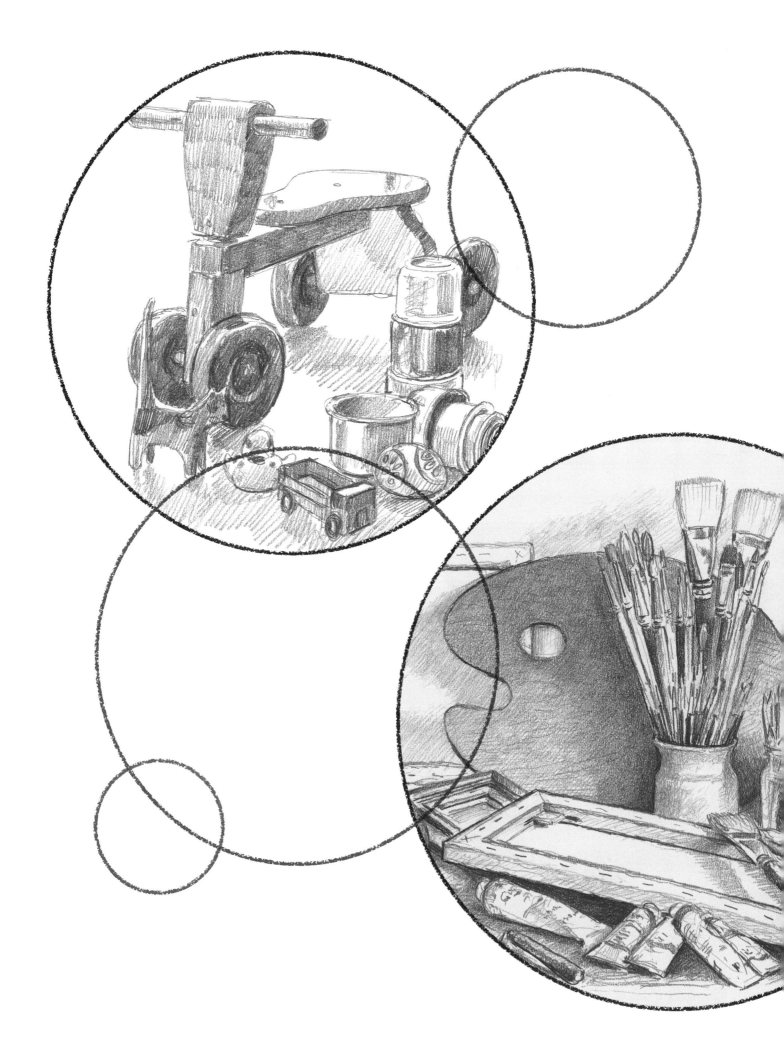

PROJECT 7: THEMED STILL LIFE

Themes in still life are there to create a kind of narrative in your drawing that can add an extra dimension of interest to the picture. Whether the themes are quite subtle or very obvious, there's a certain playful interest in composing objects to give a storyline to the still life. The theme can be a wide-ranging idea, such as travel or sport, or you can narrow the focus to something more precise, such as a *vanitas* theme or the preparation of a meal.

Sometimes finding a particular object that you want to draw in context pushes the arrangement in a special direction; noticing the attractive shape of a child's tricycle led me to a drawing of toys as a theme, for example. Thinking about drawing very small objects prompted me to draw the contents of a pocket or handbag. Then again, you might want to draw one kind of thing but in many varieties, as Frans Snyders did in the vegetable still life on page 135.

So you can be as inventive as you like in your choice of a theme, because it will add quite a lot of interest for the viewer. Themes can have quite an obsessive quality about them, but this is part of their charm. They also act as an example of your expertise in drawing particular objects, which helps to showcase your talent.

Exploring themes

There are many themes which you can use in still life, and in this chapter I have suggested just a few of them to give you a starting point. Choosing a theme helps to focus the mind of the artist, because it limits the type of object that can be used. Also the viewer can find satisfaction in being able to recognize the connection between the objects. In a way a themed still life is like a narrative; it tells a story about a particular subject, which adds a point of interest that otherwise would not be there.

The first drawing shows the different forms of material that you can incorporate in a composition to show off your abilities in rendering texture. Here we have a basket with a wooden spatula leaning against it, a ceramic jug, a wine glass, a cloth tea towel and a metal saucepan. So in one still life you can show six or more materials, and if you are dextrous enough they will make an interesting picture.

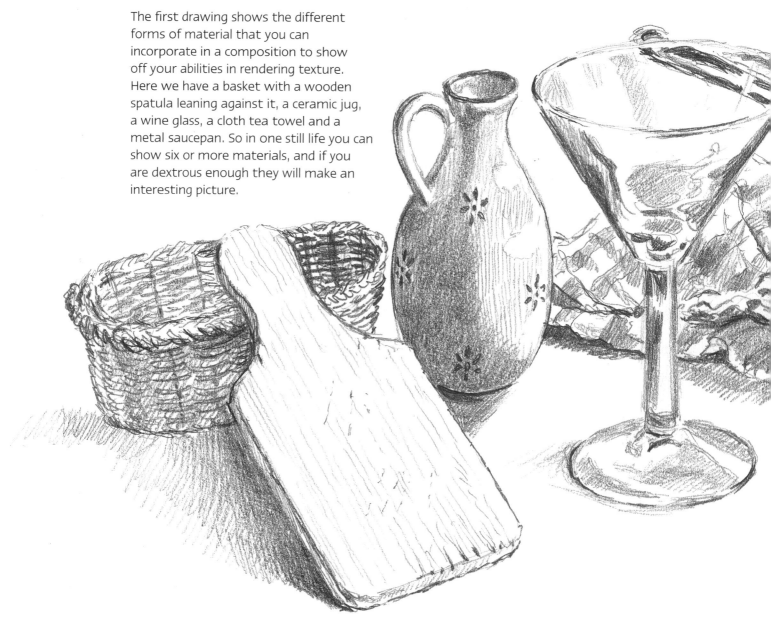

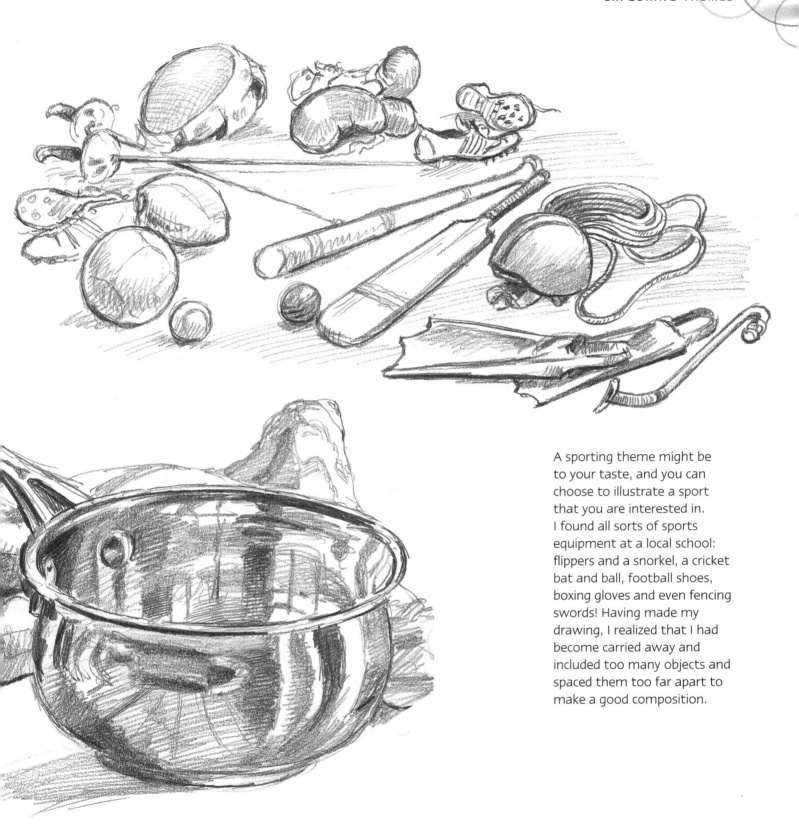

A sporting theme might be to your taste, and you can choose to illustrate a sport that you are interested in. I found all sorts of sports equipment at a local school: flippers and a snorkel, a cricket bat and ball, football shoes, boxing gloves and even fencing swords! Having made my drawing, I realized that I had become carried away and included too many objects and spaced them too far apart to make a good composition.

Next is a still life of children's toys, including a tricycle, a toy cat, a plastic duck, a toy car, a set of interlocking jars and a painted egg. There are many other toys that you could show in a composition like this. For example stuffed toys and dolls have a strong hold on the imagination, and the contrast between a large hard object like the tricycle and a woolly teddy bear would give a maximum textural range.

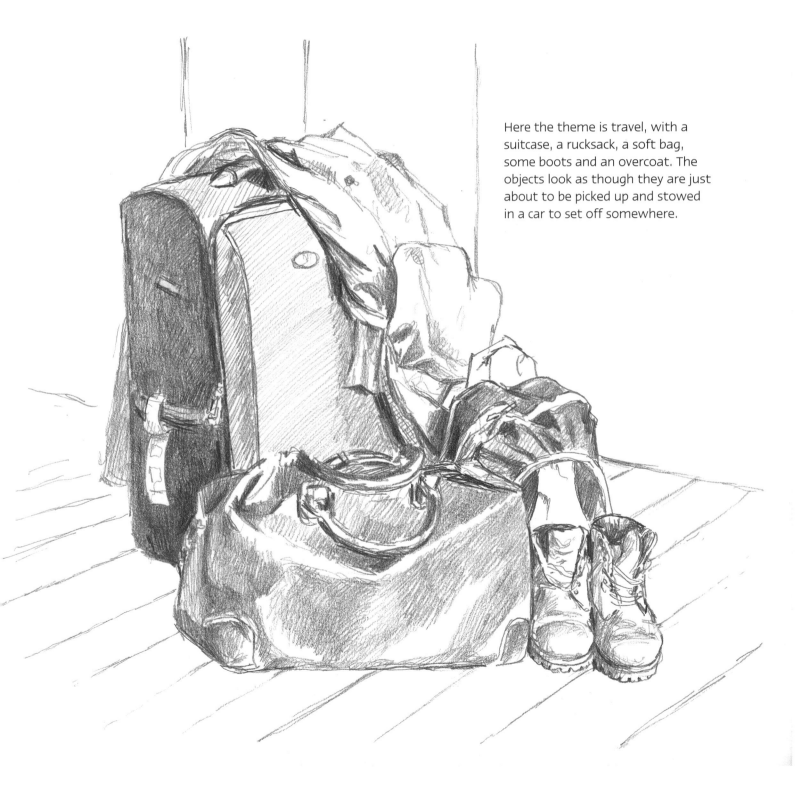

Here the theme is travel, with a suitcase, a rucksack, a soft bag, some boots and an overcoat. The objects look as though they are just about to be picked up and stowed in a car to set off somewhere.

A very popular theme for more traditional still-life artists is that of cooking. Here we see various items that may be used in the creation of a cake or pudding, or just as part of a larger meal. Again the variety of shapes and textures give you a chance to show how well you can draw.

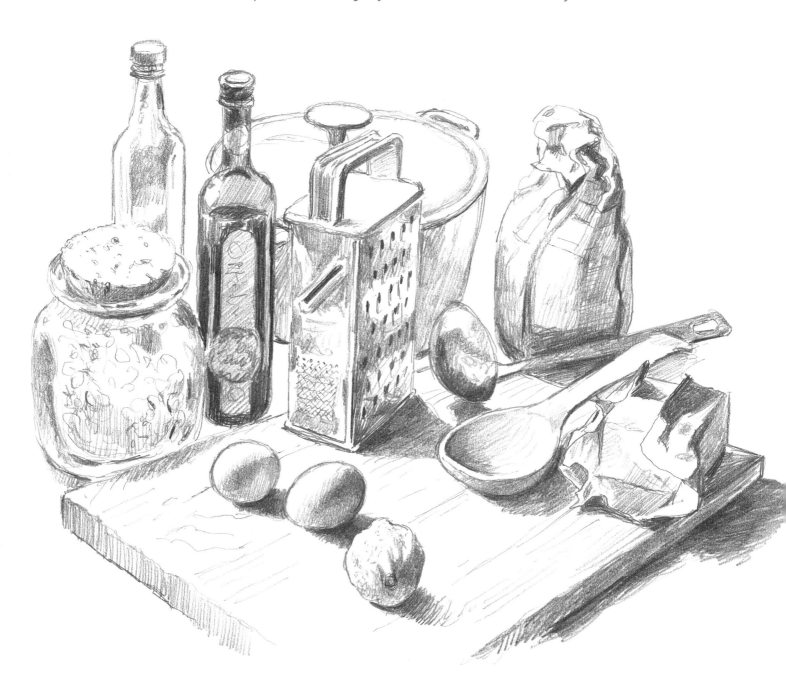

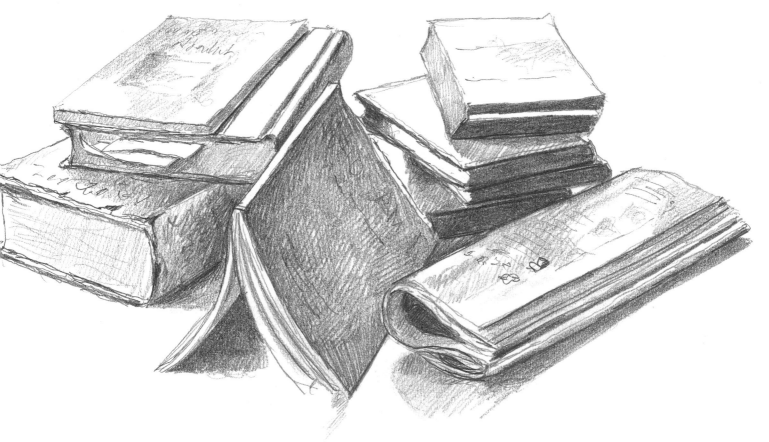

This still life consists of just books and paper and needed to be arranged quite carefully to make an interesting composition. It looks easy but in fact is quite difficult to draw convincingly.

An easy way to create a themed still life is to just take all the things that you keep in your pockets or handbag and strew them on a table. All the items will be on a small scale, so you will have to either draw them larger or work in the style of a miniature to get the best results.

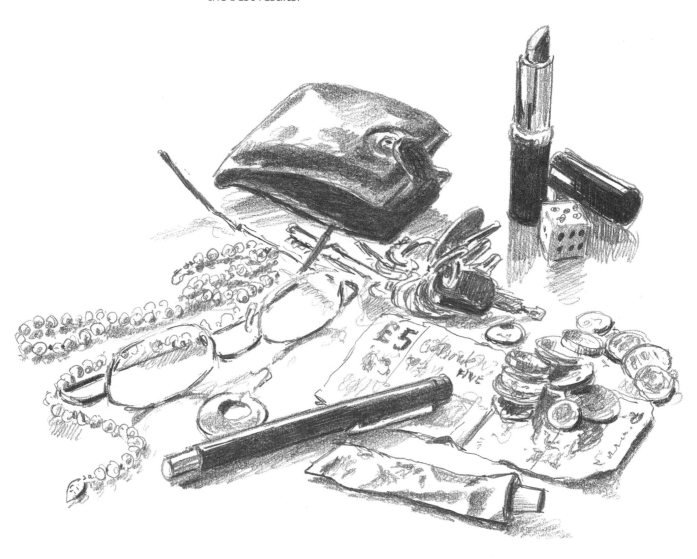

Food is another frequent subject with classic still-life artists, and a good pile of fruit, vegetables, cheese, meat, bread and wine will make a cheerful-looking composition. Add a few jars as well and other groceries such as eggs – the main thing is to bring out the richness of the variety.

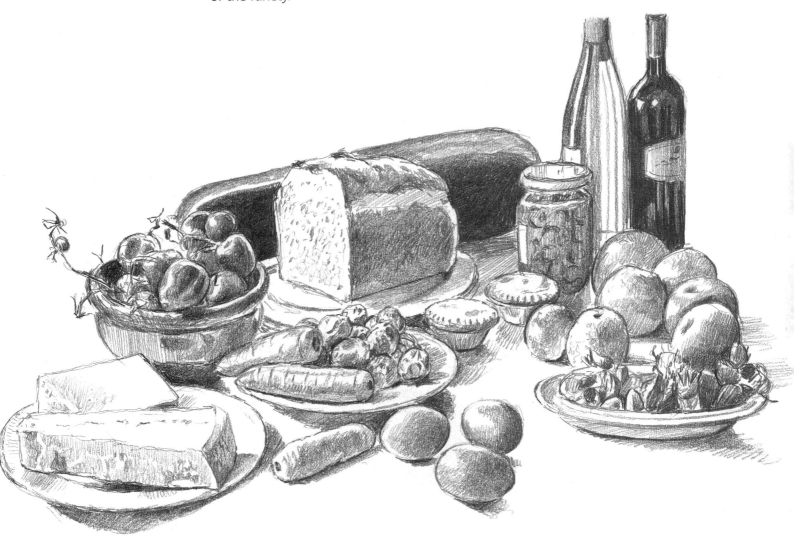

Master examples

William Brooker (1918–83) was a very talented still-life painter, specializing in groups of similar objects pushed together on a table, which he painted with great accuracy, very straight on and objectively. In this one he places all the objects at one end of a small table, which has the effect of making the space very significant.

Here Van Gogh (1853–90) shows fruit in a basket, a bottle and a bowl all set on a cloth. The heap of fruit makes a lateral thrust, while the bottle sticks up towards the top edge of the composition like an exclamation mark.

The *vanitas* still life

Vanitas pictures remind the viewer that happiness, earthly possessions and indeed life itself are transient; death is inevitable. The objects within them have symbolic meanings and there is often religious iconography. The genre reached its zenith in the Netherlands in the 16th and 17th centuries, but *vanitas* paintings were common in medieval times and artists today still produce them, even in our more secular age when our lives are longer than people could expect in earlier centuries.

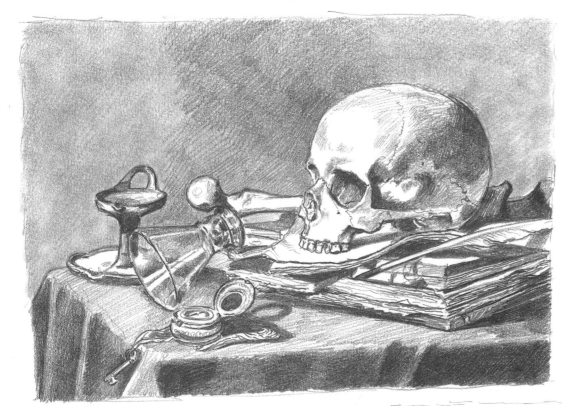

◁ This *vanitas* picture, after 17th-century Dutch painter Pieter Claesz, is dominated by the human skull, a common feature in this style of painting, and what looks like a thigh bone.

▷ Another *vanitas*-type picture, after another Golden-Age Dutch painter, Harmen Steenwijck (*c.*1612–56), shows a rather tight grouping of objects including a samurai sword, shells, books, pipes, a candlestick and a leather bottle, all piled together on the corner of a table, as though they might be swept off at any moment.

The arts and music

Artists are naturally drawn to the themes of art and music for a still life.
In earlier times, when music could only be heard in the home by virtue of
someone playing an instrument, most cultured households would have had
several members able to provide musical entertainment. Consequently, there
was no shortage of instruments to form a still life – and for objects connected
with the theme of art, all painters had to do was look around them.

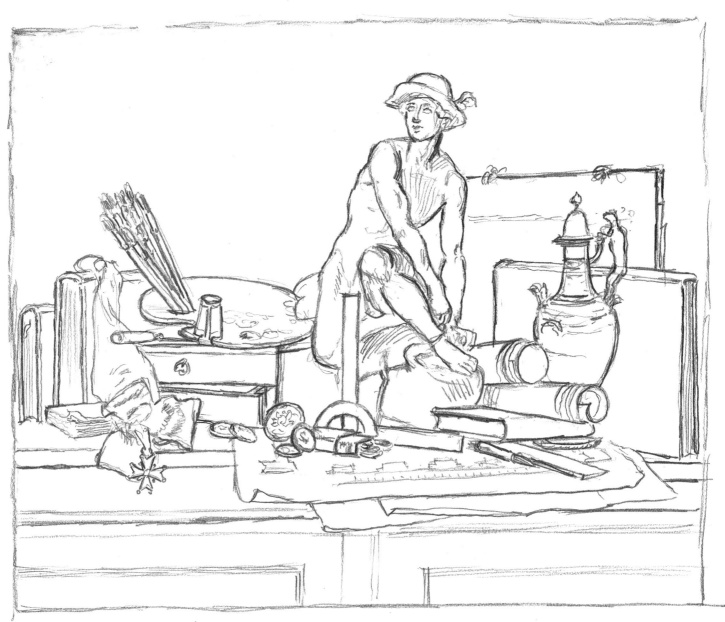

Jean-Baptiste-Siméon Chardin (1699–1779) was a very famous still-life painter in
18th-century France, and here he is taking as his theme the attributes of the arts. The
whole group is presided over by a statuette of Mercury or Hermes. This type of symbolic
theme was very popular at the time.

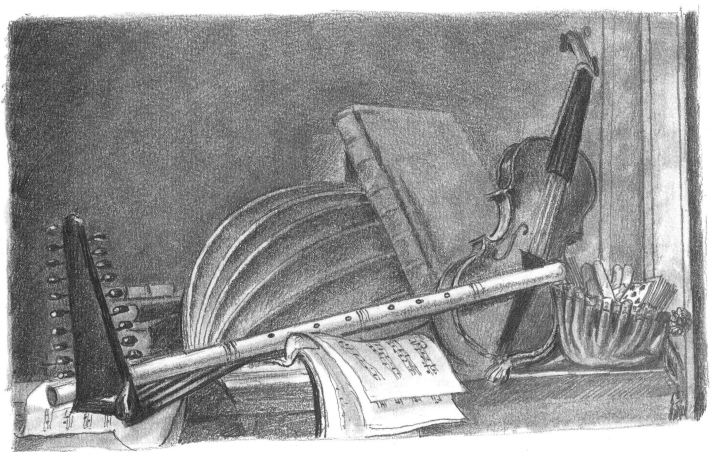

Music was a very popular subject for a still life in the 17th and 18th centuries, possibly because there were so many new varieties of instruments being designed and made. This is an example after the French artist Pierre Huillot (1674–1751).

Here is a still life that puts simple vegetables centre-stage, but as you can see the 17th-century Flemish painter Frans Snyders (1579–1657) has done his subject justice, producing a rich, crowded composition.

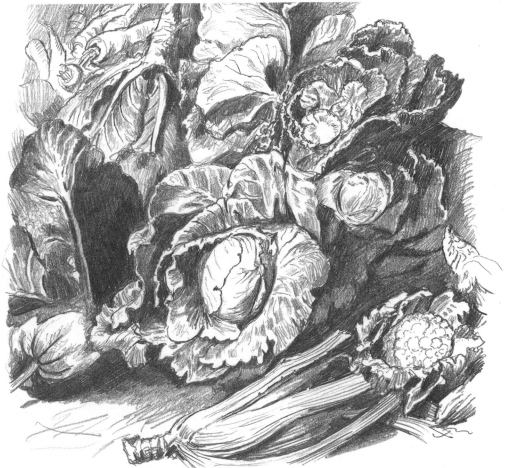

PROJECT 7

Themed still life

As you might expect, I chose for my themed still life a set of artists' materials, so here I have put together a palette, some brushes and palette knives, some paints, a couple of canvases and bottles of painting mediums. At the last moment, I added a pomegranate just to give a different shape to the scene.

▲ My first drawing is a very rough outline of the composition to see if it would work as a picture. I stood a canvas and a small picture frame against the back wall, then placed a palette bang in the middle of the background to help set the scene. In front of this I placed a jar full of paintbrushes to make a more vertical statement. Next to it is a jar of pencils and a couple of bottles of varnish and turpentine. Scattered across the foreground is a small canvas with a smaller frame under it, plus a few large brushes, a couple of palette knives and some tubes of oil paint. Just to the left of the whole arrangement is the pomegranate, but it could have been anything with a rounded shape, which I felt might be useful. So now I have got some idea of how the final composition will look.

My next task was to draw up the whole arrangement in line, making sure that everything was in proportion and the right shape. It's at this stage that you can erase any parts that don't look right and correct them, and I can't emphasize too much how important it is to continue correcting until you are satisfied with the results. This is the way that you improve your drawing systematically.

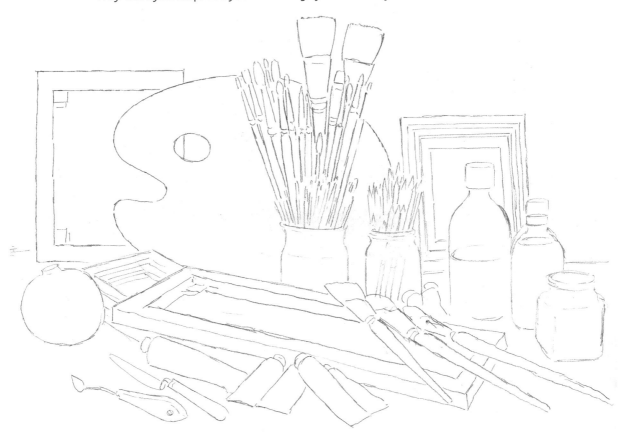

The next stage was to put in tone over all the areas that seemed to be in shadow of some sort without worrying at this stage how dark or light it was. This was simply to mark out the areas that read as tone.

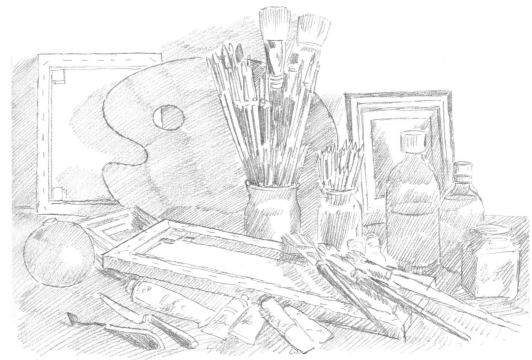

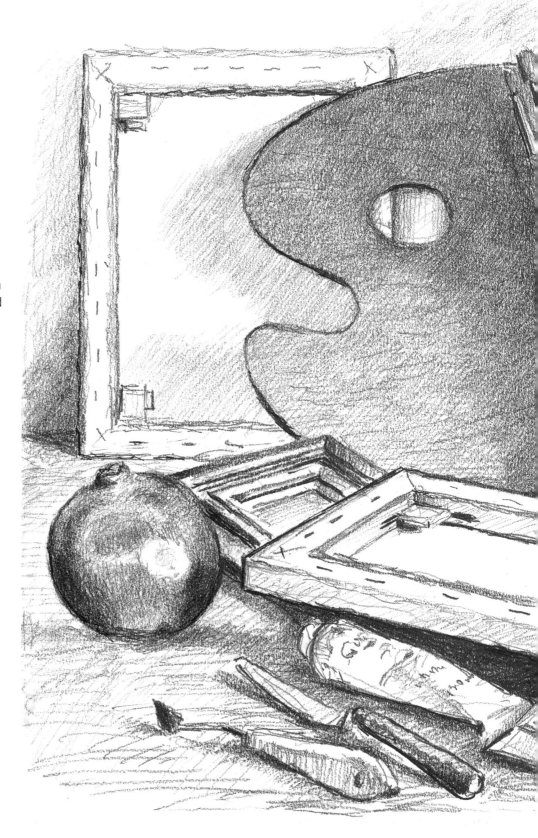

▶ Finally I deepened and varied all the tonal areas to suit what I could see. Some edges were much stronger than others, so I adapted their intensity by softening with an eraser or strengthening with darker marks.

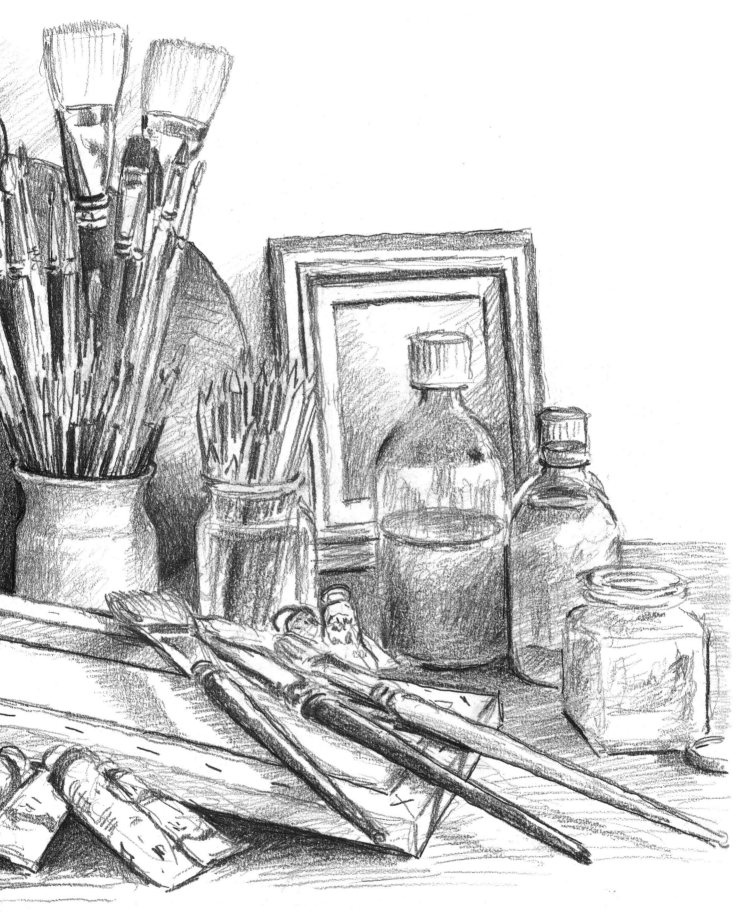

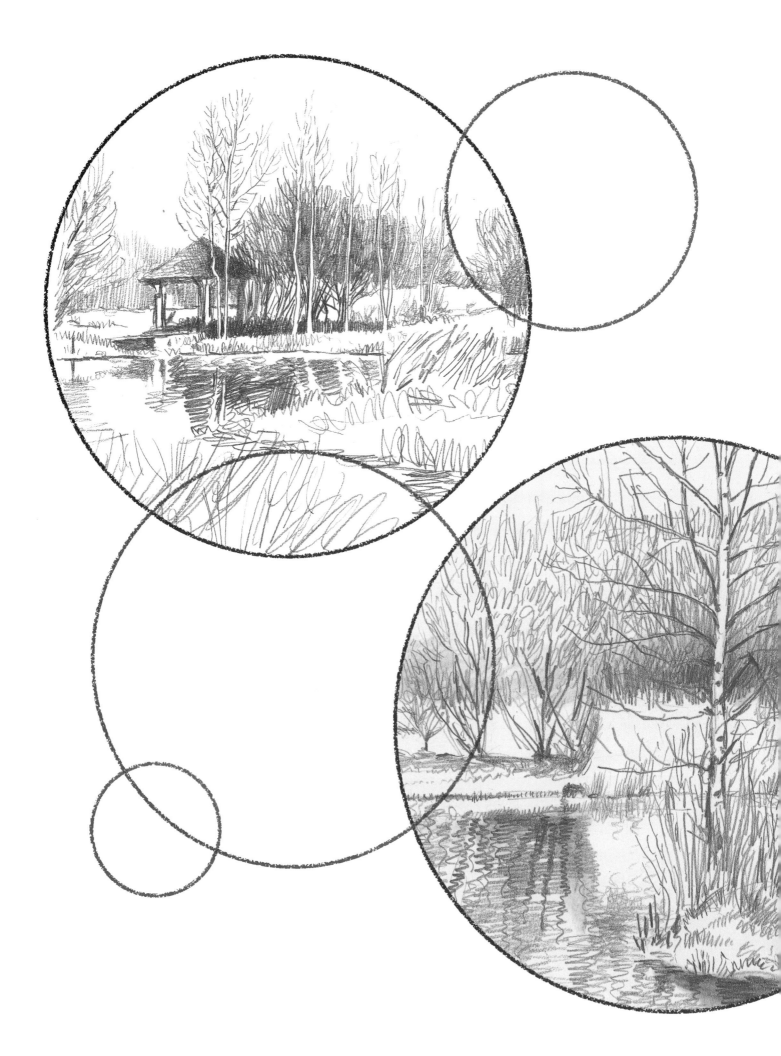

PROJECT 8: EXPLORING LANDSCAPE

This section of the book starts with a practice session, because landscape is an enormous and variable subject and any preparation for it will never be wasted time. What you'll soon notice is that landscape is all about textures, from the reflective surface of still water to rough grasses and rugged stony ground. You'll also begin to realize that what you draw on a small scale can be replicated on a larger one, which will give you confidence: if you can draw a foreground rock convincingly, you can draw a mountain too.

Looking through a frame made from a piece of card will help you to select a manageable composition from an expanse of landscape, which can be confusing at first. You may be lucky enough to have an enchanting rural scene close by, but if not there will probably be a local park or nature reserve that will stand in for a bigger view. However, if this is the case it won't be long before you want to make a journey to more open countryside, and you will need to make sure you are well-equipped. Arm yourself with plenty of well-sharpened pencils so that you do not have to keep sharpening your only one. A really good hard-backed sketchbook is also a good investment for this sort of work – and get yourself into the mood by drawing plenty of vegetation first to limber up for the moment of truth!

The textures of landscape

Before making a start on a larger scene, it is useful to familiarize yourself with some of the elements of landscape, including grass, plants, stones and water. None of these exercises is purely observational, but they use techniques based on observation to build up the textures you'll need for landscape drawing.

1 In this first exercise the method is to scribble lines outwards, without taking your pencil off the paper, until you have built up a mass of texture that rounds out into a bush shape. Then strengthen the marks significantly around one side to give a sense of depth.

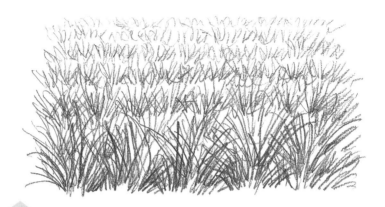

2 The second practice produces the effect of an area of grass, again using simple scribbled marks. Working from the bottom upwards, gradually reduce the strength and the depth of your marks. This gives the impression of tufts of grass receding into the distance.

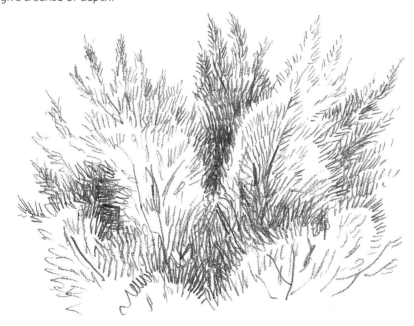

3 This drawing of a pine tree uses simple pencil strokes to represent the texture of the foliage. Note how I have put in some marks that resemble branches, to help show the structure of the tree. In some parts I have made the marks darker to denote deeper shadow.

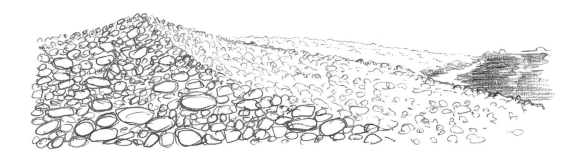

4 Now we move on to a pebble or stony beach, where you have to be patient enough to draw lots of pebble shapes of varying sizes. The closest pebbles are drawn strongly and in some detail. On the far side of the ridge of stones, draw marks that look less definite and appear to be only the tops of pebbles, to give the impression of distance.

Moving on to the sea itself, this scene shows the ripples of waves as they recede to the horizon, where they become just a strip of tone. Draw the wave shapes in undulating horizontal lines.

5

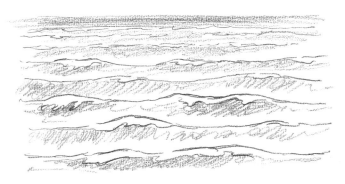

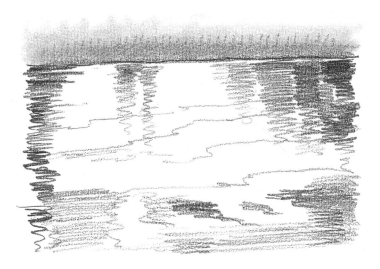

6 This pond water is less agitated than the sea. To achieve the glassy quality of the still water, lay your marks down smoothly in horizontal strokes, leaving areas of light, and put in darker tones around the edges.

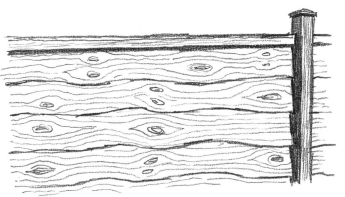

7 The final exercise is to look at the texture of a fence. Mark in the main structure and supporting post first, then draw in the planks with wavy lines, and some knot-hole shapes at various points on the planks.

Framing your scene

When starting out to draw a landscape, one thing
that is very useful is a carefully cut window frame
shape, roughly the same size as the paper that you
are going to draw on.

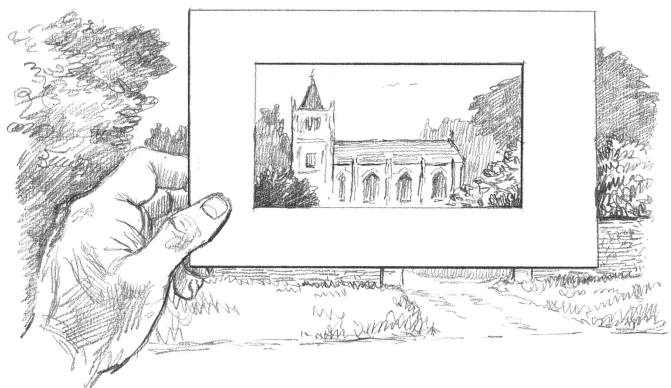

As you can see in this drawing, the size of your frame should be
big enough to get a reasonable aperture, but not so big that it is
difficult to handle. You can make the frame out of card for longer-
lasting quality, but stiff paper is usually good enough.

The framing device helps you to select from the amazing mass of
information that your eyes normally see, and decide exactly how
much of the landscape you want to draw. This decision is crucial to
getting a good result, and with practice, it is possible to make your
selection without the framing aid. But it is a good idea if you are a
beginner, and even professional artists use one sometimes.

Exploring landscape

This short project is intended to get you thinking about how you might start a landscape proper away from home. I took a short trip to a wetlands nature reserve beside the River Thames in south-west London. The environment is especially dedicated to the flora and fauna of watery and marshy places, so although it isn't quite wilderness, it has a natural feel.

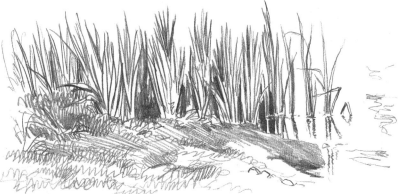

▲ Initially I just wandered along and chose anything that seemed to be typical of the reserve. First I drew this clump of reeds beside the water, concentrating on the clusters of stalks as they rose out of the ground.

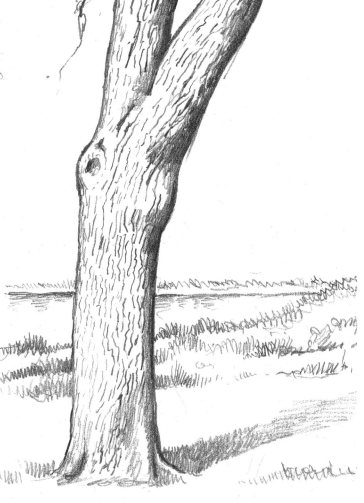

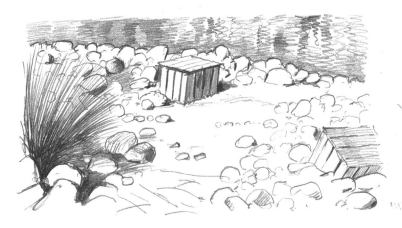

▲ Next I came across an area where the terrain was mainly lumps of rock and stones, with a few boxes for nesting purposes and some reeds – quite a different feel to the previous scene.

▲ Then I concentrated on the bark of the trunk of a tree that was near the water. All these exercises got me into the experience of drawing in this type of place, with its varying forms and textures.

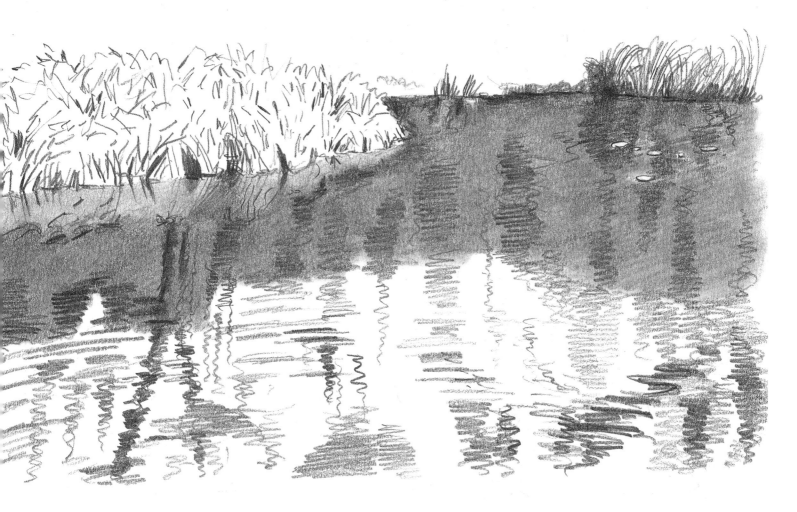

▲ Then I decided to try out two examples of water, getting a feel for the texture of its surface and how the reflections appeared when seen in different lights. The first, which is a sheltered spot of water, has many reflections that are distorted just a little by the ripples.

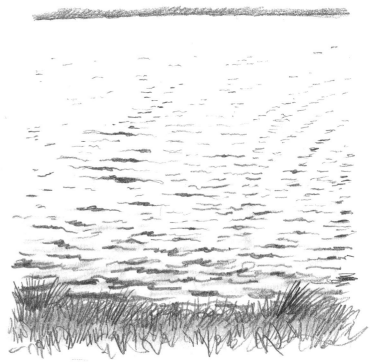

▷ The other stretch of water was more open and had many ripples across the surface, but because of the angle at which I was viewing it there wasn't much in the way of reflection.

▷ Next I began to consider the scene as a whole. Using my framing device to select a view, I drew this little wood cabin with trees around it and a path leading up to it from a bridge over the stream. There's a slightly more solid, hard-edged look to the scene.

▽ Then I looked at this rather more open expanse of stream and small trees, where there was another small shelter and a wooden bridge. The myriad streams threading through the landscape are more obvious here.

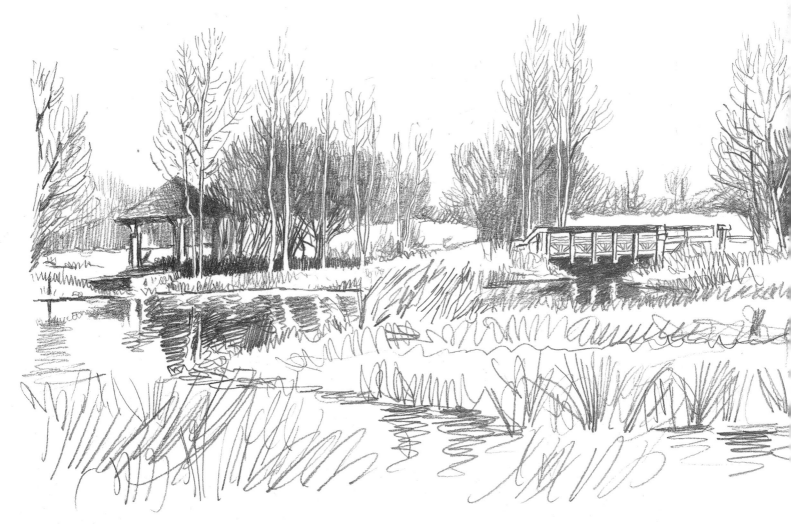

PROJECT 8
Exploring landscape

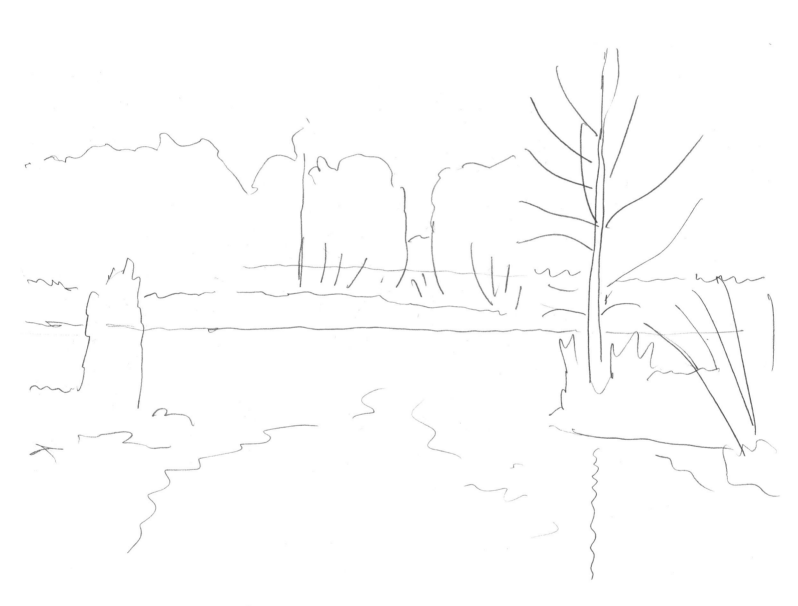

▲ Finally I decided to opt for this view across an expanse of stream with many silver birches and other marsh-loving trees scattered along the banks. At first I sketched in the main areas of the composition very simply so that I knew how much I was going to take on.

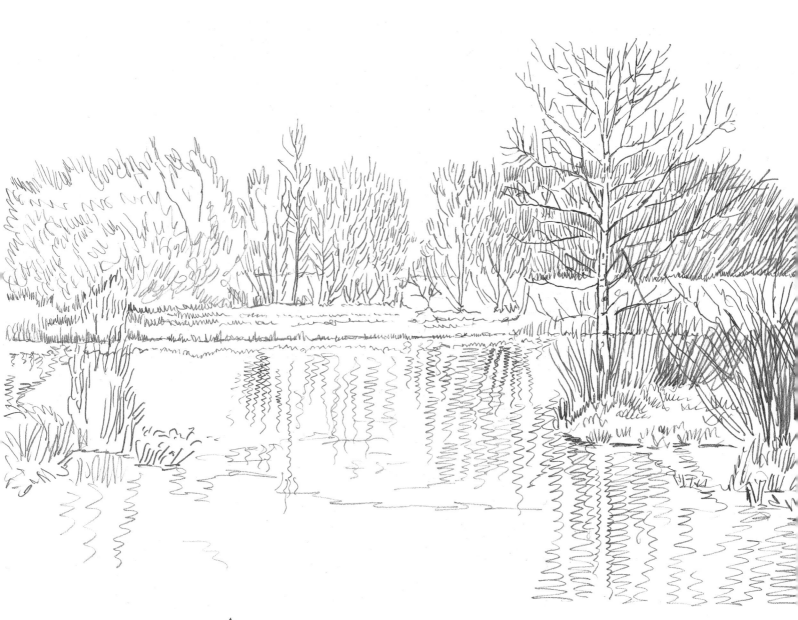

△ Then I worked up the details of the trees and the water in a linear fashion so that I had the whole scene drawn up clearly and could make any alterations as I felt necessary. The water was marked with zig-zagging marks to indicate where the deeper reflections were on the water.

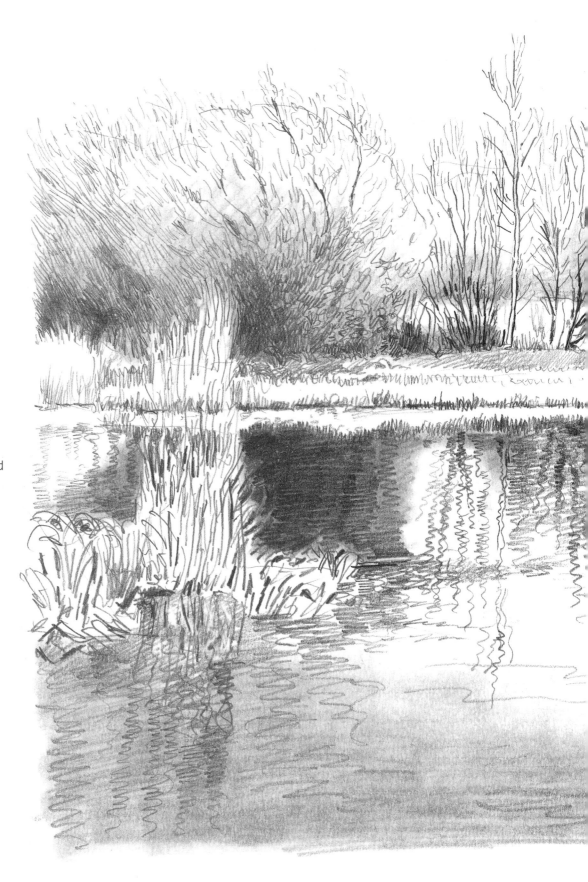

To finish the drawing I carefully put in the tonal values so that the water and trees began to show more depth and spatial qualities. This is quite a simple scene in terms of composition, but the flimsy quality of the winter trees where I could see through their branches was quite a challenge – a very light touch was needed. To achieve the smooth tonal quality of the water I used a very soft pencil (7B) and smudged the marks with my finger.

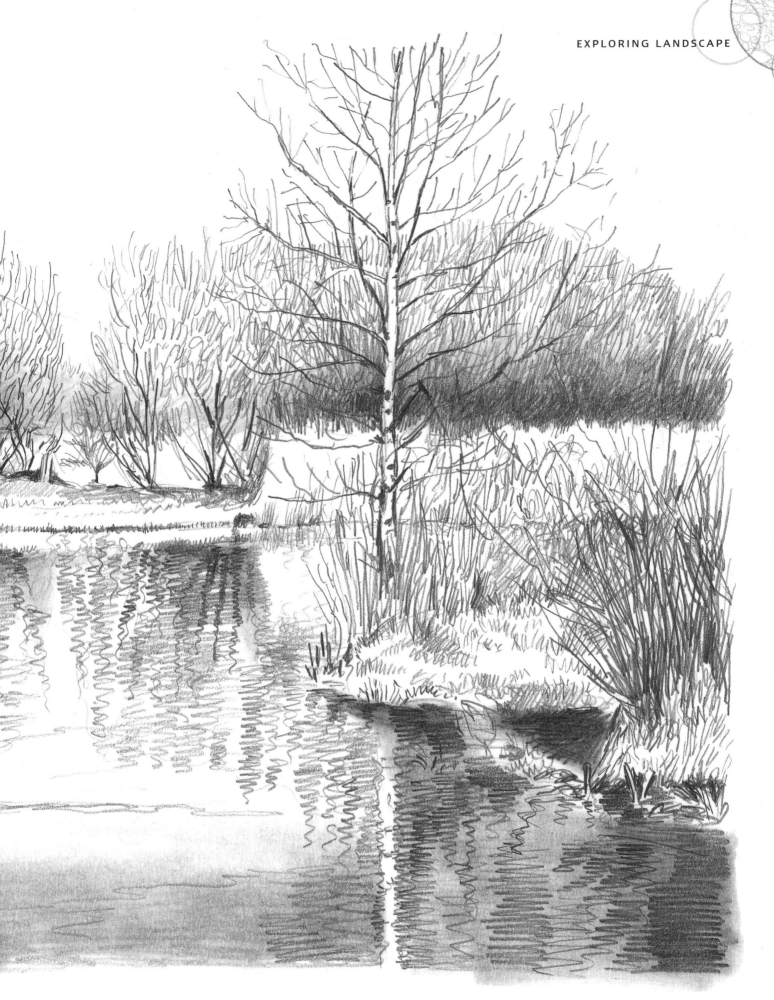

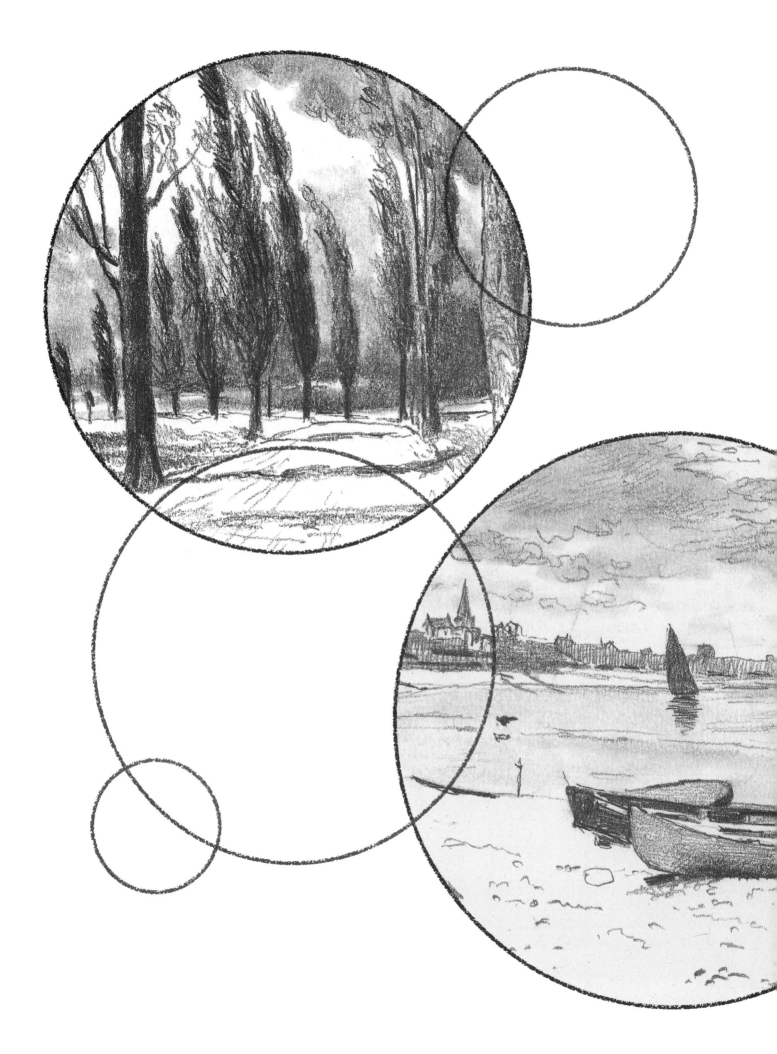

PROJECT 9: LANDSCAPE COMPOSITION

This section is all about getting to grips with the composition of a landscape. Although it might seem that you don't really need to compose a landscape as it's already there in reality, you do indeed choose your point of view, eye level and the expanse of the scene. Dividing the view into background, middle ground and foreground will help you to deal with the immensity of open areas of countryside.

Of course there are many different types of landscape, from great mountain ranges to woodlands and fens. However, most of us don't live in such wild places and the best time for tackling landscape drawings tends to be when you go on holiday to somewhere totally unlike your normal environment. Holidays are a brilliant time to get really stuck into some serious work with your pencil and sketch pad.

There are many ways of approaching a landscape, and your own particular view is part of the interest that your drawing will create. A very high eye level or a dramatization of one part of the scene are both valid approaches for an interesting composition. Expanses of calm or turbulent water, large trees and stunning rock formations all bring extra power to your drawing, so make the most of any unusual landscape you come across – but don't feel deterred by more mundane terrain, as the way you handle it can equally catch the viewer's eye.

The structure of landscape

Before you start to draw a larger and more complicated landscape from life, it's advisable to consider how it can be approached schematically. The first point to realize is that in any large open landscape, there's an area of sky with the background immediately below it, then the middle ground and finally the foreground. The horizon line is the edge of the background against the sky.

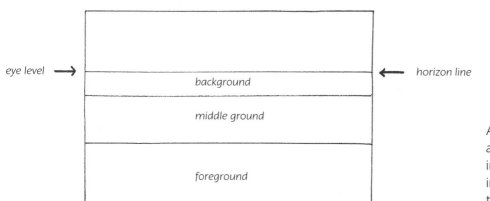

As in my example, parts of the foreground and middle ground will sometimes project into the areas behind, like the large tree in the middle ground that reaches up into the sky.

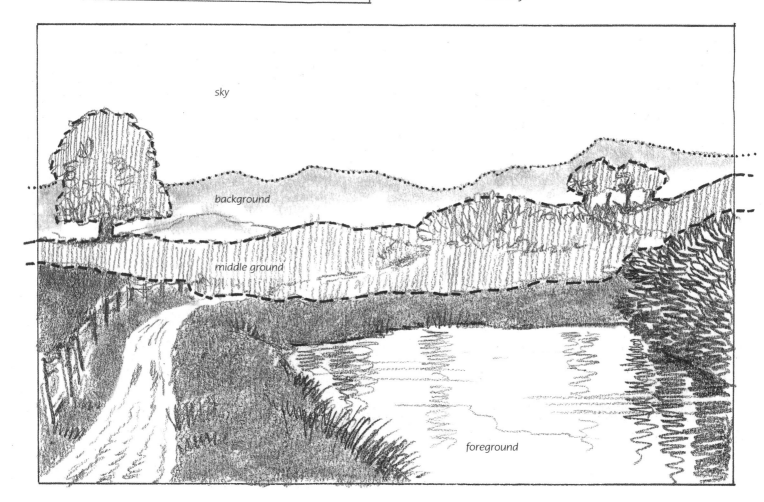

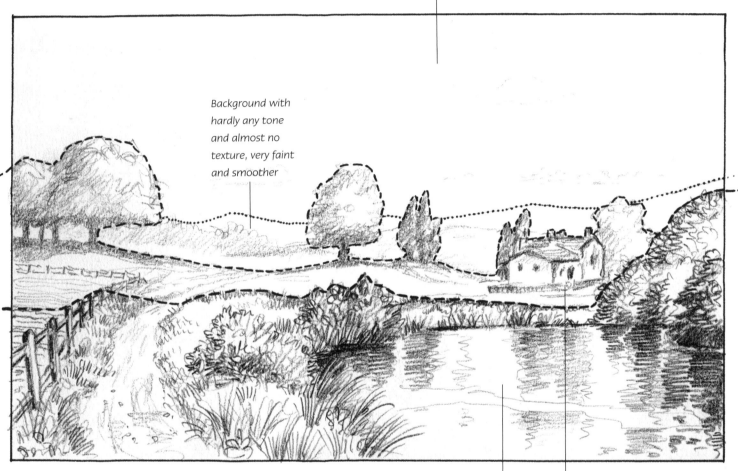

Sky can be considered as part of background

Background with hardly any tone and almost no texture, very faint and smoother

Middle ground with tone and texture but softer and less intense than the foreground

Foreground with intense tone and contrast and strong textures

In this next version of a landscape we're also aware of the fact that the background area is very faint and without detail or much texture – in fact in places it's almost as light as the sky. The middle ground has a little more definition and texture, but still not much detail. The foreground has the greatest definition and the most texture and intensity of detail. This is a result of what is known as aerial perspective, where atmospheric haze makes landscape features at a greater distance appear much less defined than those in the foreground.

Types of landscape

The never-ending interest of drawing landscapes is that there's such a variety of forms, textures and compositions encompassed by the genre. While we all have a particular type of landscape that calls to us the most, it's always possible to find a scene that sparks off a drawing. Over the next pages we'll look at various landscape compositions, some after master artists and some my own.

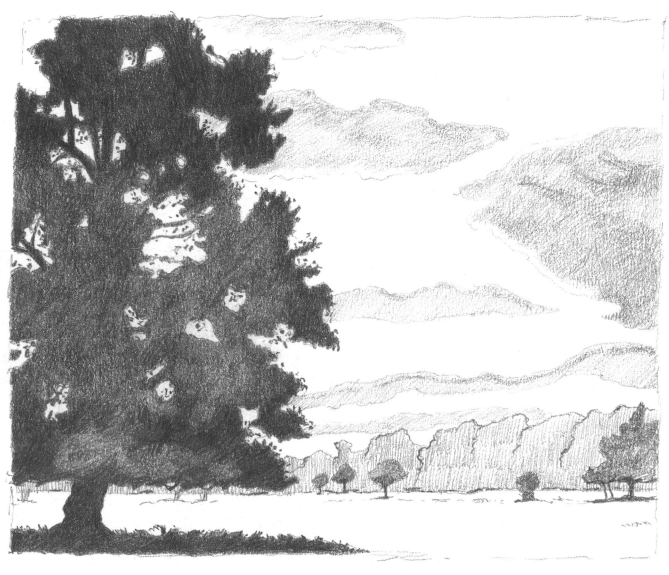

Our first example is of a large tree that dominates the foreground and in fact the whole picture. The sun is rising behind it so bright patches of light can be seen through its very dark silhouette. The fact that this tree stretches from the top to the bottom of the picture and takes up almost half of the composition means that the rest of the landscape is subordinate to it. Indeed, the picture appears to be mostly background – though the expanse of the field behind the tree is middle ground, it's not very obvious. The row of trees in the background is not much more detailed than the sky, and here the clouds play a big part in the composition. The complexity of this composition is subtle and depends on your ability to draw the clouds interestingly enough to contrast with the dominant tree.

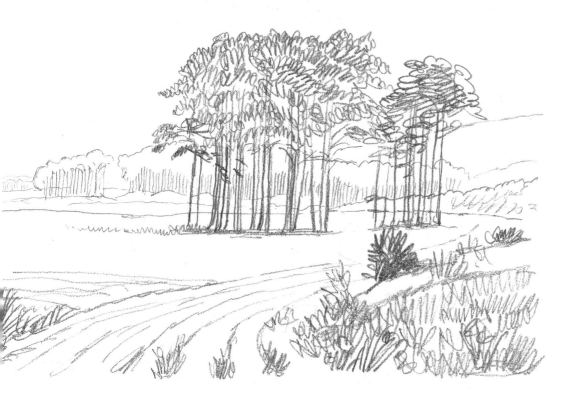

The next picture is of a landscape in which the main feature is again trees, but this time a group of them in the middle ground. A curving path extends from the forefront of the composition and swings around behind the trees, helping to pull the viewer's eye into the picture towards the main feature. Behind that is a row of low hills covered in vegetation with a bank of bushes in the near foreground.

The third scene is of a mountainous landscape with rows of rocky peaks in the background, similar terrain in the middle ground and scrub-covered lumps of rock in the foreground. The great difficulty in a scene like this is to show the difference in distance between the nearest outcrops and the distant mountains. If you're lucky there'll be some light mist between the further ranges and the middle ground outcrops, as in this picture; if not, rendering the texture and detail well-defined in the foreground and lessening towards the background is the best way. Notice how in this example the view has been selected so the nearest mountains are shown to the sides of the picture, and the furthest mountains are most prominent in the centre of the composition.

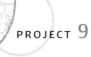

Here's a composition rather like the first example on page 156, in which a very large tree in the foreground tends to dominate the scene. However, unlike the first picture, the lines of the ploughed landscape pull the eye into the scene and lead it into the background hills and woods. The structure of the main tree is very evident here and becomes the most interesting part of the drawing.

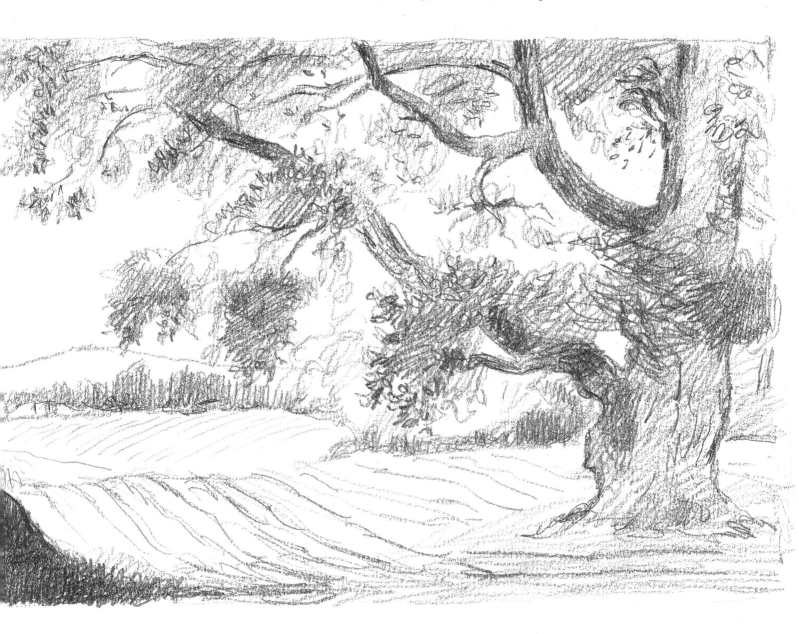

The next scene is primarily about the water in the foreground and how it reflects the rest of the scenery in the surface. The middle ground is mostly trees with a gap opening up the background to one side. As the lake takes up half of the whole composition it's quite important in the drawing and the reflections need to look convincing.

These two compositions are after the Viennese painter Gustav Klimt (1862–1918), who specialized in decorative effects. They complement each other, the first having most of the scene made up of the grassy foreground and the other with the picture composed mainly of the massed leaves of the trees. Klimt tended to reduce the depth of his paintings to flatter, more abstract areas of texture, and in the first example the large area of grass is given a little depth only by the spaced silver birch trees and the mass of dark trees in the background.

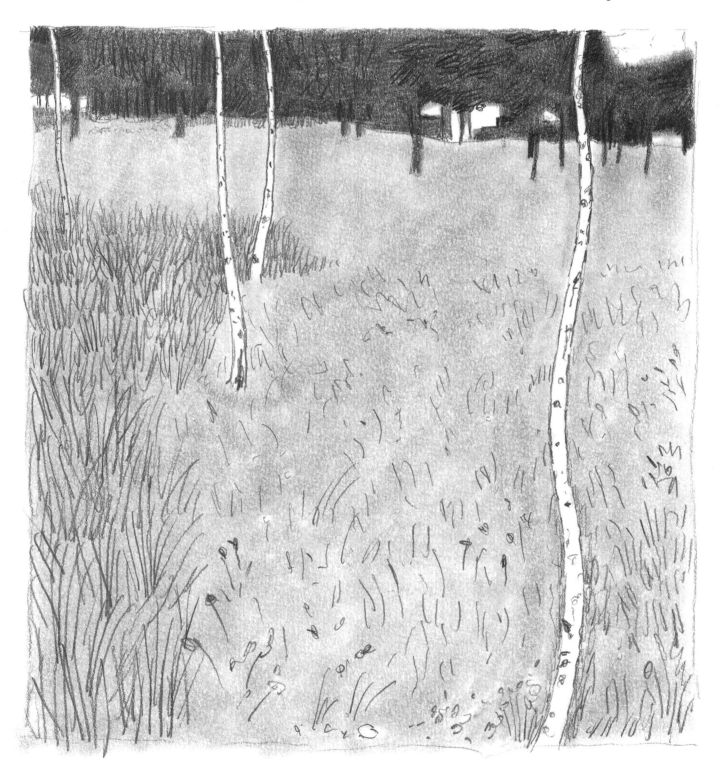

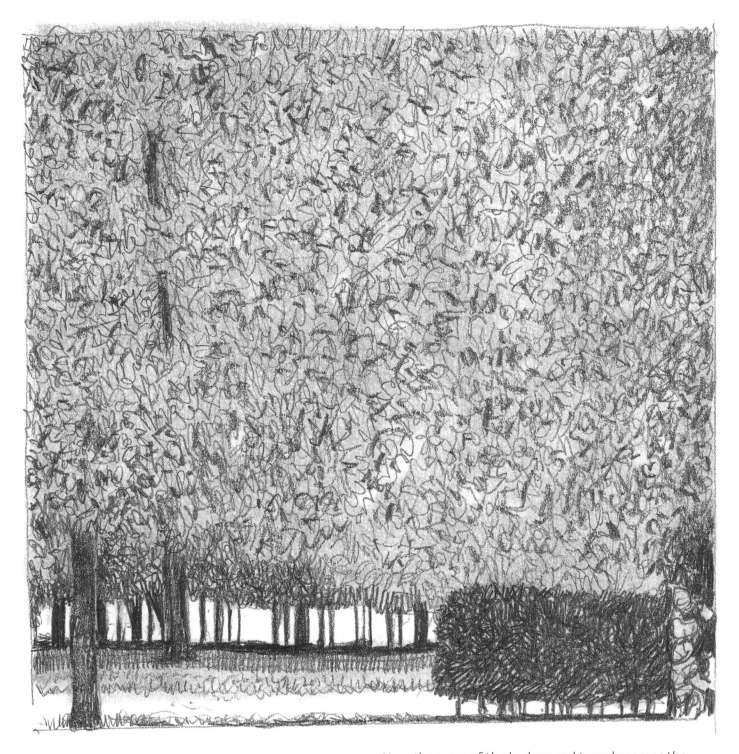

Here the mass of the background trees becomes the main area of the composition, while the foreground and middle ground are squashed into a very small area at the bottom. These effects give quite a dramatic quality to the landscapes, and the texture of the grass and leaves in both is treated in a very decorative way.

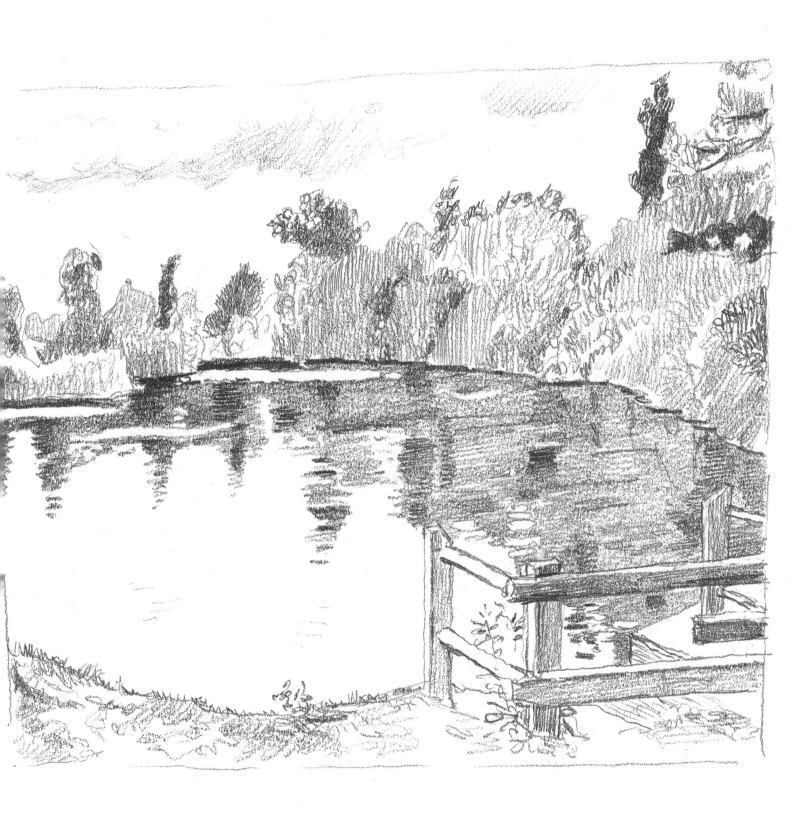

The scene on the left is another one in which water is the dominant feature, but this time it's given added depth by the device of including some ground and a small piece of fencing in the foreground. The main middle ground and background curves away on the other side of the lake, disappearing in a mass of reeds and vegetation over on the far left. Once again the reflection in the water is the key to this composition.

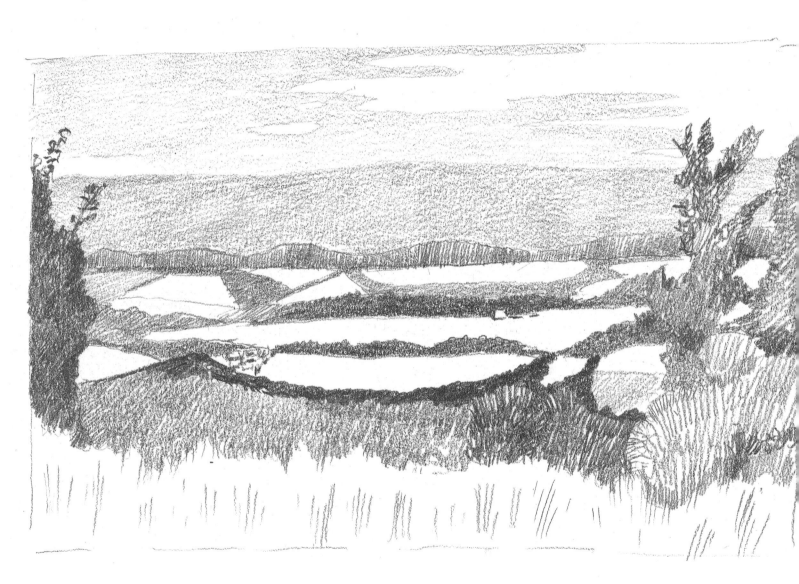

The following scene is less dramatic but, treated carefully, this kind of wide, open landscape can give a very good feel of depth in the picture. The foreground is composed of the tufts of grass and bushes on the edge of the hill that I was drawing from, which gives a good view over the fairly flat countryside stretching off into the distance. Behind that is a large area of dark cloud, above which is a lighter, more streaky sky. The texture of the bushes and grass in the foreground is important to give the right effect of space.

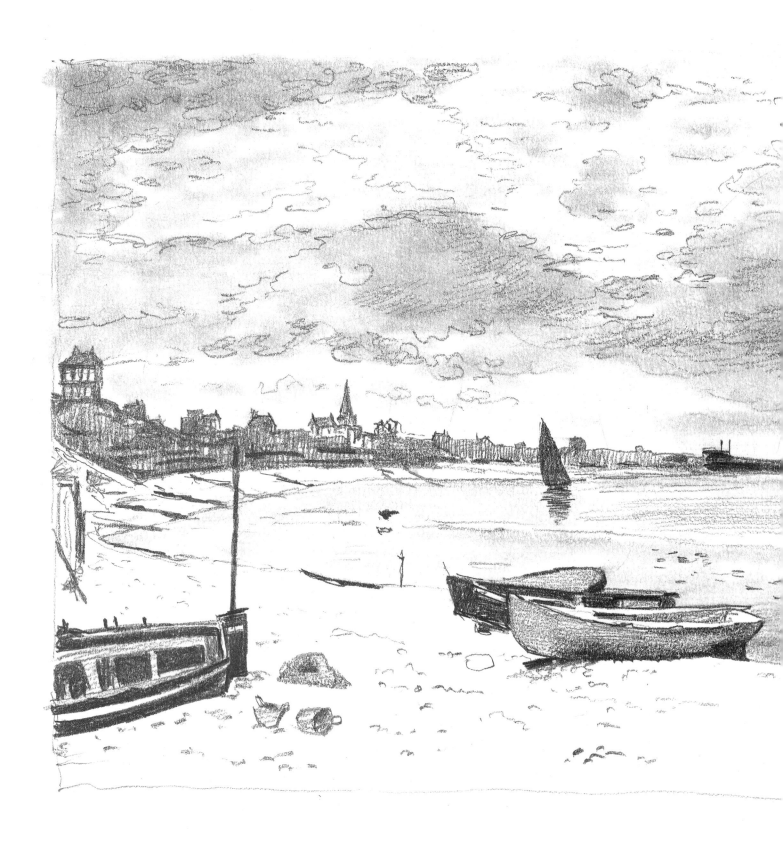

In the landscape below the main theme is the avenue of trees along the road, taking the attention of the viewer into the centre of the picture and disappearing into the dark clouds covering the lower parts of the sky. In this picture the stormy sky in the background is in fact the element that is brought to your attention by means of the avenue leading into the distance.

On the left is a version of a Claude Monet (1840–1926) painting of a beach, from which I have removed all the people to show how the landscape itself takes your attention from the foreground sweeping away around the bay to the distant horizon of the sea. The boats drawn up on the shore in the immediate foreground grab the attention first and as the coast leads the eye around we see the middle-ground dinghy and then, in the far distance, what appear to be more sails out at sea. The sky in this composition takes up half the space and is important, with its dappled cloudscape making a contrast to the lower half.

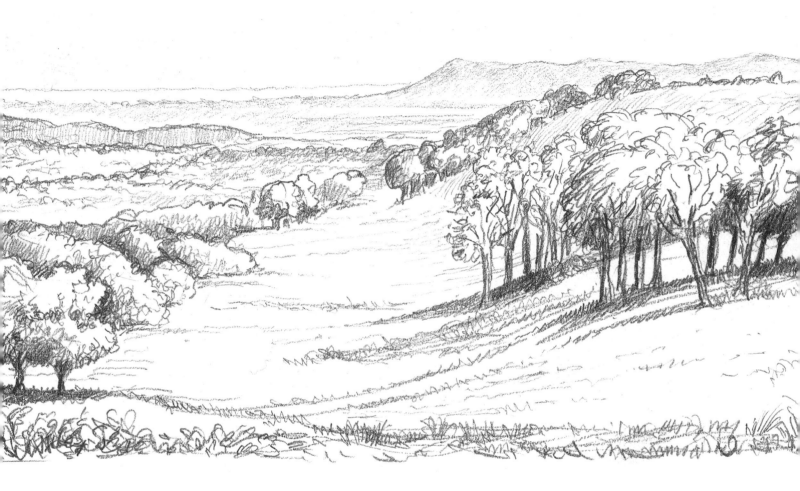

In the next two examples we have (left) a stretch of river taking the attention into the scene and (above) a stretch of open countryside pulling the attention into the distance of a hilly wooded landscape. Both devices are there to draw the attention into the picture with the masses of trees to either side acting as directional movements through the scene, enclosing our view. In the river scene the reflections on the water play a prominent part in attracting the viewer's attention, whereas in the other the mere open space in the centre of the composition is the place where the eye comes to rest. The river lures the imagination to consider what is round the corner of the stream, while the open space takes the attention towards the far-distant hills of the landscape.

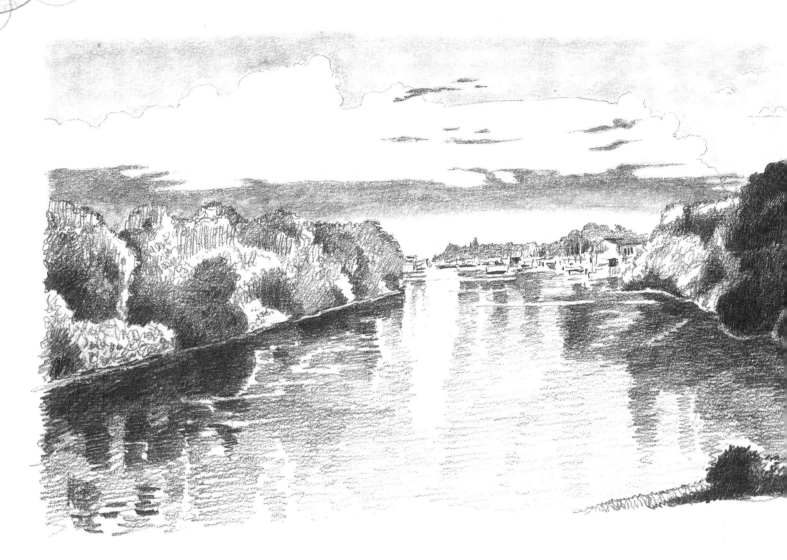

In this scene the river is pulling the eye towards the distant scenery, but the dramatic cloudy sky above seems to stretch our attention sideways to consider the breadth of the space. This sky with its reflection in the river surface is quite effective in opening up the space in the scene. The arrows in the diagram on the right show the direction the eye takes when reading the image.

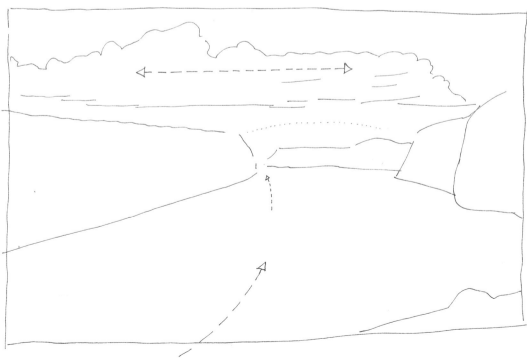

The next scene, of the dramatic coast in Dorset, England, is more complex. The centre of the composition is the circular inlet of the sea in the rocky cliff face. All the lower parts of the picture seem to indicate the direction towards this centre. The cliffs immediately above the pool also move the eye down to the water. The sky above and the slanting line of the cliff top with its row of trees and the distant downland all move the attention towards the centre line of the cliff face which dips down towards the edge of the pool.

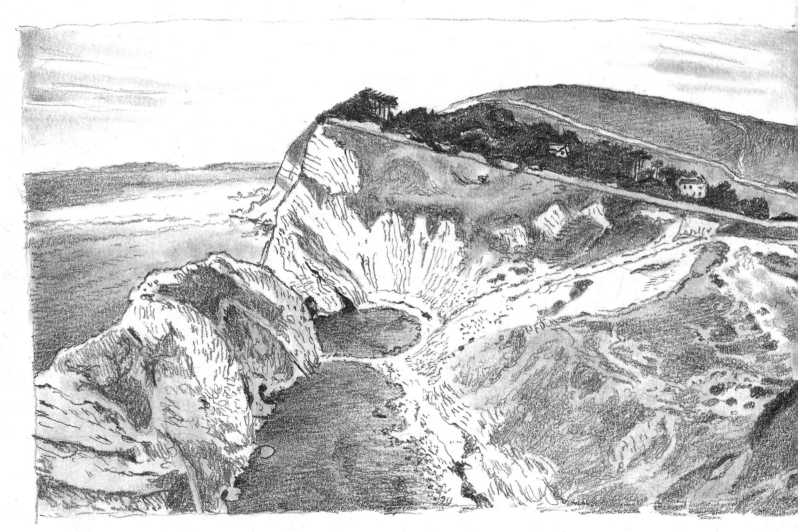

This drawing of the English Lake District has a similar effect to the coastal scene on the previous page in that the rocky edges of the lake all seem to draw our attention towards the water. The water appears to swing around the edge of the rocks, while the activity of the clouds swirls around to bring the eye back to the centre of the scene.

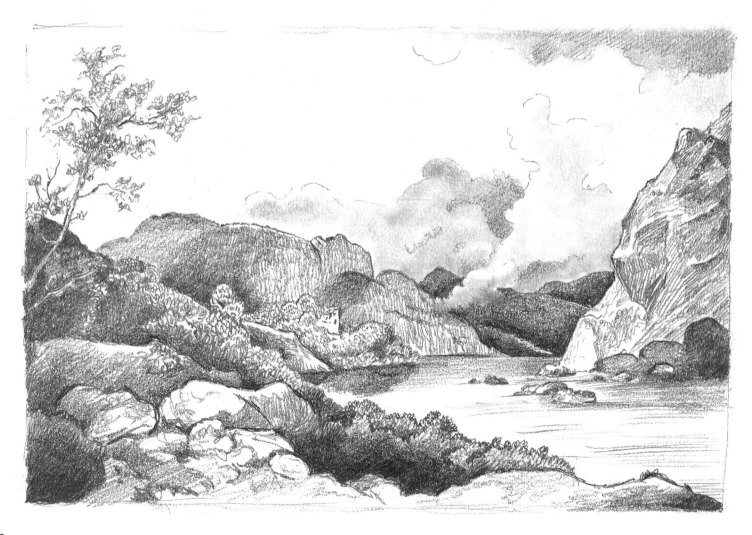

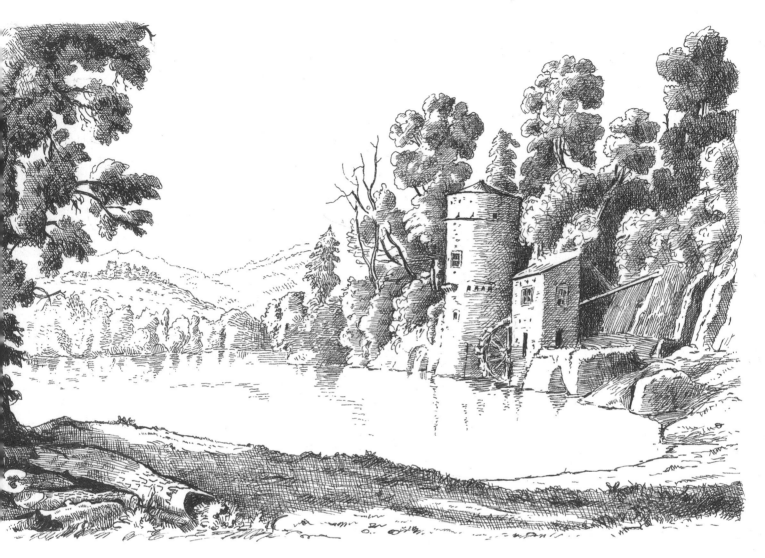

A lakeside scene after Claude Lorrain (1602–82) is slightly more complex, as you would expect from this master of landscape. The big tree on the left hems in our vision, while the foreground pulls our attention towards the area of the water. The outline of the distant landscape and the large trees sweeping down to the river on the right also concentrate the eye on the water. However, the key element is the strong vertical tower built on the riverbank which holds our attention for contemplation. This is the real centre of the piece and everything else tends to pull our attention towards it or across it.

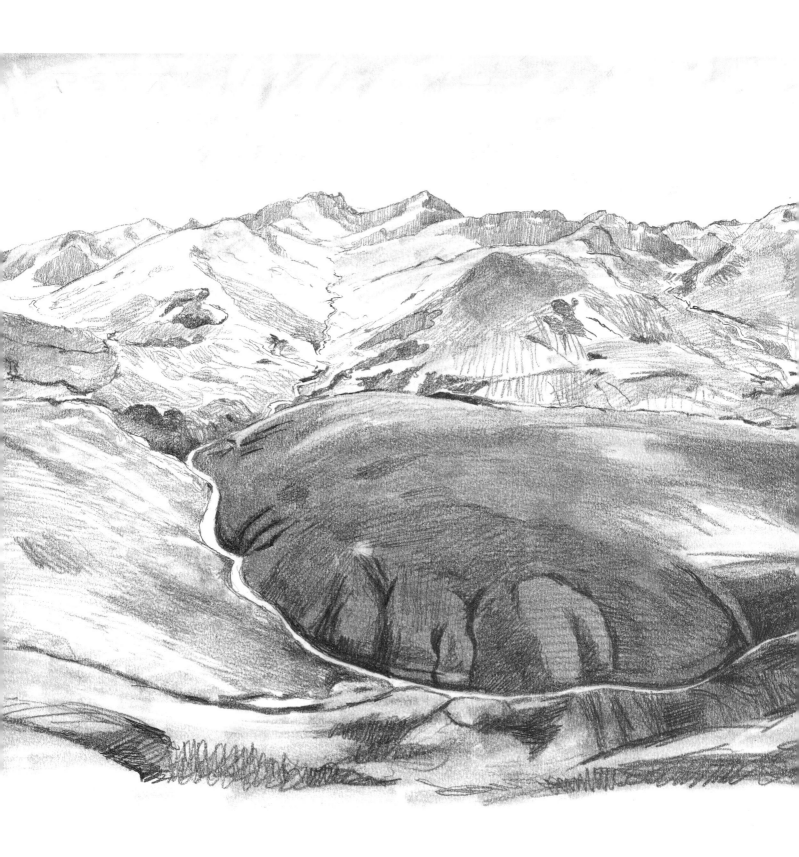

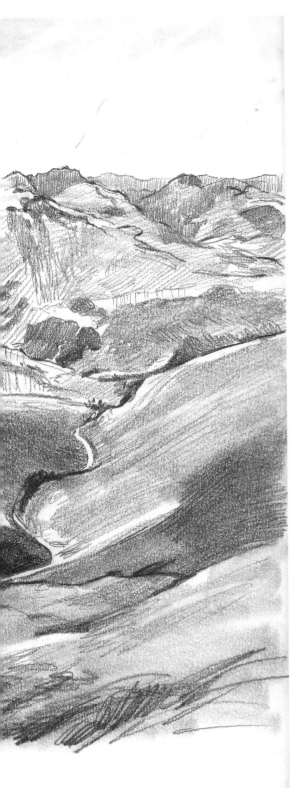

The last piece is from a painting by Michael Andrews (see also page 99), an English artist who made some very interesting landscape pictures. It's a large view of an area in the Scottish Highlands, in which he has a very high-level view of the landscape. This in itself is a complex thing to arrange as everything tends to seem distant and the scale is difficult to assess. He has made a choice of showing in mid-composition a great expanse of moorland, hemmed in by larger peaks and mountain ranges, and he carefully contrasts the sharper, rocky mountains in the background with the smoother aspect of the moor. All the surrounding country seems to point towards the central mass of the moor, which is beautifully delineated by the streams around its edge. The drama of this smooth mass among the rugged rocks is masterly. The curve of the distant horizon also helps to give an idea of the expanse of this landscape.

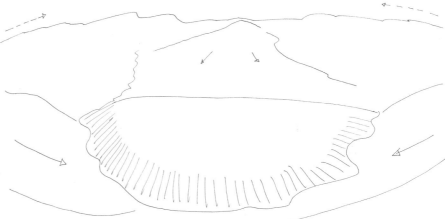

Landscape composition

When I decided to put together this final piece of landscape drawing, I went to Hampton Court on the River Thames, close to where I used to live when I was a boy. Although there are plenty of houses in the vicinity, they are all well hidden by trees and the areas of footpath along the river. Also close by was a rather nice park that I used to play in when I was young, which was quite nicely wooded and had a small lake in it.

First I walked around the park and the river to get ideas for my drawing. In the park I sketched very quickly this possible scene of the lake, which seemed nice and open.

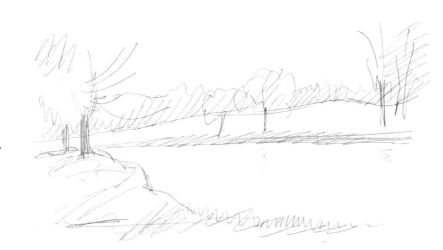

▽ ▷ Then I walked along the riverbank, making these three rough sketches of places I might choose to draw. As well as the sketches, I took several photographs of all the possible places that seemed attractive to me.

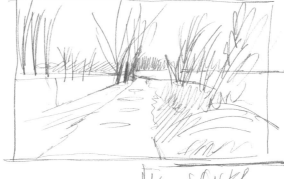

▼ Looking at my sketches, I tried to decide which scene I was going to draw up more carefully. I returned to the park and began this view of the lake, with the rippling water and the willow trees around it.

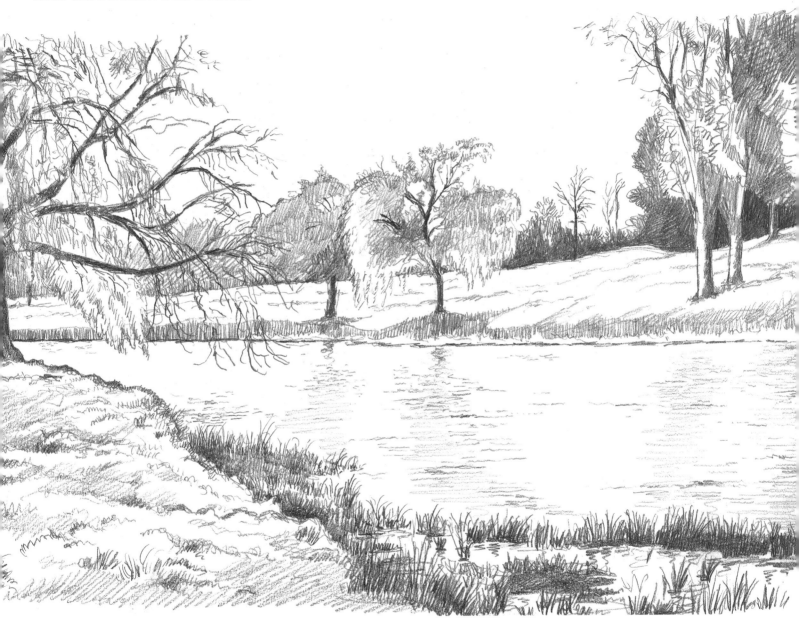

As you can see I produced a fairly complete drawing, but somehow I was not quite satisfied with the result. You will find this often happens, which doesn't necessarily mean that there is anything wrong with your drawing, because you are often the worst critic of your work and you cannot be truly objective about it until much later on.

I was keen to try something else, and so I went back to the riverbank and walked until I reached a spot that I had both sketched and photographed. I made another sketch, taking a bit more time over it than before.

Satisfied that this was the place I wanted to draw, I then sat down and began to draw more carefully a simple outline drawing of the scene, making sure that all the trees were correctly aligned, and that the edges of the river were clearly marked. It had been raining, so there were many large puddles along the river path.

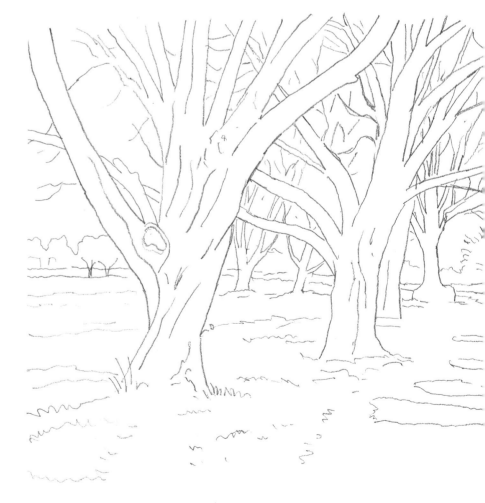

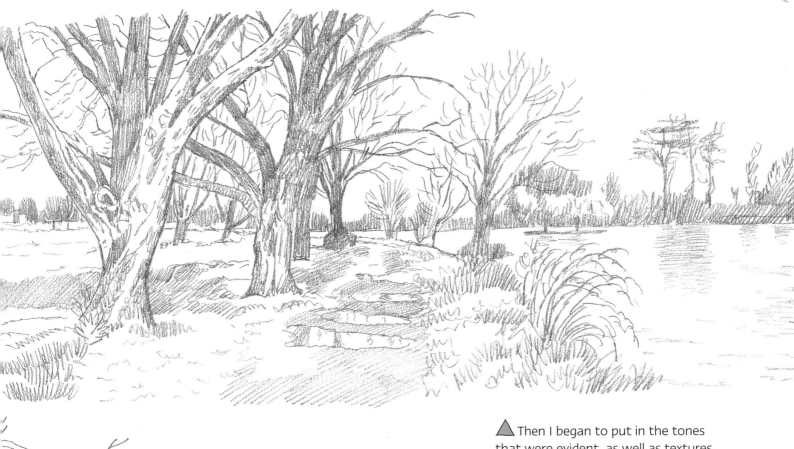

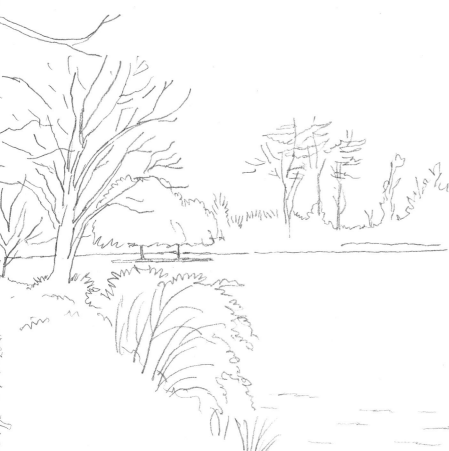

Then I began to put in the tones that were evident, as well as textures, especially of the tree bark and the longer grass. I tried to keep this as even in tone as I could so that I would be able to see where the heavier and darker marks were going to be put later.

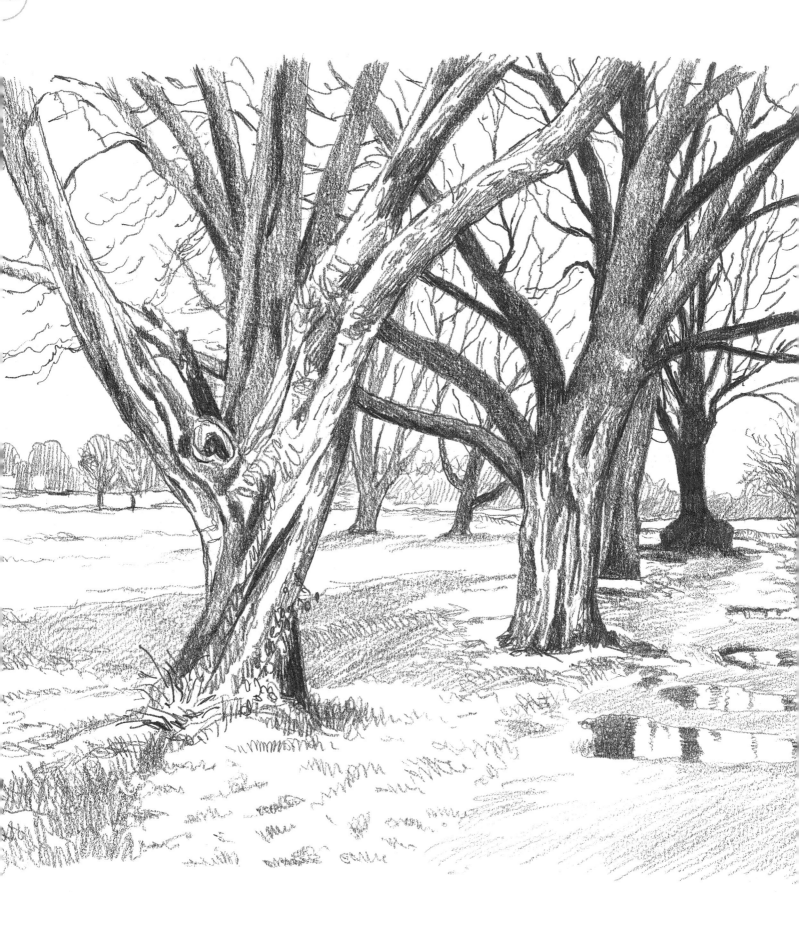

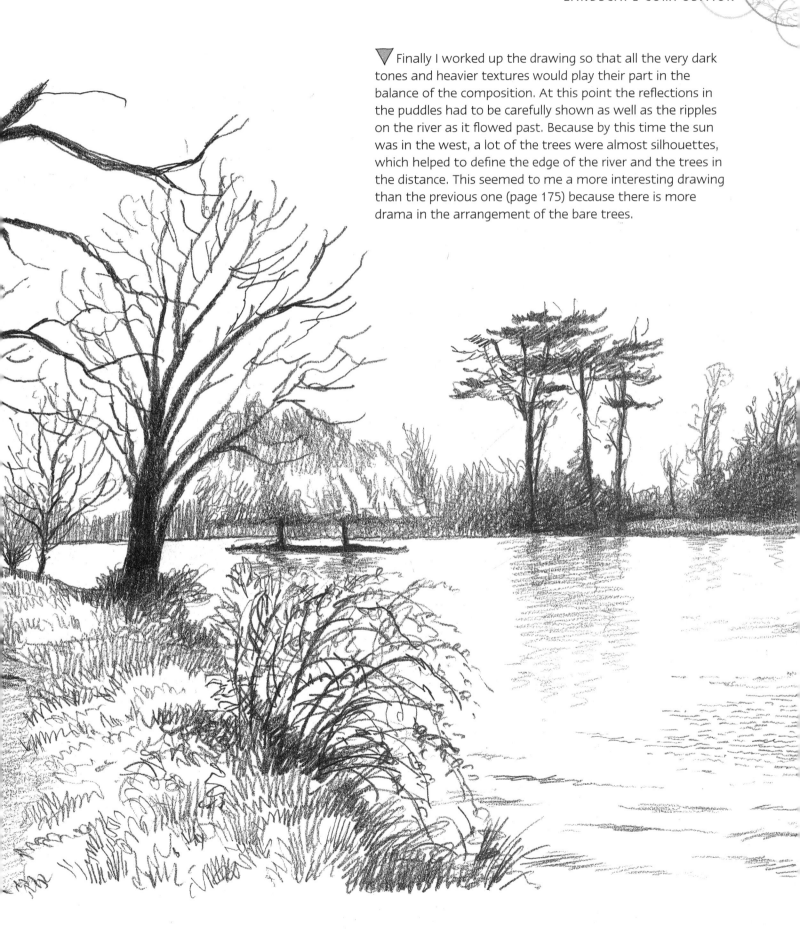

▼ Finally I worked up the drawing so that all the very dark tones and heavier textures would play their part in the balance of the composition. At this point the reflections in the puddles had to be carefully shown as well as the ripples on the river as it flowed past. Because by this time the sun was in the west, a lot of the trees were almost silhouettes, which helped to define the edge of the river and the trees in the distance. This seemed to me a more interesting drawing than the previous one (page 175) because there is more drama in the arrangement of the bare trees.

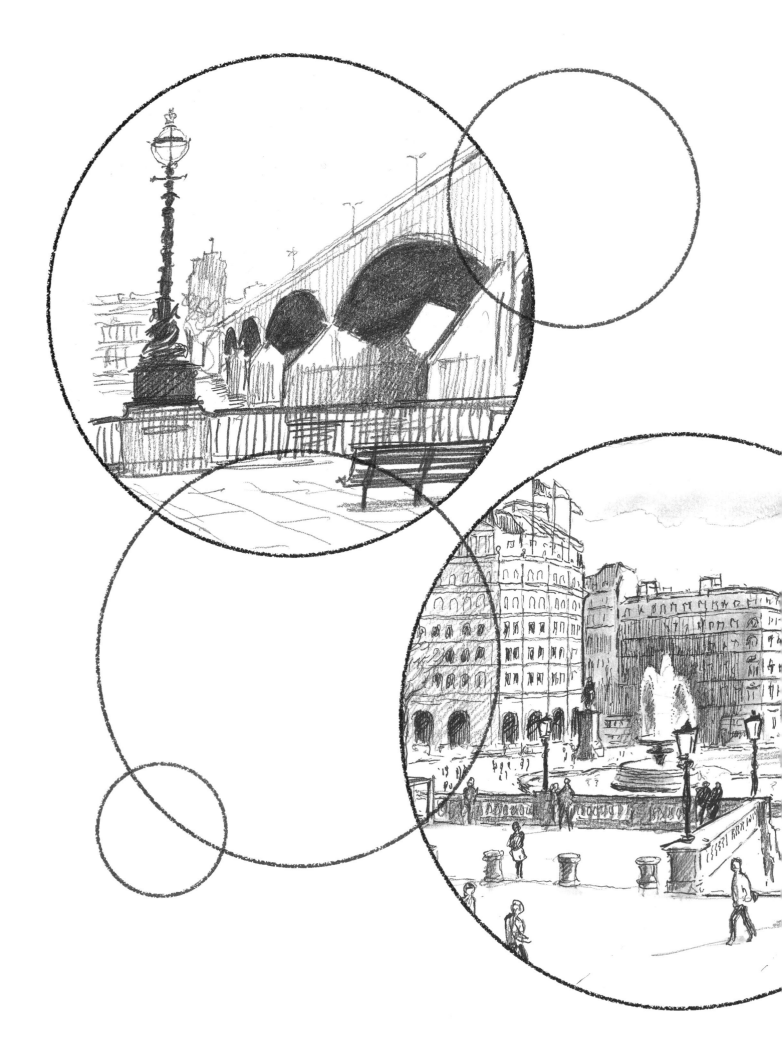

PROJECT 10: CITY PANORAMA

The problem you'll find in tackling urban scenes is that there's so much competing for your attention it can be difficult to make a sensible choice of subject. However, the same rules apply as in a rural landscape – select how much you are going to draw from your own viewpoint, and don't be confused by a lot of detail.

What you'll discover in the urban environment is that there are lots of incidental bits of architecture that seem to demand that you put them all in. However, this is where you have to decide exactly how much of this detail will be drawn precisely and how much will be reduced to very simple marks that just suggest the detail. Features such as windows, doors and chimneys are the obvious elements that come into this category. Most of what you see is recorded in your mind only as a general impression, and this is probably the best way to show it. The details that you do have to be precise about are those that are in the foreground or are points of focus.

Remember that you don't have to put every building and piece of street furniture in, especially if it might produce an awkward area of design in the whole picture. This is where you can use artistic licence to create the best composition rather than simply making a record of the scene.

Street scenes

Looking at the urban scene presents a different problem to the rural landscape because your view will often be cluttered with multiple signage, cars and so forth. For this reason, if you live in a quiet residential area it's a good idea to progress gradually from there to the centre of the town.

So our first compositions here are streets of residential housing with roadside trees, cars and minimum signage. Even so your spatial area will be rather constrained by the narrowness of the streets and the closely built houses.

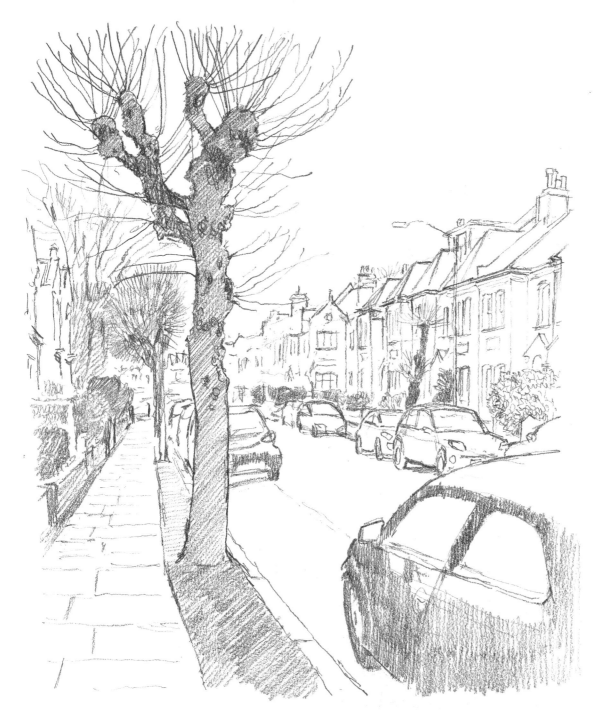

This drawing is a view down a road with the houses on the opposite side jumbled together and the pollarded tree at the side of the road acting like a frame on the left of the picture. The cars alongside the kerb are significantly cutting off your view of the road, which is the largest space in the scene. You immediately see how this lacks the spacious qualities of the more open landscape of the countryside.

The next picture is of a town where the road divides, giving a concentrated view of the near side of the road and a more open view of the far side. The lamppost, road sign and parked car give you an easy introduction to the street paraphernalia possible in urban scenes.

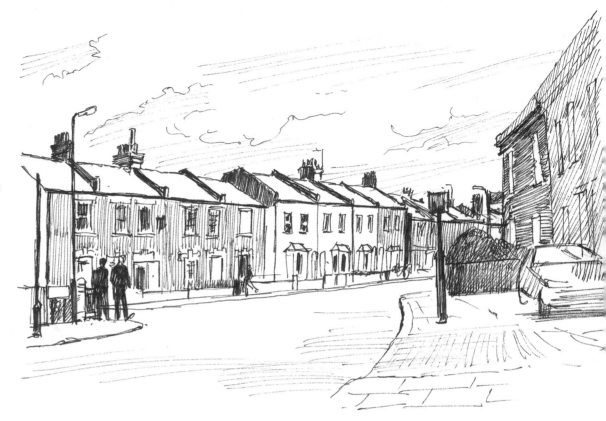

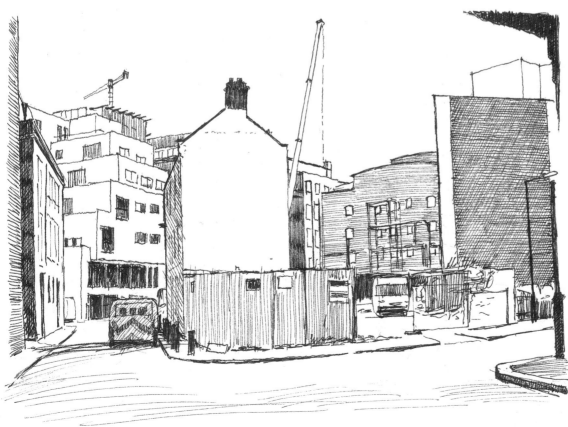

Here some building works are taking place in a city location where the corrugated fence cutting off the work site from the road reveals the blank side of a row of buildings, up against which the new buildings will rise. The cranes and scaffolding in the centre of the scene are framed by the large new buildings on either side.

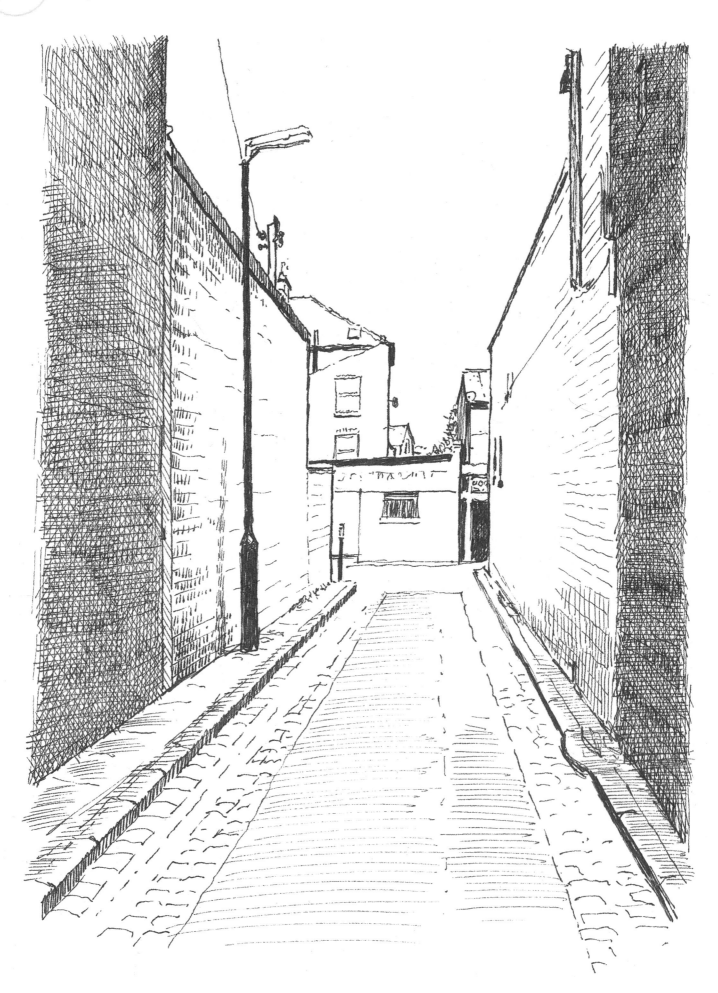

Now a couple of awkward spaces in the centre of a town. The picture on the left shows a narrow alleyway between shop fronts giving access to areas behind the commercial frontage. It is rather like a large slot in the building, showing a little sky and blank brick surfaces.

The second of these two scenes is the back of some large buildings, where a car park is in temporary use. Soon these spaces will be filled by new buildings, but until then we have a view of these large blank surfaces which indicate that these are not the main fronts of the buildings concerned. This is really an exercise in drawing large areas of texture and cast shadows.

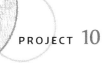

Here we have a town scene, again not the frontage of the street but the view from a railway or underground station. The large masses of the buildings rise out of the surface of the platform and the curving railway lines. A couple of station lamps emphasize the perspective of the lines and the platform.

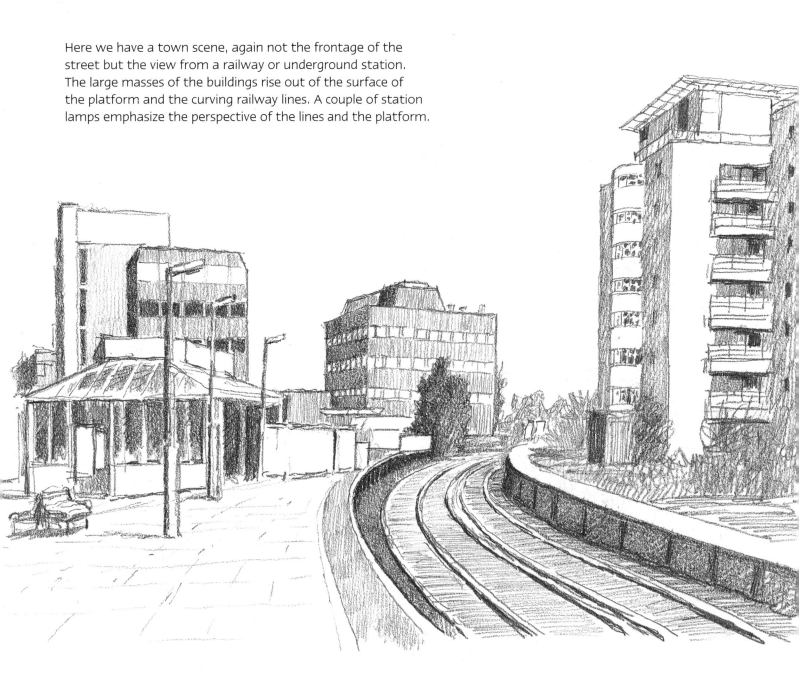

Now a romantic night-time view of an American city, showing a decorative skyscraper illuminated by searchlights. This dramatic piece (right) after Georgia O'Keefe is a pattern of bright windows gleaming against the solid block of the tall building. There is little or no perspective in this big city scene and hardly any midtones, only darks and lights.

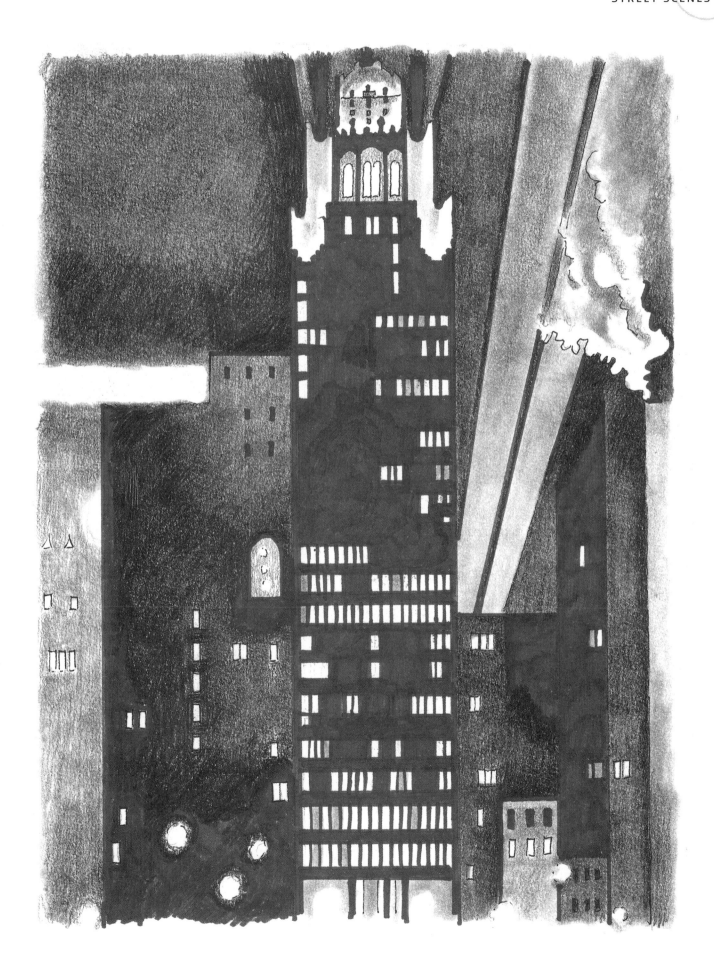

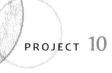

A trip to the city

I decided to go on a journey to get some examples of urban landscapes that had some direct significance for me, so I took the train to London's Trafalgar Square. This is one of the city's main focal points, and I thought that I would be able to find plenty of scenes that gave a good idea of the problems to be solved when drawing in a busy urban environment.

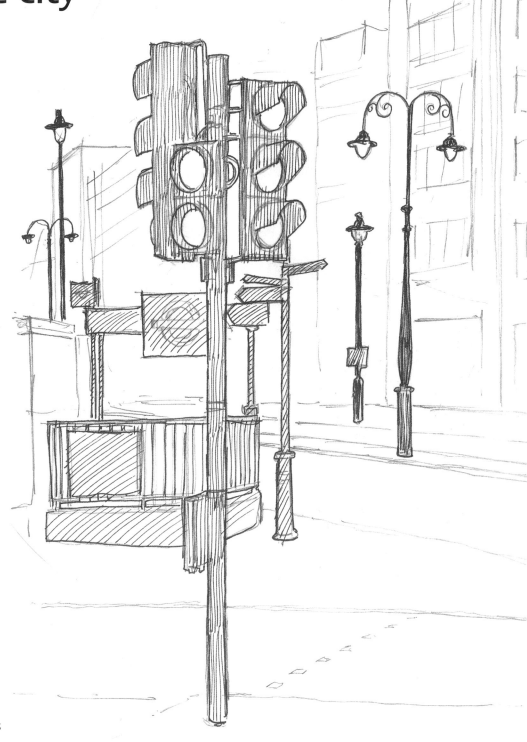

Immediately on emerging from the station I was confronted by two views of the end of a large thoroughfare called the Strand. Here is the mass of lampposts, traffic lights, rubbish bins, bus stops and railings that make up the everyday look of a London street. Notice how the traffic lights and lampposts are all clustered together from the position in which I was viewing the scene. I have purposely left the buildings only outlined in order to point out how much of the scene can be taken up with street furniture.

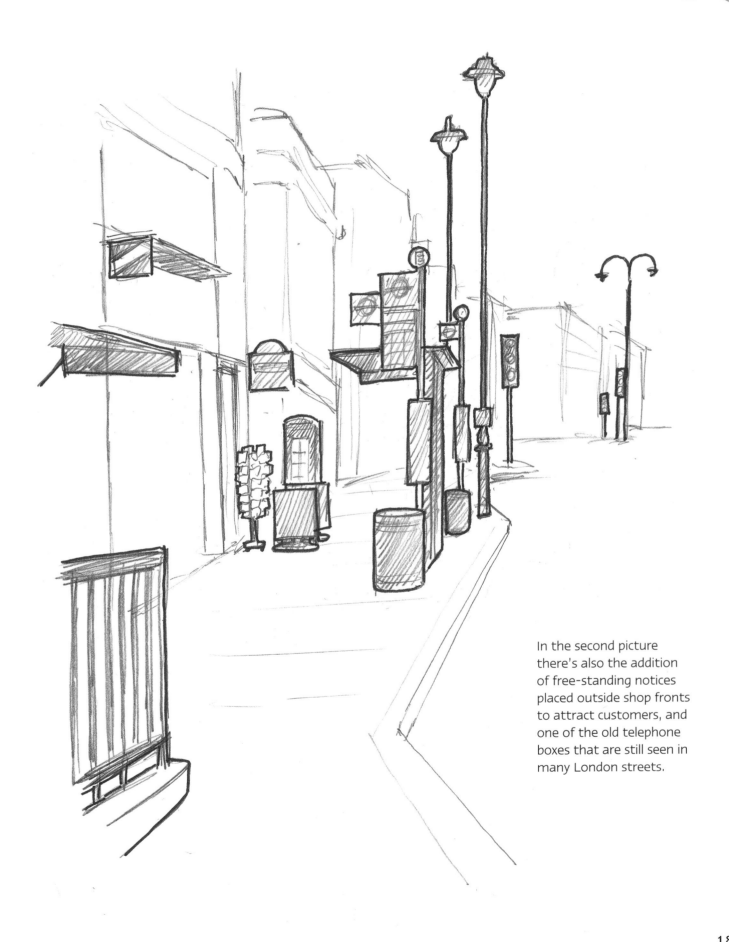

In the second picture there's also the addition of free-standing notices placed outside shop fronts to attract customers, and one of the old telephone boxes that are still seen in many London streets.

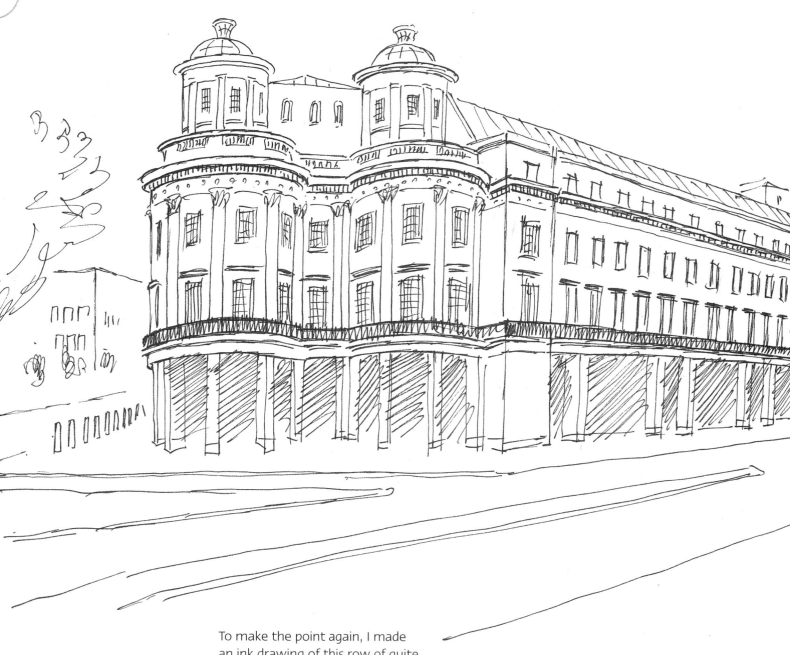

To make the point again, I made an ink drawing of this row of quite elegant buildings along the street, without any of the lampposts and other impedimenta that you find in a large city. It looks very spacious, doesn't it?

In the next drawing I've used a large watercolour brush to add the silhouettes of the lamps and traffic lights which actually punctuate the space along this street. They immediately break up the space in a rather interesting way that helps to give more of a sense of what it is like to stand in the position that I was drawing from. So don't ignore the street furniture, but if it tends to overpower your picture you can always leave some of it out. This is the selectivity that's expected of artists.

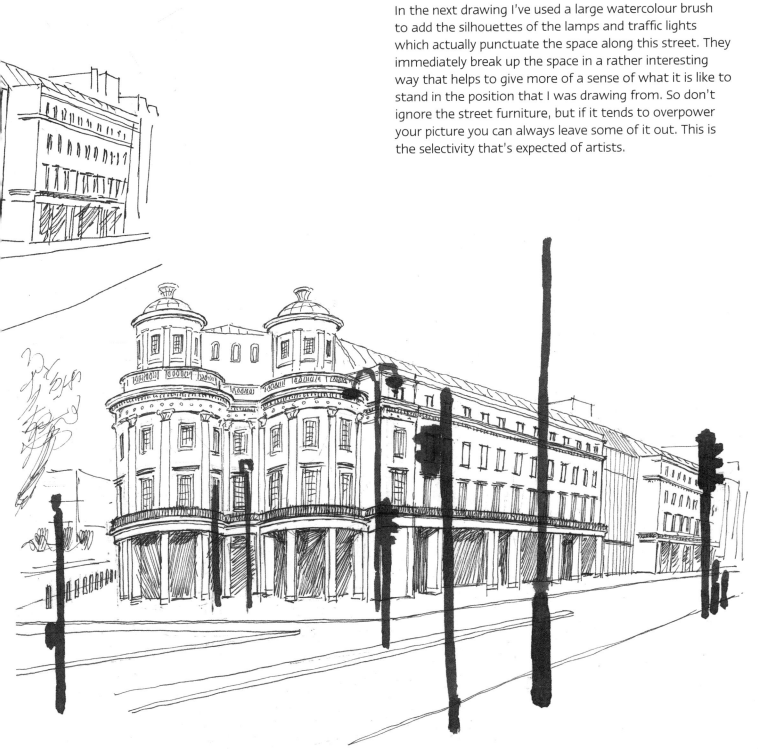

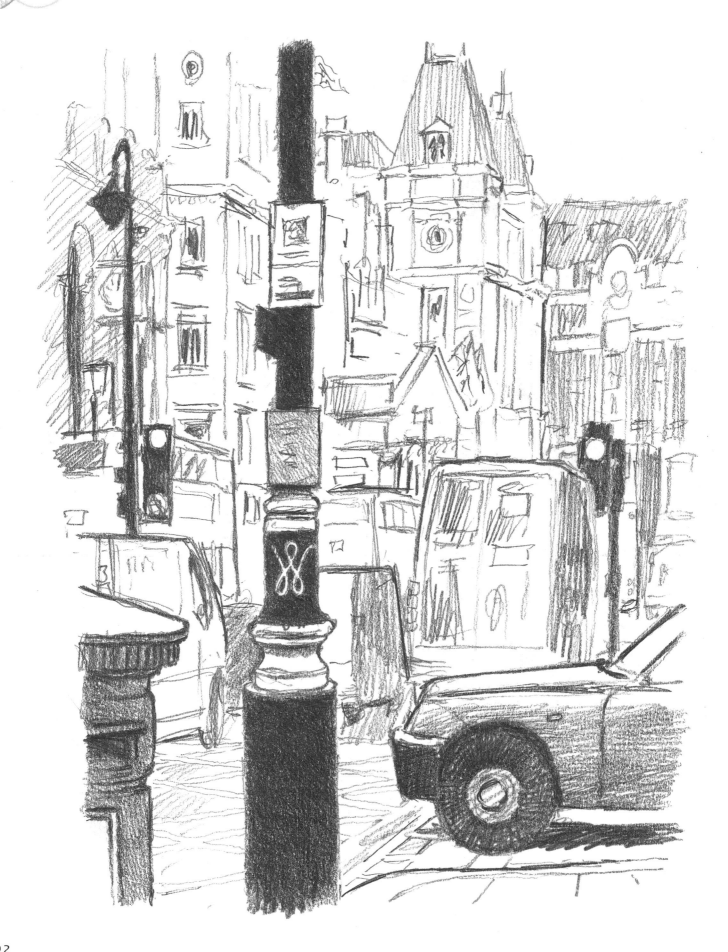

In the picture on the left you can see how the traffic jams in large towns always give a crowded look to the streets and with the lamps and other paraphernalia the whole picture can look very busy. This isn't a bad thing, because this may well be what you want to portray as typical city life.

However, you can find big spaces as well, especially if, as in London, there's a river running through the town. This view is on the south bank of the River Thames looking up at Waterloo Bridge. There are walkways along the side of the river which allow you to step back and see some very nice spaces contrasting with the solid architecture of the massive spans. The deep shadows under the bridge bring a certain drama to the scene.

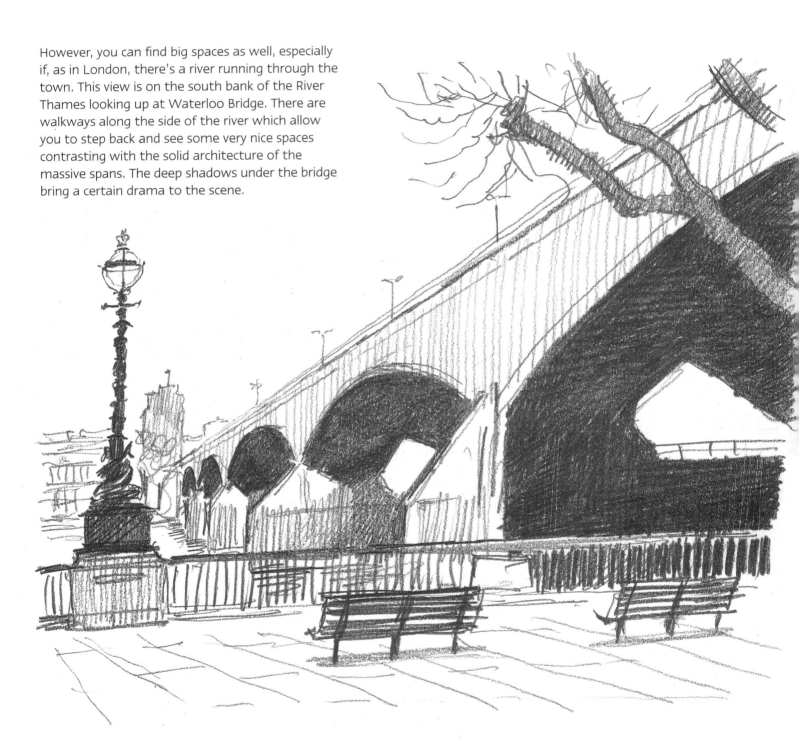

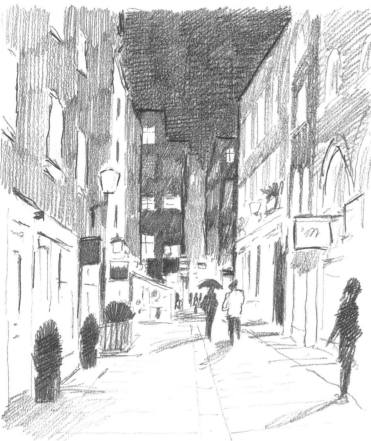

This drawing of a pedestrian walkway between shops and restaurants gives a good idea of the bright streets at night in a town. Figures walking along the street tend to look like silhouettes.

Here's a similar effect by daylight, seen from the top of the steps up to the National Gallery in Trafalgar Square. A large ornamental lamp stands in the centre of the picture, and around it can be seen a street of large classical buildings stretching off into the distance. The people dotted about help to define the space between the viewer and the buildings.

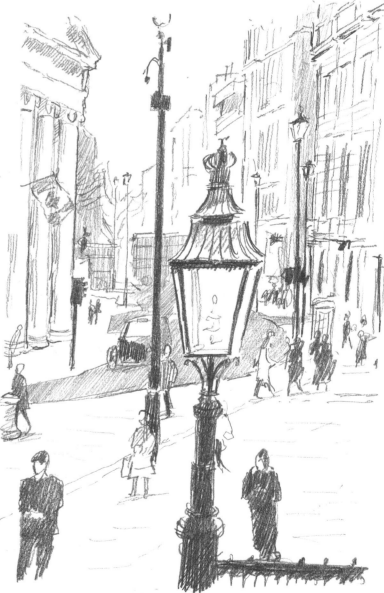

And now the view is from the lower part of Trafalgar Square, where once again the street furniture becomes a way of defining the space between the viewer and the figures and traffic. It's quite difficult to draw people as they pass by in the street, so the best way is to take photographs that incorporate the pedestrians so that you can place them in the scene afterwards. I have used ink again here because I find it is sympathetic to drawing the details of the buildings.

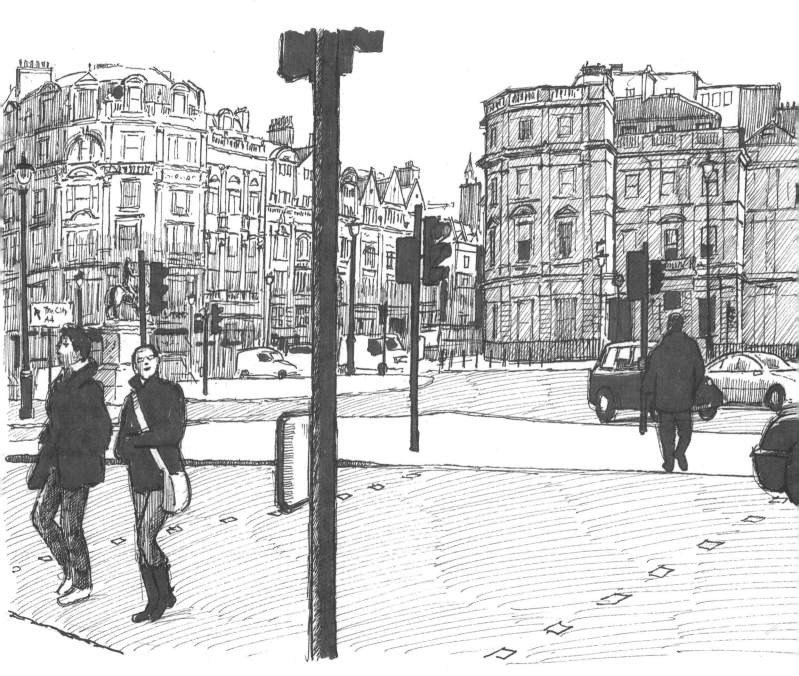

PROJECT 10

City panorama

To make a sufficiently dramatic scene to show the most effective method of drawing in the city, I chose as large a panorama as I could of Trafalgar Square, without trying to get everything in. I placed myself in the middle of the steps of the National Gallery and looked straight across the square towards Whitehall with Nelson's Column right in the middle of the scene, but without being able to see the top, where Nelson's statue stands. This gave me a focal point for the scene without including a large expanse of sky. After all, I wanted to portray the city buildings rather than just the central column.

▽ To start with I sketched in the main areas of the blocks of architecture, indicating the open space of the square where people were wandering about. I did this in pencil so that if any of the spaces were wrong I could erase them.

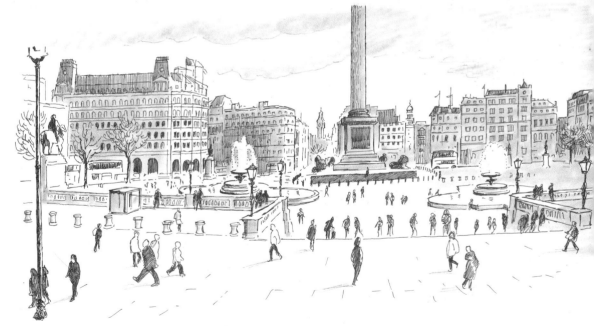

▲ Next, still using pencil, I drew up the whole square in some detail, although the large numbers of windows visible were put in as simply as possible. At this stage I could still alter anything that didn't work, and if I decided I didn't like the position of a tree or lamppost, or even a rooftop, I could get rid of them. My aim was to maintain the overall spacious quality of the scene rather than worry about every detail.

▲ Having got the whole scene drawn in I could now put in more people, and add some tone as well. I decided to mainly use ink and so the first thing was to draw the whole picture all over again with a pen. This may seem a bit tiresome, but it can often lead to a better picture. I also started to mark in the tones of the main buildings with a very soft all-over tone, which helped to show up the white splash of the fountains in the square. I did this with pencil to keep it soft at first, then I went over all the areas that I wanted to be more definite with inked-in areas of tone, which looks a lot darker than the pencil. At this stage I put in a lot of people crossing the square and looking at the fountains.

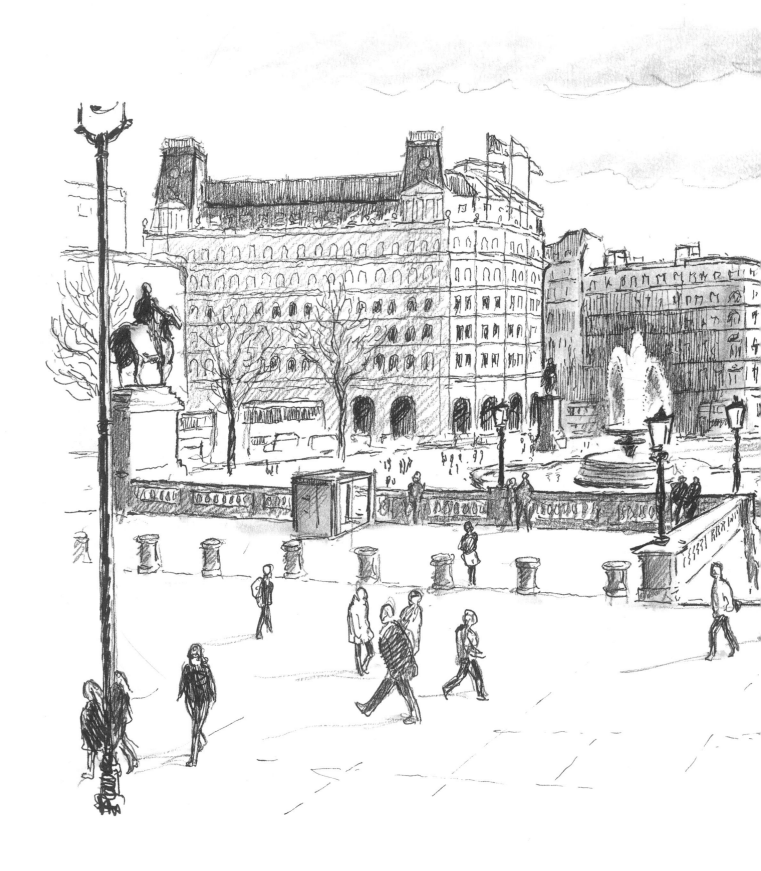

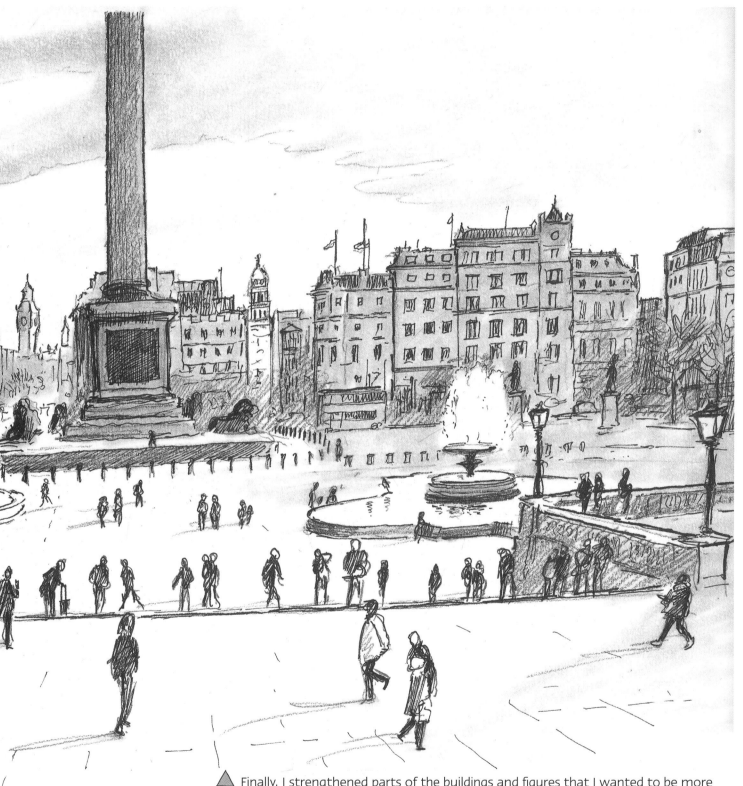

Finally, I strengthened parts of the buildings and figures that I wanted to be more obvious, such as the edges of the nearest structures and some of the foreground people. From here on I could add more tone bit by bit with either pencil or ink until I was quite sure that I had given the tonal values their due and made the buildings look as solid as they should. I particularly made sure that the white water of the fountains stood out against darker backgrounds. As in any landscape, the elements further away – in this case the buildings – are less defined than those closer to the foreground.

PROJECT 11: **FIGURE COMPOSITION**

Figure composition is probably the most difficult form of drawing for any artist to attempt. Not only is it technically challenging, the viewers of your work will obviously know the proportions and movements of the human body very well and will spot any mistakes. But, of course, for you as an artist there is great interest in attempting to draw a group of figures that bear some resemblance to human life.

This section starts with a reminder of the proportions of the human figure and some of the oddities that you may have to deal with in foreshortening. However, nothing is better than your own studies of the human form. Don't reject the use of photography to help here, although your own perception in studies drawn from life will ultimately give you more information than even the finest photographs.

There are many ways of simplifying the way that you look at a figure, and I have included some of them. Geometric simplification works very well in most cases. Some understanding of what goes on under the surface of a body is also very useful, and you should make an attempt to learn a little about anatomy.

The hardest thing to show accurately is movement, and there are no short cuts to observing what happens when a body is in motion. This observation is not only crucial to the artistic process but is endlessly fascinating.

Measurements

The first thing that you need to consider is the relative proportions of the human figure. This is normally drawn as if the head is a unit of measurement that goes about seven and a half times into the full length of the figure. However, to simplify this and also to produce a more attractive proportion, the ratio is often drawn as eight head lengths. Called the heroic proportion, this produces a slightly more graceful figure, typically used by the Old Masters for paintings of religious, mythical and military figures.

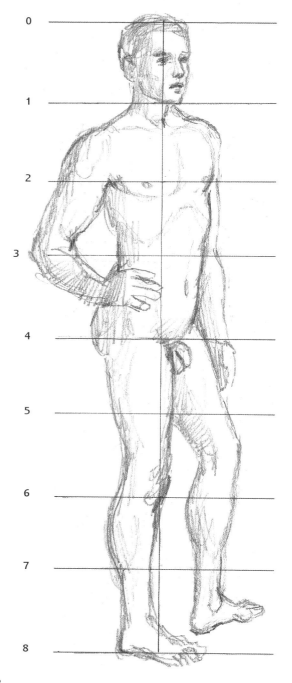

So here is a simple diagram of the figure with these proportions marked out so that you can see the effect. The picture of the female is slightly smaller than the male as this is usually the case, but the proportion is exactly the same. In actual fact there are some slight differences in proportion between the sexes, but these don't matter until you have become quite expert, and then you will begin to discover them for yourself.

The next thing to consider is that unless your model is standing straight in front of you and on the same level, the body will often appear to be foreshortened, or in perspective. This has the effect of changing the natural proportions somewhat, and as you can see in these next two figures, there is a difference in some of the measurements.

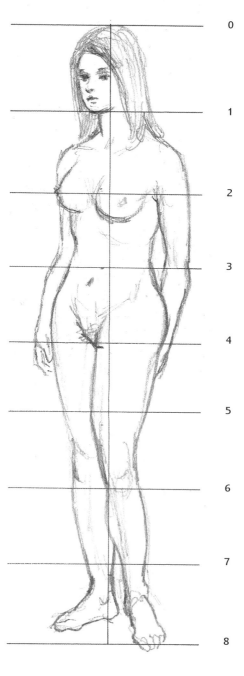

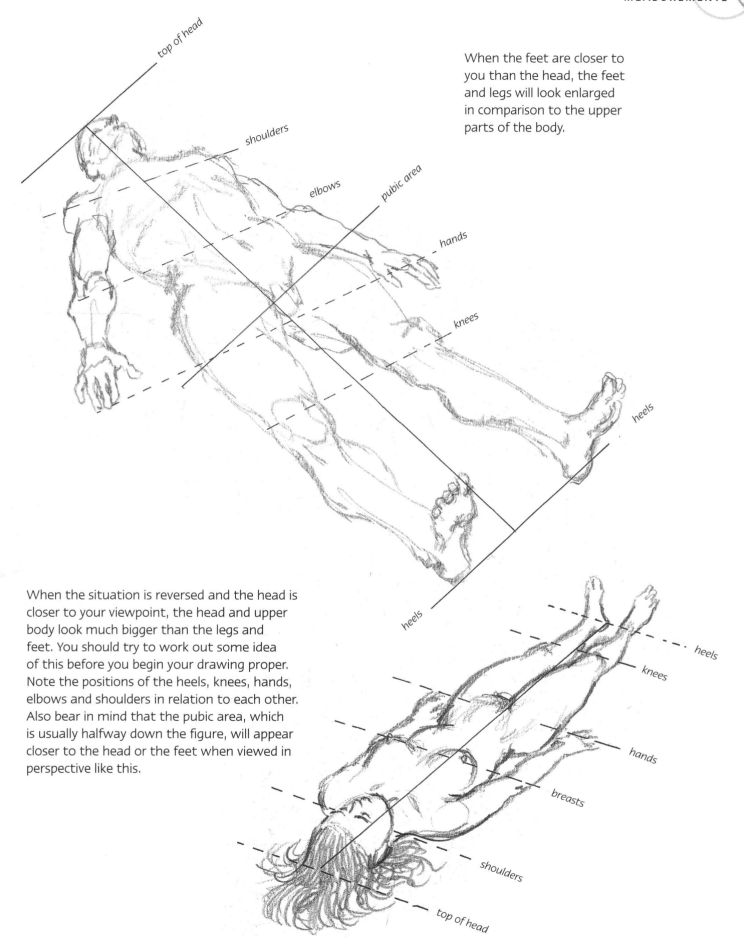

top of head

shoulders

elbows

pubic area

hands

knees

heels

heels

When the feet are closer to you than the head, the feet and legs will look enlarged in comparison to the upper parts of the body.

heels

knees

hands

breasts

shoulders

top of head

When the situation is reversed and the head is closer to your viewpoint, the head and upper body look much bigger than the legs and feet. You should try to work out some idea of this before you begin your drawing proper. Note the positions of the heels, knees, hands, elbows and shoulders in relation to each other. Also bear in mind that the pubic area, which is usually halfway down the figure, will appear closer to the head or the feet when viewed in perspective like this.

Here I've drawn the same model reclining on her side from both the foot end and the head end. You can see how the size of the feet in relation to the size of the head, and the length of the torso and head in relation to the length of the legs, is quite different in each.

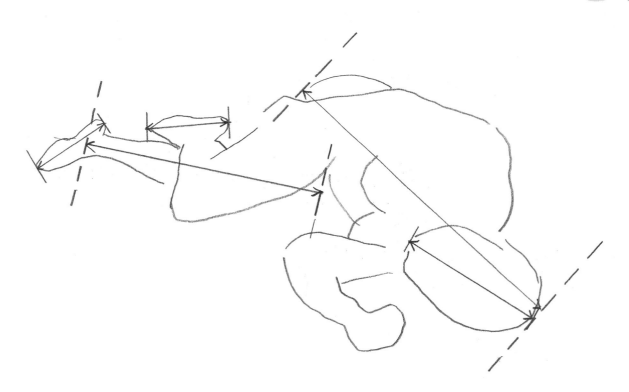

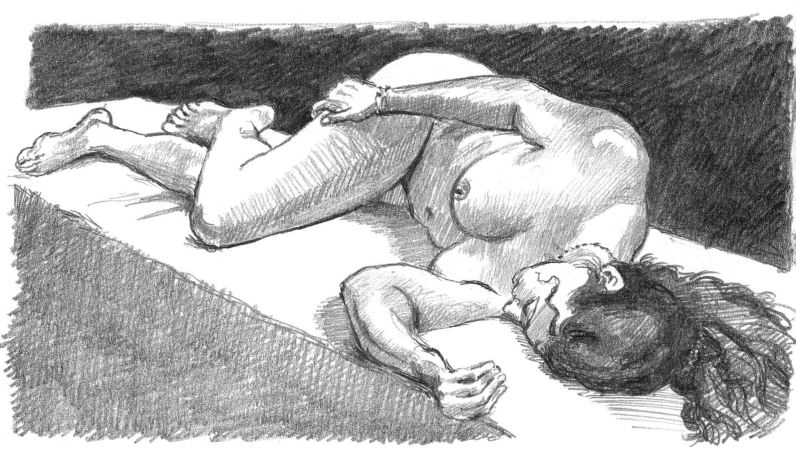

Blocking in the shape

Here we look at the figure as a whole and try to simplify the drawing by blocking in the main area as a simple geometric shape before engaging with the detail. You won't always have to do this, as once you are more proficient you'll be able to project it as a mental image. However, at the beginning it's sensible to draw the main shapes so that you're aware of the space that the figure occupies.

In the first figure treated thus (below), I've drawn a large triangle that is taller than it is wide and then marked places where I think that the shoulders, breasts and hips appear on that triangle. Putting a vertical through the centre also helps to get the feeling of the body's position.

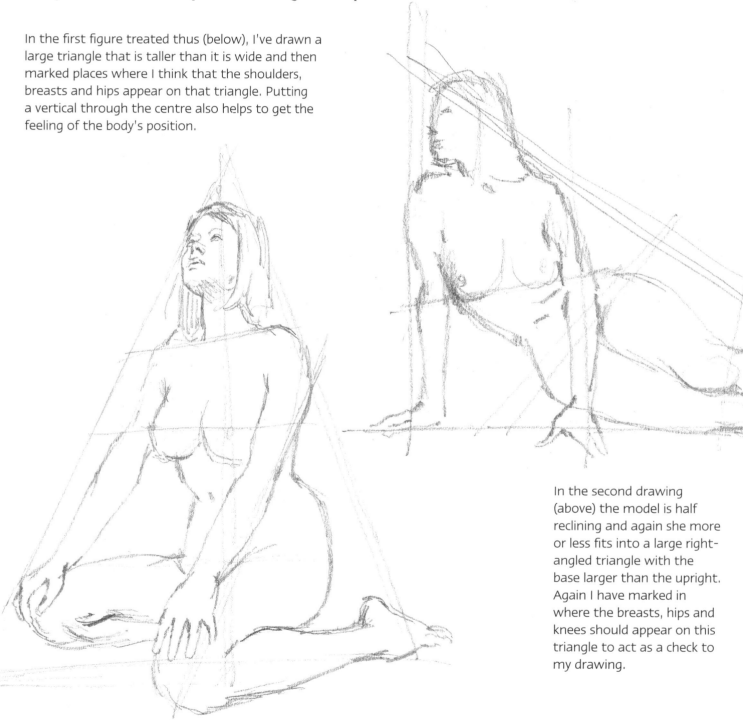

In the second drawing (above) the model is half reclining and again she more or less fits into a large right-angled triangle with the base larger than the upright. Again I have marked in where the breasts, hips and knees should appear on this triangle to act as a check to my drawing.

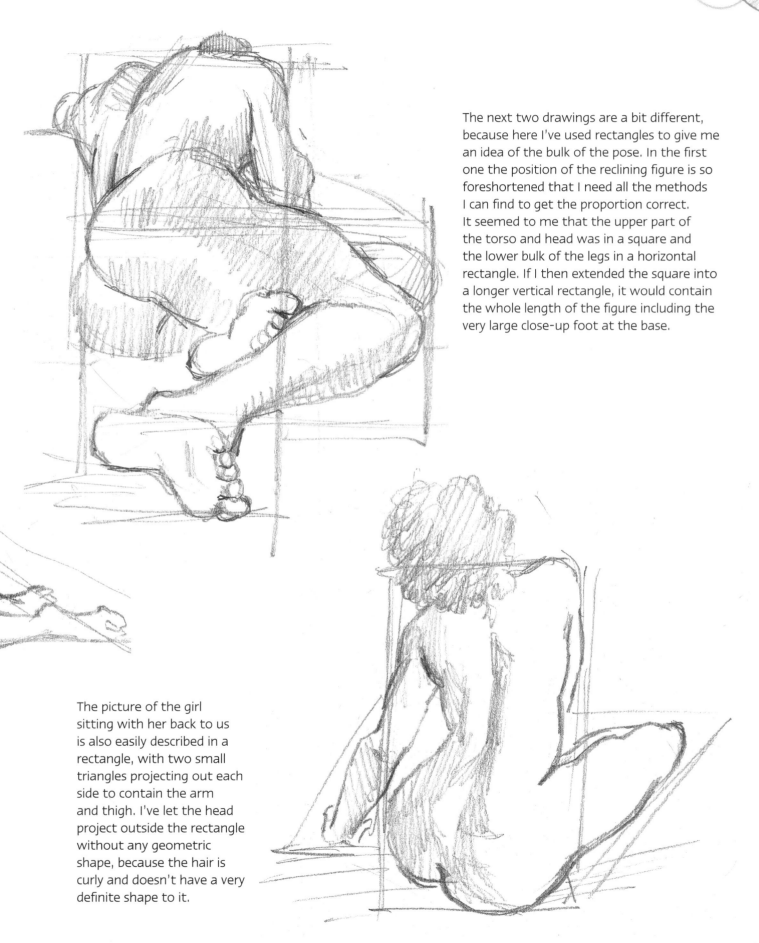

The next two drawings are a bit different, because here I've used rectangles to give me an idea of the bulk of the pose. In the first one the position of the reclining figure is so foreshortened that I need all the methods I can find to get the proportion correct. It seemed to me that the upper part of the torso and head was in a square and the lower bulk of the legs in a horizontal rectangle. If I then extended the square into a longer vertical rectangle, it would contain the whole length of the figure including the very large close-up foot at the base.

The picture of the girl sitting with her back to us is also easily described in a rectangle, with two small triangles projecting out each side to contain the arm and thigh. I've let the head project outside the rectangle without any geometric shape, because the hair is curly and doesn't have a very definite shape to it.

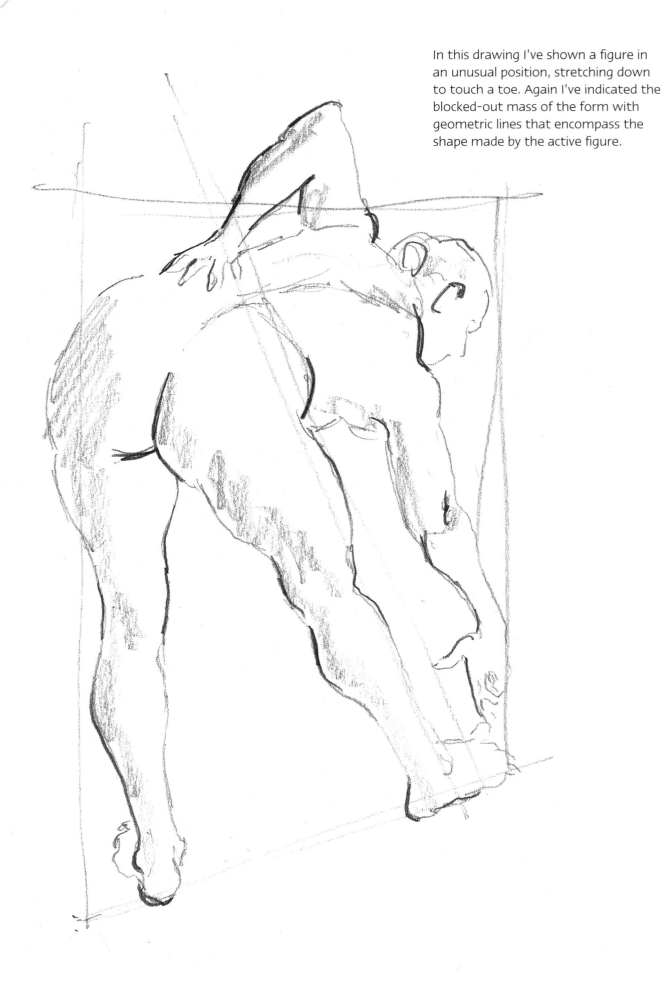

In this drawing I've shown a figure in an unusual position, stretching down to touch a toe. Again I've indicated the blocked-out mass of the form with geometric lines that encompass the shape made by the active figure.

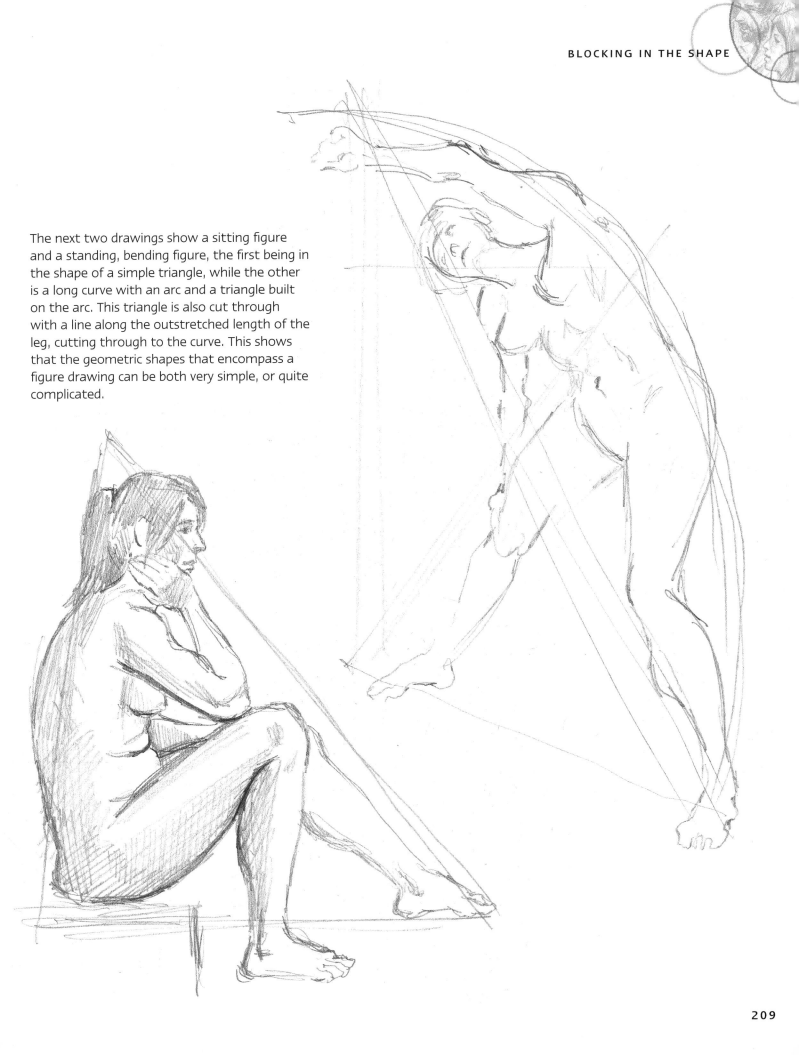

The next two drawings show a sitting figure and a standing, bending figure, the first being in the shape of a simple triangle, while the other is a long curve with an arc and a triangle built on the arc. This triangle is also cut through with a line along the outstretched length of the leg, cutting through to the curve. This shows that the geometric shapes that encompass a figure drawing can be both very simple, or quite complicated.

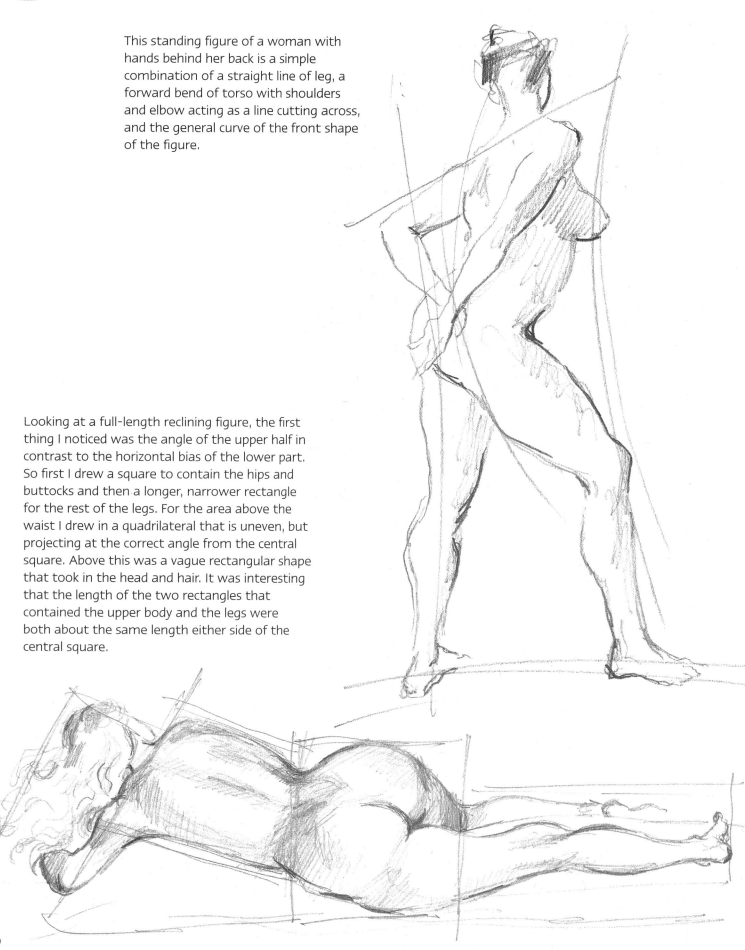

This standing figure of a woman with hands behind her back is a simple combination of a straight line of leg, a forward bend of torso with shoulders and elbow acting as a line cutting across, and the general curve of the front shape of the figure.

Looking at a full-length reclining figure, the first thing I noticed was the angle of the upper half in contrast to the horizontal bias of the lower part. So first I drew a square to contain the hips and buttocks and then a longer, narrower rectangle for the rest of the legs. For the area above the waist I drew in a quadrilateral that is uneven, but projecting at the correct angle from the central square. Above this was a vague rectangular shape that took in the head and hair. It was interesting that the length of the two rectangles that contained the upper body and the legs were both about the same length either side of the central square.

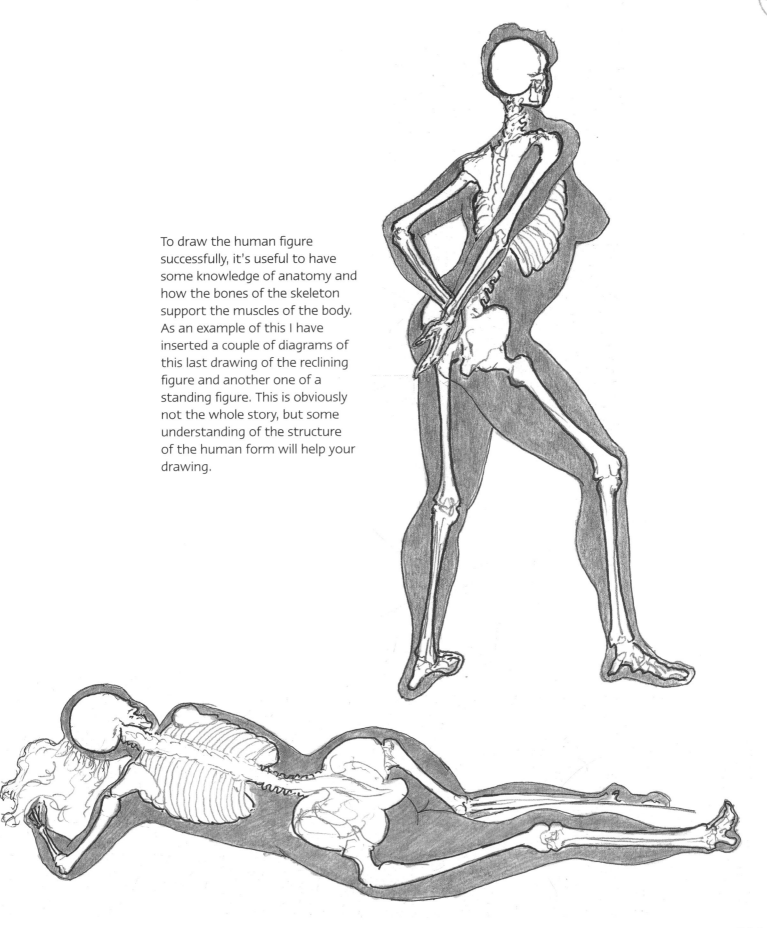

To draw the human figure successfully, it's useful to have some knowledge of anatomy and how the bones of the skeleton support the muscles of the body. As an example of this I have inserted a couple of diagrams of this last drawing of the reclining figure and another one of a standing figure. This is obviously not the whole story, but some understanding of the structure of the human form will help your drawing.

Building tone

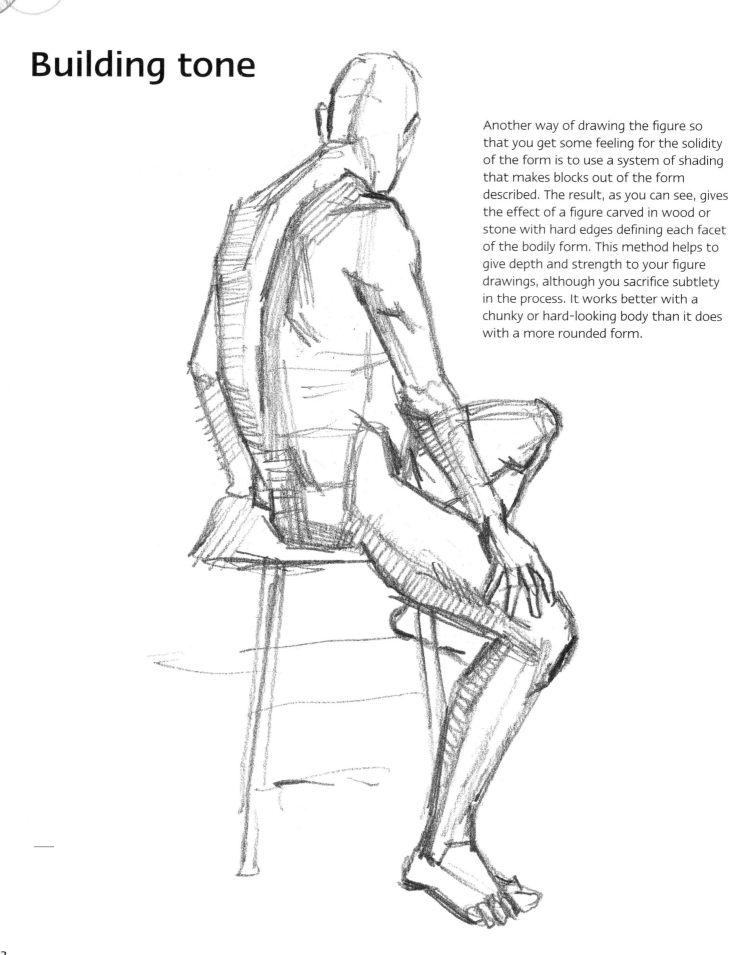

Another way of drawing the figure so that you get some feeling for the solidity of the form is to use a system of shading that makes blocks out of the form described. The result, as you can see, gives the effect of a figure carved in wood or stone with hard edges defining each facet of the bodily form. This method helps to give depth and strength to your figure drawings, although you sacrifice subtlety in the process. It works better with a chunky or hard-looking body than it does with a more rounded form.

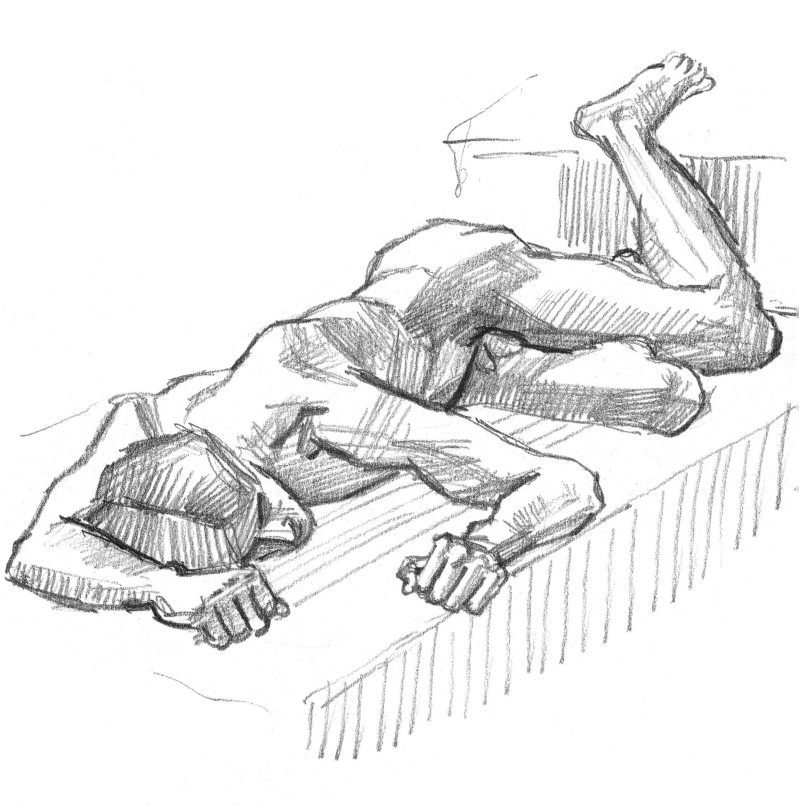

Here in the next two drawings is a more gentle version of the same process where the form is clearly defined by the use of tone, but without much variation in the tone. The resulting drama of the light areas contrasting with the darker shadowed areas makes for an effective method to show form.

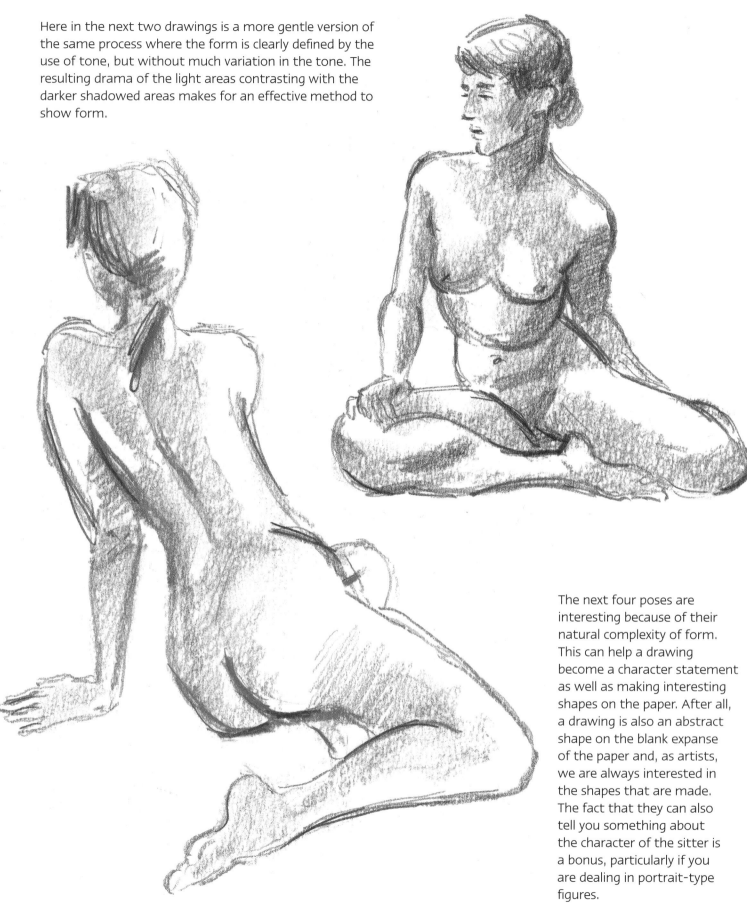

The next four poses are interesting because of their natural complexity of form. This can help a drawing become a character statement as well as making interesting shapes on the paper. After all, a drawing is also an abstract shape on the blank expanse of the paper and, as artists, we are always interested in the shapes that are made. The fact that they can also tell you something about the character of the sitter is a bonus, particularly if you are dealing in portrait-type figures.

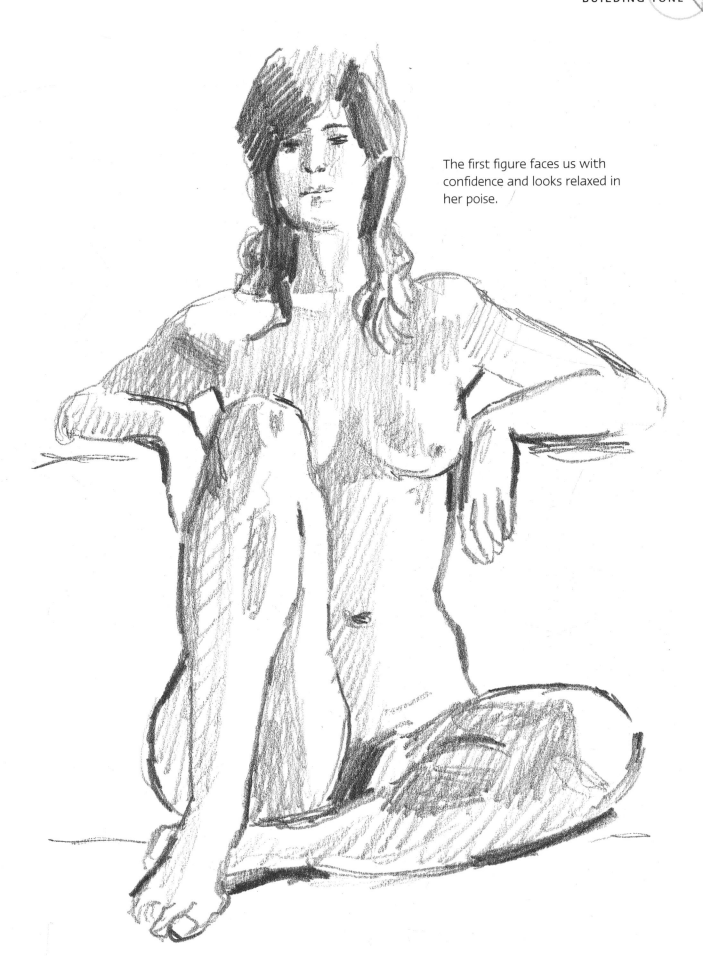

The first figure faces us with confidence and looks relaxed in her poise.

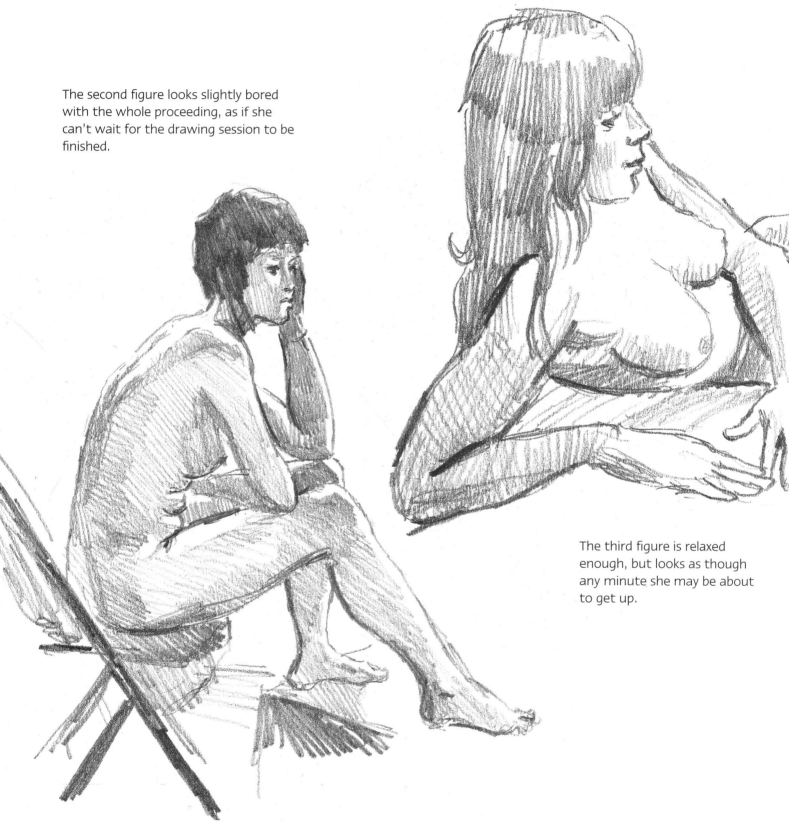

The second figure looks slightly bored with the whole proceeding, as if she can't wait for the drawing session to be finished.

The third figure is relaxed enough, but looks as though any minute she may be about to get up.

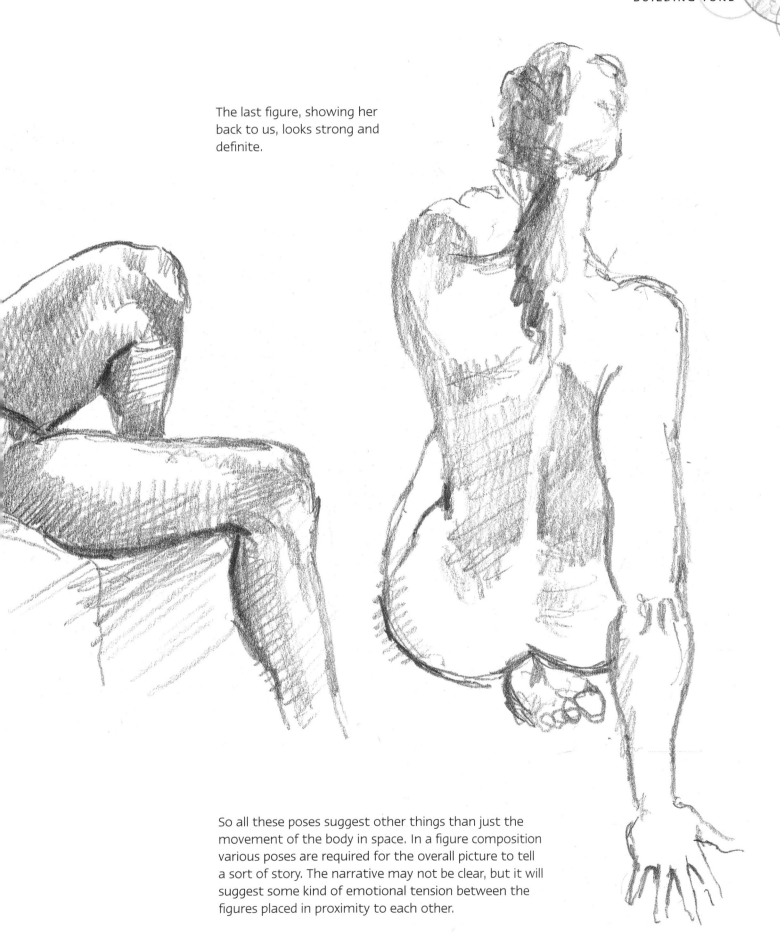

The last figure, showing her back to us, looks strong and definite.

So all these poses suggest other things than just the movement of the body in space. In a figure composition various poses are required for the overall picture to tell a sort of story. The narrative may not be clear, but it will suggest some kind of emotional tension between the figures placed in proximity to each other.

Movement

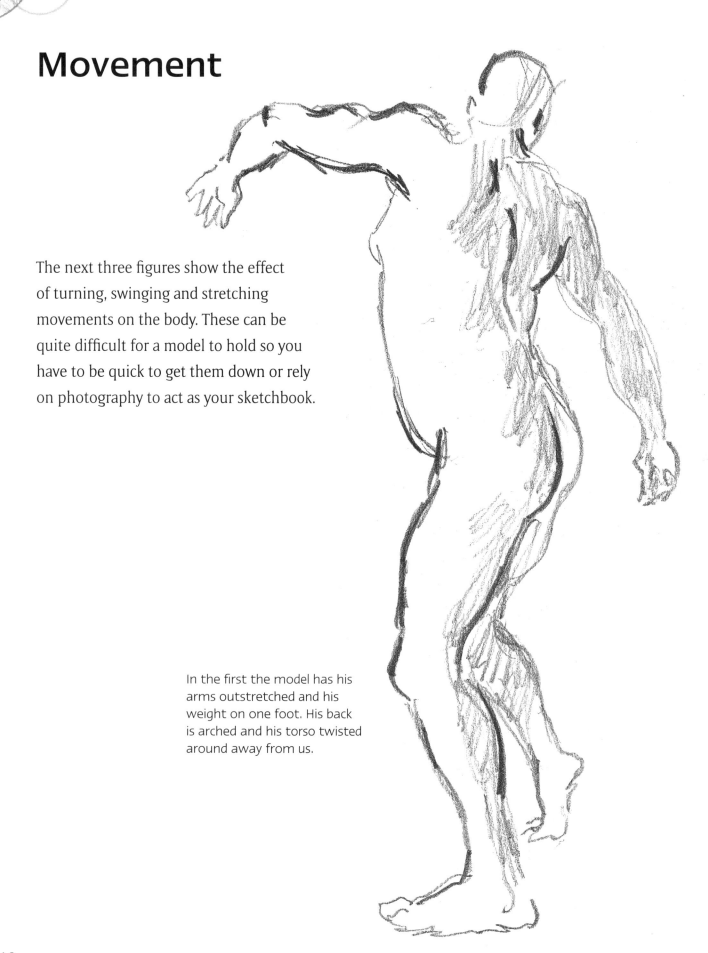

The next three figures show the effect of turning, swinging and stretching movements on the body. These can be quite difficult for a model to hold so you have to be quick to get them down or rely on photography to act as your sketchbook.

In the first the model has his arms outstretched and his weight on one foot. His back is arched and his torso twisted around away from us.

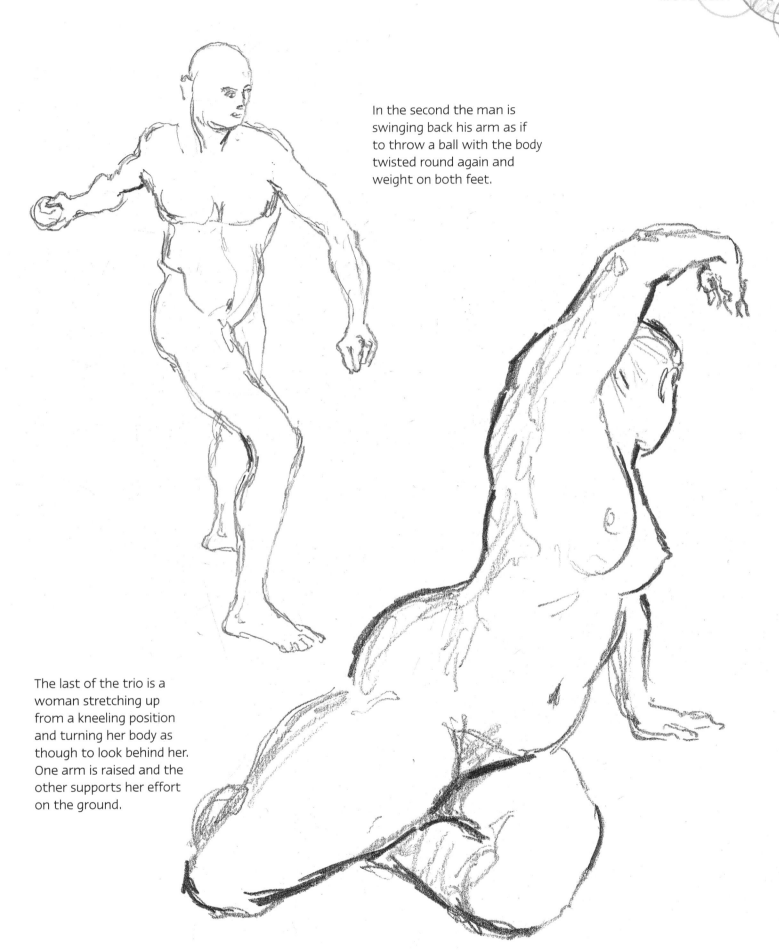

In the second the man is swinging back his arm as if to throw a ball with the body twisted round again and weight on both feet.

The last of the trio is a woman stretching up from a kneeling position and turning her body as though to look behind her. One arm is raised and the other supports her effort on the ground.

Figure relationships

When you engage in a figure composition, you're going to be placing several figures on the paper with some kind of connection with each other, merely because they're in the same drawing – so it's a good idea from the start to choose a situation that has an inherent reason for the figures to be together.

Here two men are engaged in boxing, with one man seen from behind throwing a punch at the one facing us, who is ducking and weaving to avoid the punch. It's nearly always possible to get people to pose separately for your compositions, but their movements need to be informed by the knowledge of how the other person will be posed. If this is difficult, you can always get them to make the moves together while you photograph them.

This couple are dancing together in a jive fashion. The man leans back to take the pull of the girl as she turns and swings to the music. In dancing the man's role is nearly always supporting, which the girl makes use of to show off her paces.

When it comes to children the variety of movement becomes much more flexible and the shapes that they produce have a delightful energy and spontaneity to them. Here you can see four different pictures of movement and the relationship between two figures.

The first pair of children are out in the garden and the boy is indicating something that has caught his interest. The girl is watching him but isn't about to move to join in his inspection.

Here the children are indoors at a desk where the girl is drawing or writing while the boy points to her work and chatters to her about it.

In the last two drawings the children are separate. The boy is running and brandishing a stick, while the girl is engaged in swinging a hoop around her waist. Both of these figures are very mobile and getting an exact sketch of their movements from life would be difficult. Once again the camera can come to the rescue, but do try to draw people in motion sometimes to catch the feeling of the movement rather than copying it frozen by the camera.

PROJECT 11

Figure composition

Drawing a figure composition is quite a major task, but if you go about it in a systematic way you won't find it too difficult. The first thing is to determine your format – I decided that mine would either be a short rectangle or a square shape.

▽ The second was of two men and a girl in a room talking or arguing.

▲ As you can see, I had three possible compositions in mind. One had a man lying on the grass with a girl kneeling next to him and another man running towards them.

▷ Finally, I decided that this idea of some young people playing ball on the beach might be the best way of doing my figure composition.

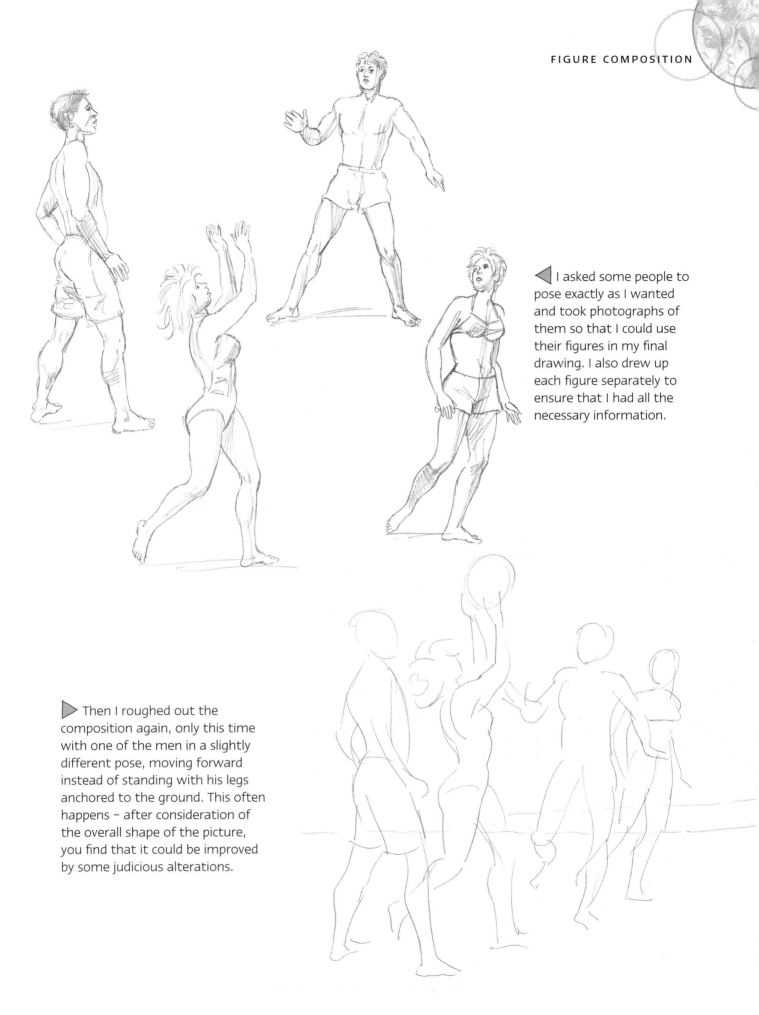

◀ I asked some people to pose exactly as I wanted and took photographs of them so that I could use their figures in my final drawing. I also drew up each figure separately to ensure that I had all the necessary information.

▶ Then I roughed out the composition again, only this time with one of the men in a slightly different pose, moving forward instead of standing with his legs anchored to the ground. This often happens – after consideration of the overall shape of the picture, you find that it could be improved by some judicious alterations.

With reference to all my extra information, I now began a more careful drawing of the background and the outlines of the figures in the poses I had chosen, correcting any mistakes at this stage.

Once the picture was clearly drawn up I began to put in tone to show where the sun gave shadows to the figures. I kept the tone as light as possible as I didn't want heavy tones until I was sure that the light tone worked as a whole.

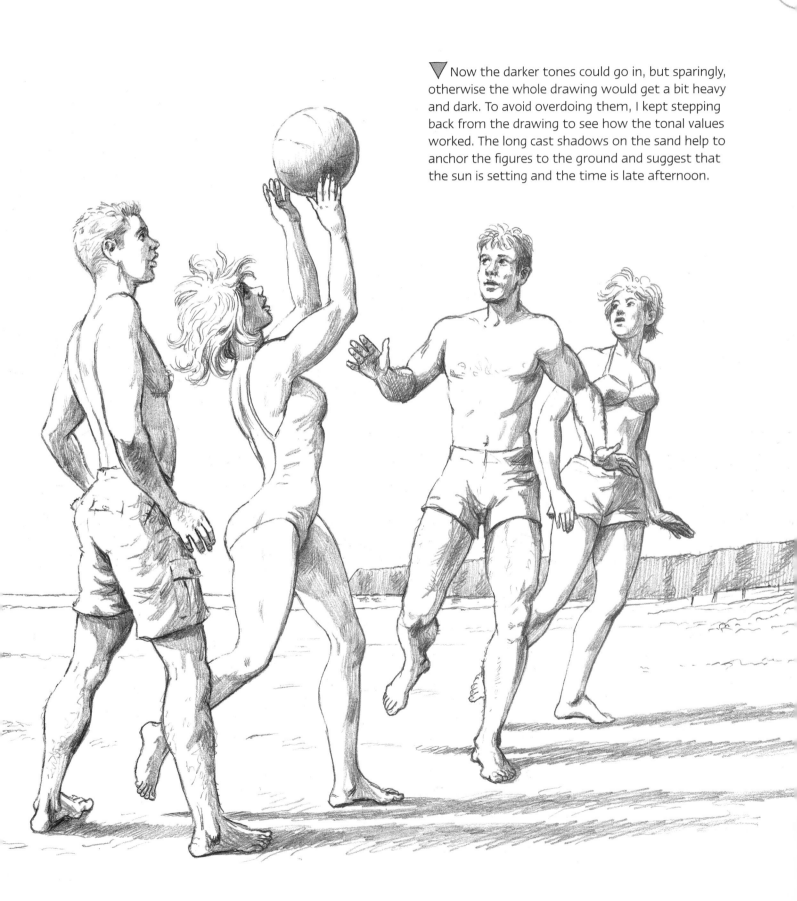

▼ Now the darker tones could go in, but sparingly, otherwise the whole drawing would get a bit heavy and dark. To avoid overdoing them, I kept stepping back from the drawing to see how the tonal values worked. The long cast shadows on the sand help to anchor the figures to the ground and suggest that the sun is setting and the time is late afternoon.

PROJECT 12: **GROUP PORTRAIT**

A group portrait differs from any other portrait only in that you have several people present, which of course makes the project more time-consuming. The main thing is to compose the figures and faces of your sitters in an interesting way and to work hard to achieve a resemblance, just as you would in a single portrait.

It's not easy to collect several people together in order to draw them at once, so usually the best bet is to draw them individually and fit them together later on. The point you have to watch here is that they are all the same proportion and relate to each other; you need to make the figures harmonize and form a group, rather than just a disparate set of people. To achieve this you can make the characters in the drawing look towards each other or connect with their body language, which makes the composition much more potent. This isn't easy when you are drawing them separately, but anything that you can do to bring out the connections between them will enhance your picture.

In the case of very young children you'll have your work cut out keeping them still for long enough to draw, so don't hesitate to take photographs to supplement any unfinished drawings – but don't worry if your efforts don't reach completion, because the work that you do to solve all these problems is invaluable for your artistic development.

Preparing a group portrait

Portrait drawing is different from other genres in that there's a need to capture likenesses of the people concerned – and while most people are happy with a flattering portrait they often don't like a drawing that doesn't fit with how they see themselves. In other words, your freedom for artistic licence is more limited than in, say, landscapes, but will be allowed as long as it's in the sitter's favour!

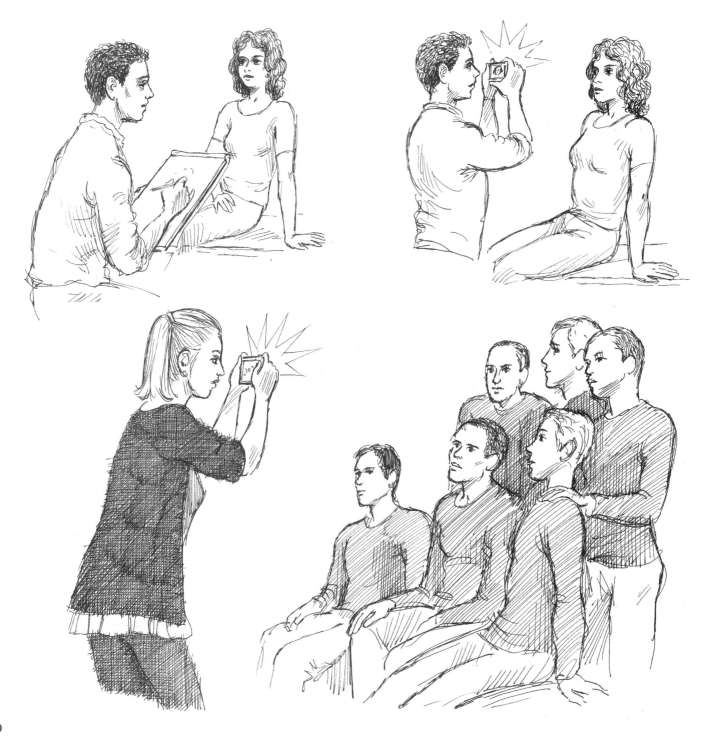

So, when it comes to drawing a group of people, the task in hand is to make sure that all the faces of the individuals are recognizable enough to satisfy their inspection. It's a good idea to get some photographic reference as well to ensure that you have got all the necessary information, taking shots of each face from different angles and also the whole composition. Draw sketches of each person and the composition to give yourself plenty of reference material that will work as backup if you need to halt the proceedings at any time and return to them later – especially with a large group, who may not all be able to reassemble.

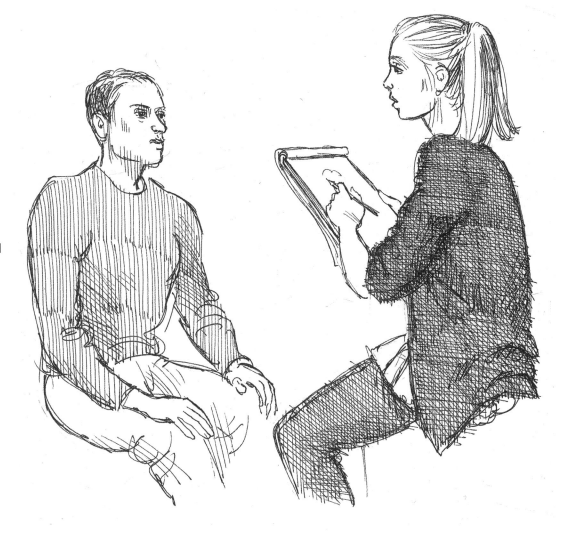

Small groups

In this portrait context, 'group' means anything other than one person, and the group you will most often be asked to draw is just two people, usually with a close relationship with each other.

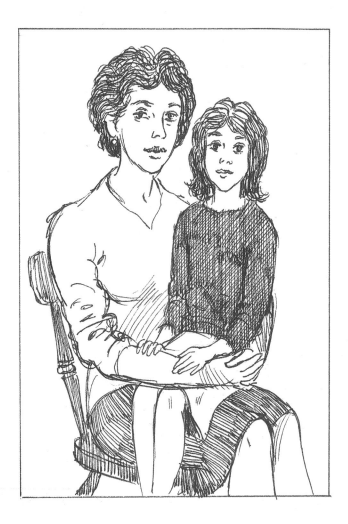

The first example I show here is a mother with her little girl on her lap, which creates a nice tight composition, and as long as the child will stay still for long enough there's no real problem with such a drawing. Obviously, once you've sketched in the main shapes of the two figures you can then draw the child first as quickly as possible, and when he or she wants to move you can then concentrate on the mother. The other thing about this combination of figures is that you only really have to satisfy the mother; the child usually is pleased with any representation that is even slightly human!

The second type of group, probably lovers or a married couple, is a bit more tricky because you will want a close connection between the two people, but they may find it difficult to sit so close as in my example for any length of time. Entwining figures can make a good composition, but depending on your speed of execution, you may find that they find difficulty in holding the intimate pose.

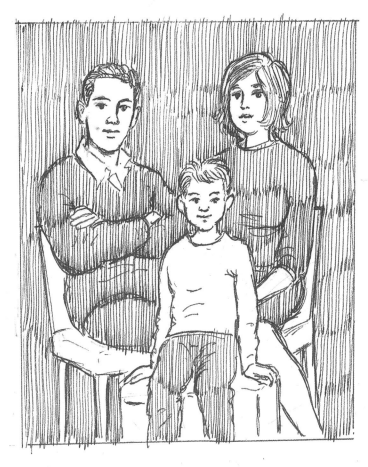

The next group has progressed to three people. The first trio is the obvious one of a couple and their child. The two adults sit next to each other and the child is in the centre of the composition, linking the two larger figures.

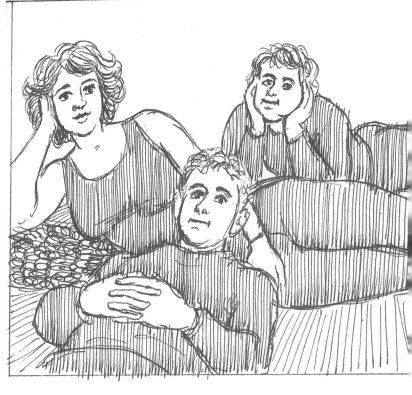

The second trio is two brothers and their sister, arranged in a much less formal composition than those shown so far. This isn't usually difficult with siblings under a certain age because of the sort of relationship they tend to have with each other. They probably won't mind a less conventional pose because they'll treat it as a sort of game.

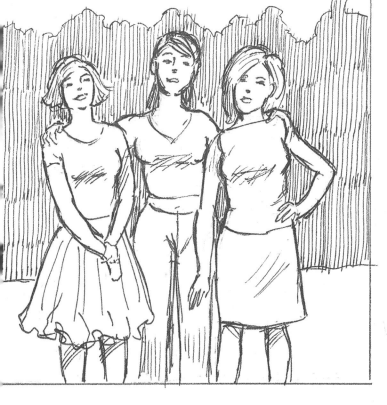

The last of these groups (left) is of three female friends, who are drawn as though interrupted out on a jaunt. Posed against a backdrop of trees, they might have been caught on camera as they were on a day out in the country. Quite often a photograph of the composition is a good idea, supplemented with careful drawings of each person which you can do individually later on.

Larger groups

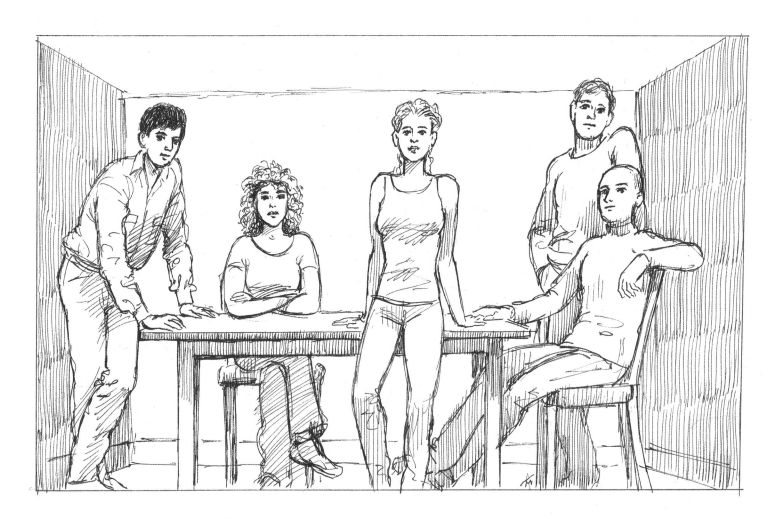

Now we look at a group of five people gathered around a table, which acts as a sort of support structure. With two sitting and three standing you get a certain dynamic in the composition which creates interest. It's also easier to make an interesting group with an uneven rather than even number of people. One of the standing figures is leaning on the back of the chair of the sitting figure at one end while another leans on the table at the opposite end. The central figure also leans back on the table, but being female she is not too bulky for the central role. The two seated figures, male and female, help to create a more horizontal shape to the arrangement.

Here's another group of five people, but this time out in the garden, obviously in summer. The arrangement isn't as limited as the interior scene because there's more depth of space in which the figures can be placed. The main thing is to be able to arrange them so that the group looks natural. I have opted for one young man standing with his hands in his pockets to one side of the composition, and an older man on the far side reclining in a deck chair with a book on his lap. These two enclose the others neatly. The other seated figure of a woman is opposed in arrangement to the seated man, their legs overlapping from our viewpoint. In the centre, but much further back, are a young man pushing a lawnmower and another man seated on the grass behind the woman so that only his head and shoulders show. The background of the conservatory, bushes and trees gives more sensation of depth in the composition.

Next we look at an even larger group that's more like a team portrait of the sort that might be commissioned. Here a group of young, athletic-looking men are casually grouped with those in the foreground sitting and the others standing behind them. There's a certain amount of artistic licence here, because the standing men appear to be on ground lower than that on which the others are sitting. This is done in order to bring their respective faces closer together to create a tighter composition. The fact that they are wearing matching sweaters also helps to bind the figures together.

This group is much less formal – it's the sort of gathering that you sometimes find in a family that's getting together for a party in the garden during the summer. The compositional feature is a large hammock on which two of the people are reclining. Arranged around them is the rest of the group. Again the figures at each end are the brackets that hold the arrangement and I've put them in as two men, the older people in the group. Two young men are in the hammock, one closer to the viewer with arms and legs dangling down. The figures behind are two young women and a small boy who add a sort of grace note to the scene. Behind them we can see a fence and a couple of tree trunks, so there is not a great deal of depth. It is almost like a group on a stage.

Family groups

An easy way to set about drawing groups of people is to start with your own family – they're usually available, and they might be more amenable to your first experiments than people that you don't know so well. So here's a series of portraits of my own family to give you some examples of how you might go about it.

The first is of my eldest son and grandson, caught in a pose photographically, as the latter wouldn't keep still for any time at all. It's an unusual portrait because a profile view isn't the norm.

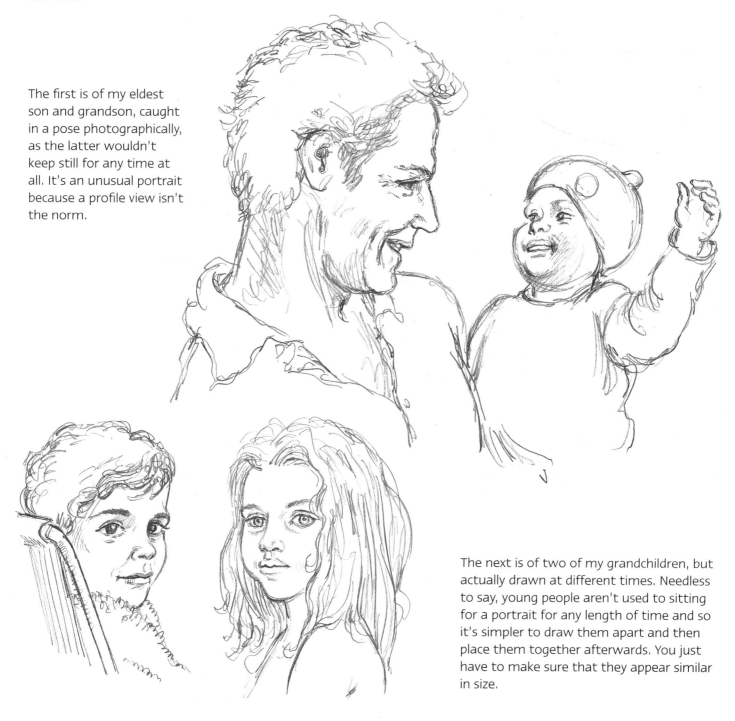

The next is of two of my grandchildren, but actually drawn at different times. Needless to say, young people aren't used to sitting for a portrait for any length of time and so it's simpler to draw them apart and then place them together afterwards. You just have to make sure that they appear similar in size.

Next comes a pair of trios, one of a grandchild and friends, and the other of myself and my sisters. These are based on photographs because the children were quite animated and the self-portrait needed some reference. Both compositions make use of the fact that the figures are placed quite close together, with the drawing activity of the children and the dark clothing of the older group linking each trio.

The next group is another trio with my youngest
daughter, my son-in-law and their child all together.
Again the actual pose was photographed and the
drawings all done separately later.

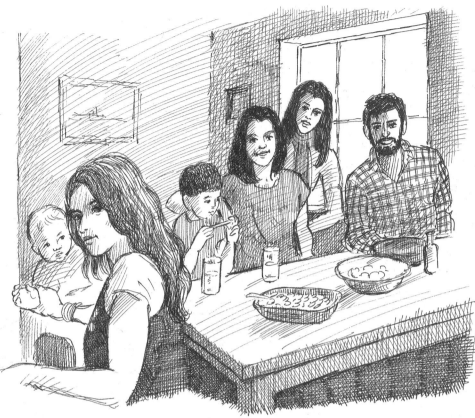

This drawing shows my daughter with her daughter, cuddling up together. I used a combination of photographic reference and sketches of them both.

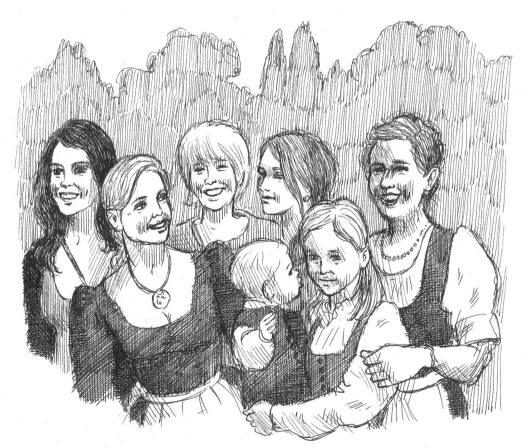

The next picture is based on a holiday photograph with a family group around a table where some lunch preparations were in progress. The looseness of the composition is typical of an informal photograph. The diagonal of the table and the turning movement of the nearest figure give a certain dynamic to the scene.

The last scene is of a time when we went to Bavaria to visit my daughter-in-law's family. At one point all the female members of the family were together with one grandson, closely gathered for a photograph. I later made drawings of each one individually.

Group portrait

▷ Having decided that I would draw my youngest daughter and her family for the final composition, I first made a quick sketch of them in position. I also took photographs, as the little boy and the baby obviously weren't going to pose for long. This is a basic outline of shapes and proportions.

◁ Next I drew a more careful line drawing using my sketches and photographs to get the shapes and features correct. At this stage, any alterations can still be easily made, but you are trying to end up with a definitive drawing.

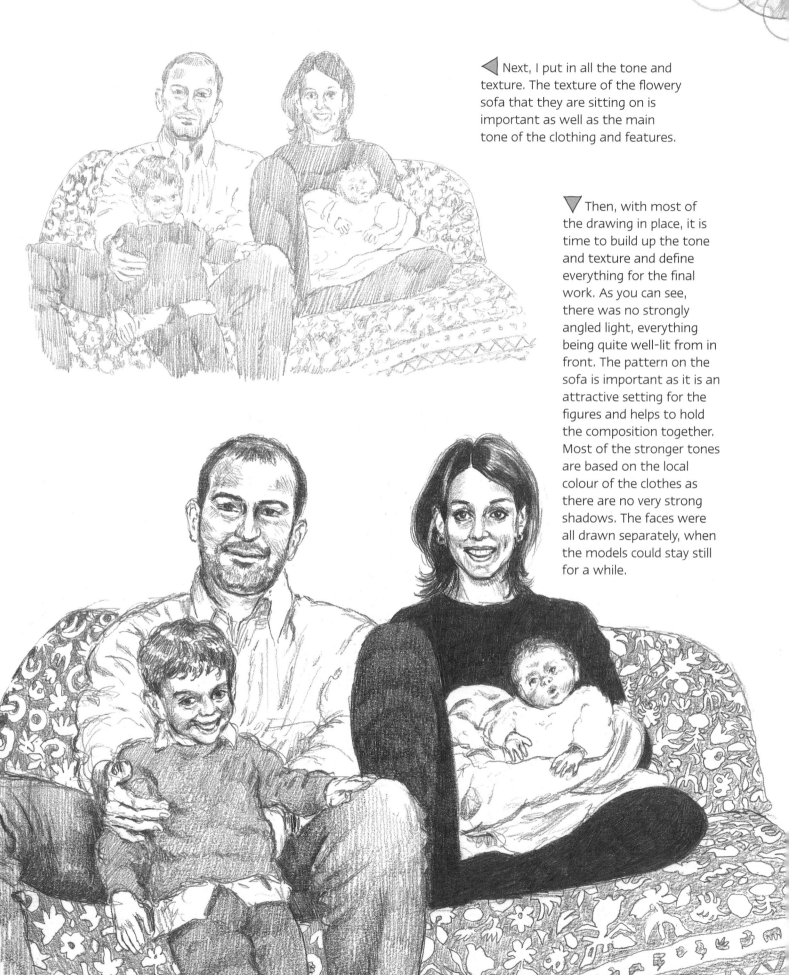

◁ Next, I put in all the tone and texture. The texture of the flowery sofa that they are sitting on is important as well as the main tone of the clothing and features.

▽ Then, with most of the drawing in place, it is time to build up the tone and texture and define everything for the final work. As you can see, there was no strongly angled light, everything being quite well-lit from in front. The pattern on the sofa is important as it is an attractive setting for the figures and helps to hold the composition together. Most of the stronger tones are based on the local colour of the clothes as there are no very strong shadows. The faces were all drawn separately, when the models could stay still for a while.

Master examples

◁ In this informal family group after Dame Laura Knight (1877–1970), the artist Lamorna Birch stands holding onto a tree to help support one of his young daughters, tucked under his arm. His other daughter sits astride another branch of a tree over in the right-hand side of the composition. Behind is a river and more trees. It must have been quite difficult to keep these poses for long, and it may be that Dame Laura relied on photographic reference.

▷ This intriguing composition of a group of Newcastle fisher girls posed in their typical dress in 1900 must have been quite carefully composed by the unknown photographer. The girls are obviously not in ordinary working dress but something a little more decorative to have their photograph taken. The various characters of the girls show in the type of pose that they have adopted. The photograph has quite good definition and so might easily have been taken for an artist to work from.

▷ Here is a very complex figure composition after Henri de Toulouse-Lautrec (1864–1901) that includes many of the habitués of the Moulin Rouge in Paris in 1892. The large balcony edge which cuts across the lower left-hand corner gives a movement through the picture. Then you see a group of people around what is probably a small table, which isn't visible. In the foreground is a young woman lit from below, while in the background various people stand around in the larger space.

FINAL PROJECT: **SELF-PORTRAIT**

Because the artist is staring so intensely at his or her face, self-portraits always have an extra power; you'll find that when you're drawing other people they either go into a dream or look rather bored, but when it comes to drawing yourself you don't have that problem. All you'll need is at least one mirror, though photographs of yourself can help you to gain a more objective view of your face and check that you've got your features in proportion.

The many examples of artists' self-portraits in this section will give you some idea of the rich variety of approaches that have been used in the genre. Some of them might make it difficult for you to recognize the artist in real life, but that's because when you're drawing yourself you have no one else to please – you can simply follow your own artistic desire to produce a good drawing.

This has been placed as the last project in the book because it's like a signing-off piece. Here you're going to commune only with yourself, and you may find that it's a practice you'll want to return to again and again. Great artists such as Rembrandt certainly did, leaving marvellous collections of self-portraits that tell us a lot about their artistic development over time. So now is the time to enjoy your own skill and see what you can make of this interesting business of drawing.

At some time or another all artists have a go at a self-portrait or two, it being the simplest way to obtain a sitter. All you need to do is grab a sketchbook or a board and paper, sit down in front of a good-sized mirror and draw away.

Another reason why artists draw many self-portraits is that you don't have to worry about anybody else's opinion of the result; when the model is only yourself, you can be as objective as possible about the drawing and you won't be offended if the likeness is neither perfect nor flattering; you'll be more concerned about the artistic verity of the drawing.

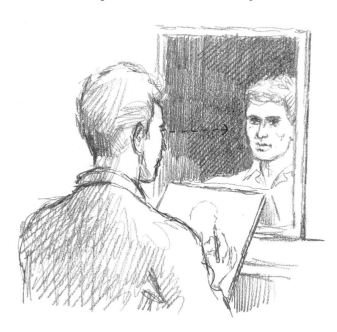

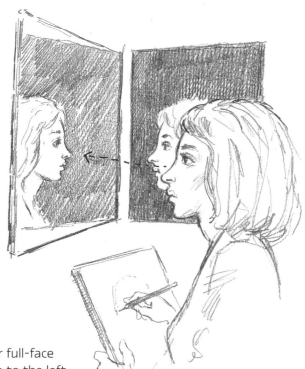

A feature of the self-portrait is that you'll tend to be looking at your full-face image, and the only real variation on this is to turn your head a little to the left or right and glance at yourself from the corner of your eye. This will give you a three-quarter view of your face but your eyes will still be looking straight at you. To avoid this you'll need to get indirect views of your own head by using two mirrors at an angle to each other, but this is a rather complicated way to work.

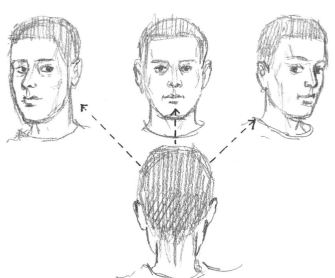

The other alternative is to take a photograph of yourself and work from that, but when you are drawing the final piece, refer back to a mirror image because you will see much more information there than the photograph will give you.

Master examples

The best way to learn is to study what the experts have done, and you'll find the following self-portraits useful when you're engaging with your own. Some are quite unusual in that it's quite hard to recognize a photographic likeness. This should give you encouragement to experiment with your attempts to draw yourself. After all, you have no one to please except yourself.

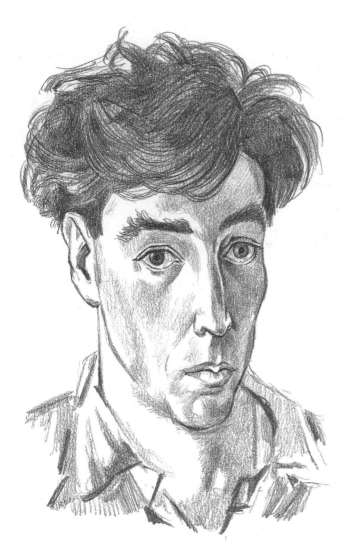

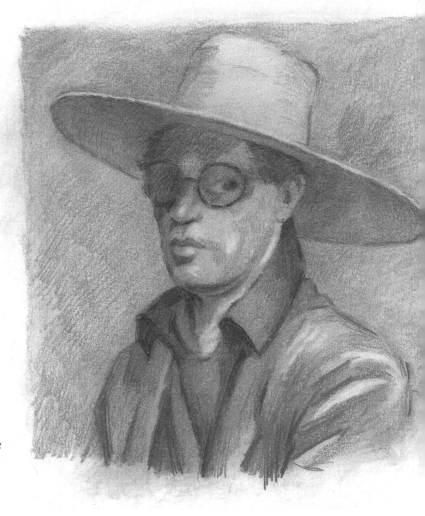

This next portrait, dating from 1956, is a copy after Duncan Grant, a leading light in the English art world. Here he shows himself in a protective hat and large glasses which almost hide his face. Whether you would be able to recognize the man after seeing this image is doubtful, but obviously to him it was an interesting thing to do. The dark shadows cast across the face by the big hat seem to make the lower part of the face more definite.

The first image is after a renowned illustrator and painter from the first half of the 20th century, John Minton. He was the image of the romantic idea of an artist, with soulful eyes, unruly hair and a rather sombre look. His self-portrait, done in 1953, shows this aspect quite clearly and there are other portraits of him that prove he was quite accurate in his efforts.

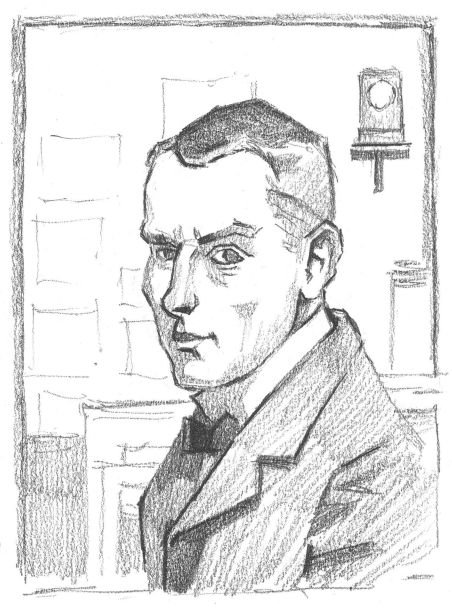

▷ This picture after Robert Bevan (1865–1925), done just before the First World War, is a beautifully understated piece of work which gets across the look of the artist very directly. He has reduced all modelling and form to the minimum but still gives enough information to show depth and dimension.

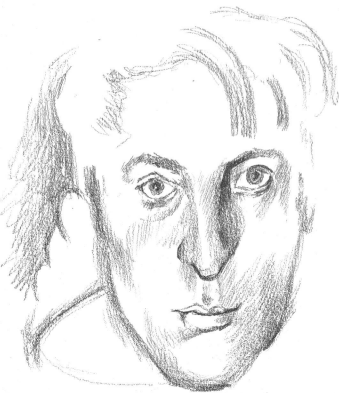

◁ The next drawing is after a quick pencil sketch done by Edward Burra in 1929. It is drawn without any attempt to get the whole head in. He has concentrated on the features alone with the central area of the nose, eyes and mouth worked out carefully and the rest put in just enough to anchor them down and give the drawing some depth.

▼ The example below, after John Craxton in 1945, is interesting as an instance of a slightly naïve type of drawing done by an obviously talented draughtsman. He hasn't tried to show much in the way of form, except for the rather baroque folds in the clothing. He was in his early twenties when he drew this, and the youthful quality comes across admirably. The very dark lines and the touches of highlights make a very decorative image.

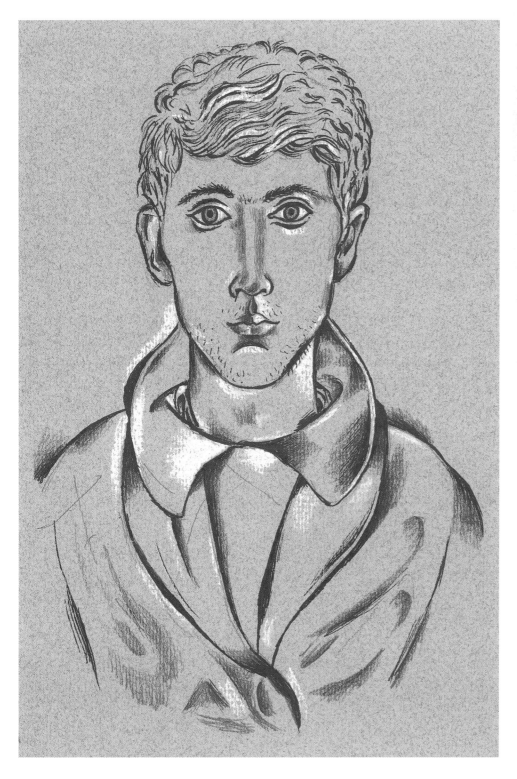

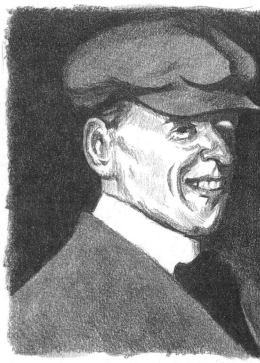

▲ This drawing of a painting by J. D. Fergusson in 1902 shows a very immediate image of the artist. The strong darks and the simple handling of the clothing has a very graphic look and reminds me of the sort of drawings that were used in posters in the early part of the 20th century.

The next drawing is very different to the others we've explored so far. It looks like the sort of thing someone might have scrawled onto a paper napkin while drinking in a pub. It has marvellous nervous energy, and is probably quite accurate in the emotional intensity of the face. The thick, slightly blobby lines are brilliantly handled to give a lot of information in a simple, direct way. As you can see, your drawing doesn't have to be an academic exercise in detail – sometimes an immediate drawing like this has more power. Alan Davie (b. 1920) is a well-respected artist and this example shows why.

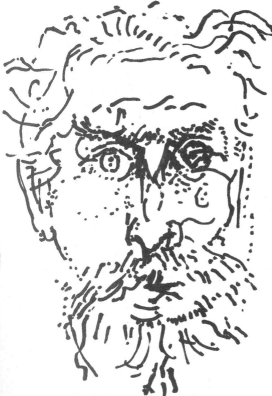

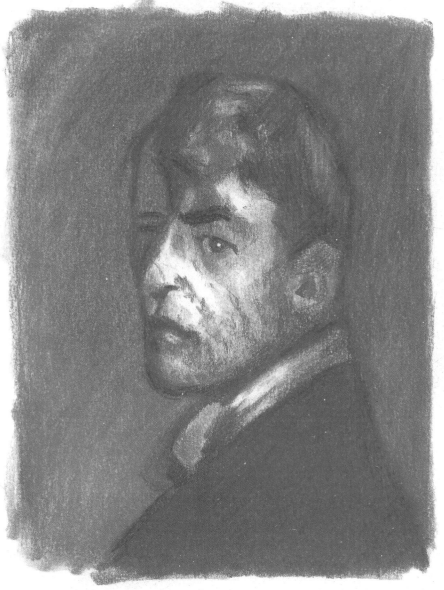

Here are a couple of drawings after master artists that seem to go against all the ordinary understanding of what a portrait is for. The first, by Walter Sickert in 1896, the great British Impressionist, is a dark study with the face looming out of the gloom. He has kept the handling of the form very simple, and the way a ray of light has revealed the side of the face is quite dramatic.

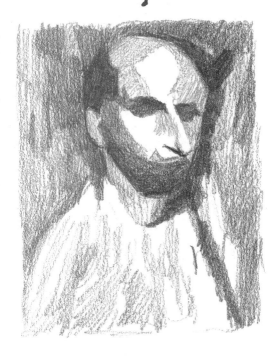

The next one, by David Bomberg in 1937, is even less conventional in that the form is greatly reduced and yet it still reveals a head. It's interesting to consider what the artist was showing in a portrait like this – which has none of the polite effects of an academic drawing.

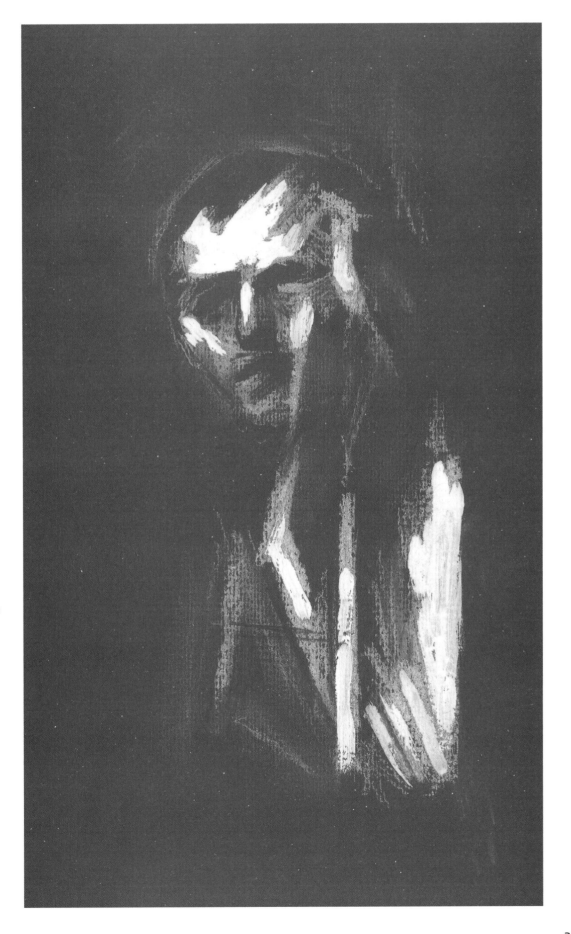

▷ One more step in a similar direction with this self-portrait by Frank Auerbach in 1959, one of the leading lights in British painting. It is obviously a head of a man, but what more can you tell from this image? His interest in the handling of the medium is probably more important to him than the possible recognition factor. As you can see from these examples, there are many ways to approach this genre of portraiture than first seems possible.

Making my self-portrait

So now I shall show the stages of a self-portrait that I attempted while in my garden studio. The light is behind me so that my face is in shadow, and as I was wearing a white shirt at the time there's a big contrast between the area of skin and the area of cotton shirt. The glasses emphasize the stare of the eyes which is endemic in most self-portraits.

▲ I started by just blocking in a simple shape that gave me the proportions of the head and body. This is well worth doing, because it's easy to lose the proportion when you get into the detail.

▲ Then I began to describe more carefully an outline of the main shapes and form, which I drew lightly so that I could easily change it if I made a mistake. This is the stage when any erasing is done, so take your time about this part in your own self-portrait. It's worth getting it right now, because later on it will be more difficult.

▷ Then I put in the tonal area, keeping the tone the same all over the picture. This is important, because it's easy to get tones wrong if you start putting them in heavily straight away.

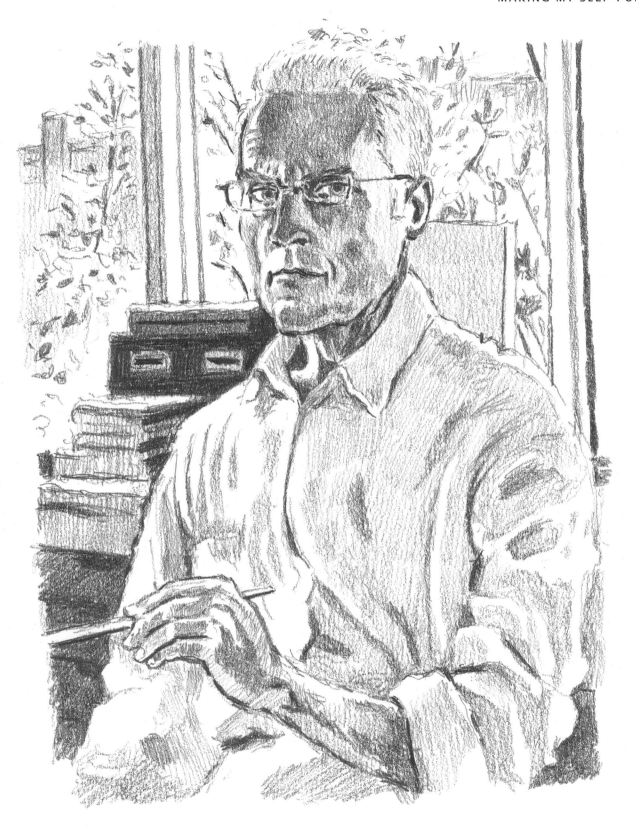

▲ The last stage was to build up my tonal values so that the picture started to look properly solid and with the effect of the light falling on the edge of the face and the shirt folds. The tone of the objects just behind my shoulder was useful to bring my figure forward in the picture. This is a very straightforward, naturalistic drawing, unlike some of the examples that you've just seen, but that's my own style – and fortunately it makes for an easier demonstration of how to do a self-portrait.